STAR TREK™

DESIGNING STARSHIPS
THE *U.S.S. VOYAGER* AND BEYOND

MORE THAN 30 SHIPS IN EXTRAORDINARY DETAIL

Published by Eaglemoss Ltd. 2018
1st Floor, Kensington Village, Avonmore Road, W14 8TS, London, UK.

General Editor: **Ben Robinson**
Project Manager: **Jo Bourne**
Written by **Ben Robinson** and **Marcus Riley**
Designed by **Stephen Scanlan**

Most of the contents of this book were originally published as part of
STAR TREK – The Official Starships Collection
For back issues: order online at
www.shop.eaglemoss.com

ISBN 978-1-85875-532-8

CONTENTS

ACKNOWLEDGMENTS

The authors would like to thank all of the artists, production
designers, producers and writers who contributed to the ships that fill
the pages of this book.

The greatest thanks of all are due to Gene Roddenberry and
Matt Jefferies, who started it all and gave us a genuinely new kind of
starship that has provided an amazingly adaptable template for what
has followed. They are both much missed, but their legacy lives on.

We'd like to thank in no particular order Andy Probert,
Herman Zimmerman, Rick Sternbach, John Eaves, Alex Jaeger,
Doug Drexler, Bill George, Nilo Rodis, Greg Jein, Niel Wray, David Rossi,
Ron B. Moore, Dan Curry, Jim Martin, David Negron Jr, Rob Bonchune,
Adam 'Mojo' Lebowitz, David Lombardi, and Syd Mead all of whom
contributed to this book when they gave the original interviews for
STAR TREK The Magazine and STAR TREK The Official Starships Collection.
We'd also like to pay tribute to the late Richard James and
Robert McCall. They could not have been more helpful or generous
with their time.

We'd also like to thank the team at CBS Consumer Products:
Risa Kessler, John Van Citters and Marian Cordry.

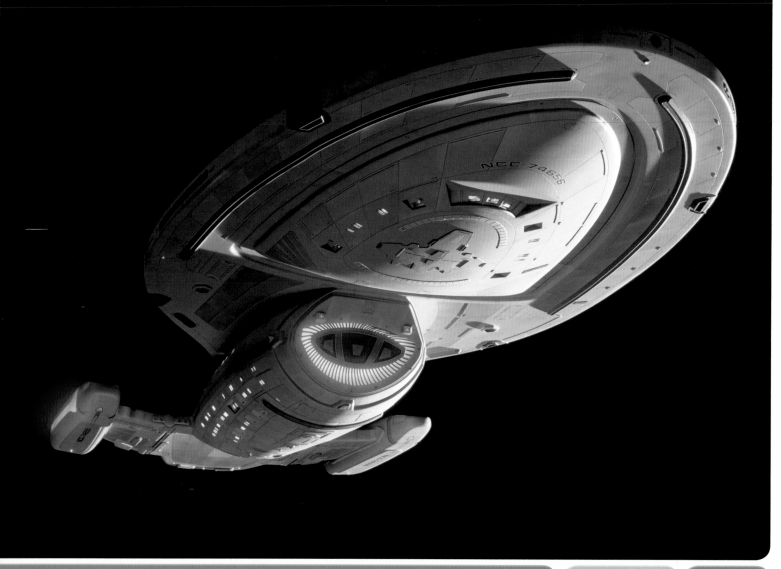

DESIGNING THE

III

U.S.S. VOYAGER

The design for the *U.S.S. Voyager* drew inspiration from a killer whale, a Starfleet runabout and a sleek and curvy car.

The *U.S.S. Voyager* was always meant to hark back to Kirk's original *Enterprise.* Whereas the *Enterprise*-D had been designed to be a hotel in space with all the facilities of a university, *Voyager* was a small, maneuverable craft. "It is a ship that was specifically designed for action," co-creator Jeri Taylor told *Cinefantastique.* "It's smaller, it more

maneuverable, it can land on a planet's surface, it can be sent into situations where a *Galaxy*-class starship simply can't function."

Design work began in the fall of 1993, as *STAR TREK: THE NEXT GENERATION*'s run on TV drew to a close. The project was headed up by *TNG*'s production designer, with *Voyager*'s design being led by concept artist Rick Sternbach.

Richard James knew that their starship would also need a new look, but, as he remembers, it couldn't be too new, "Mr. Berman said, 'I want it to be different; I don't want it to look like *THE NEXT GENERATION* or *DEEP SPACE NINE.*' But he also said that if people were flipping channels, then he wanted them to instantly recognize the fact that it was *STAR TREK.*"

◀ Sternbach started work by filling pages with quick sketches in felt pen. Many of the ideas built on his designs for the runabout in which the nacelles had been turned "upside down."

▲ At this early stage the producers picked out this design, which featured a wedge-shaped "saucer section."

As Sternbach recalls, when he first started work on the ship he knew very little about it. The writer's bible described *Voyager* as having a "streamlined, bullet sort of shape" and he was told that the producers wanted the new design to be much smaller than the *Enterprise*-D.

FIRST THOUGHTS

As usual, he started by producing a series of rough sketches, looking for a basic shape. "The early felt-pen sketches show a number of shapes drawn over and over, as I attempted to settle on a first best guess at the new ship. A streamlined, dart-like primary hull was matched to a flattened, elongated engineering hull, sporting swept-back runabout pylons."

In these days it was important that whatever Sternbach designed could actually be made as a physical model and as he recalls, he talked to the

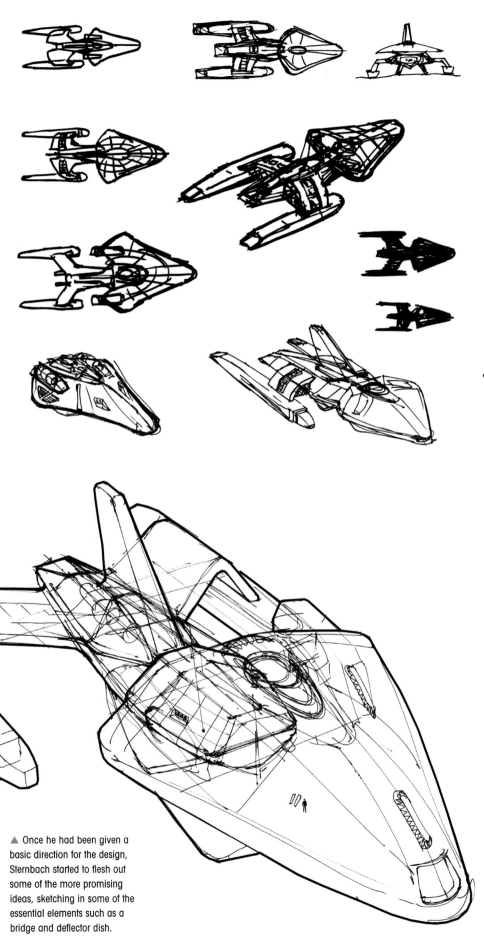

▲ Once he had been given a basic direction for the design, Sternbach started to flesh out some of the more promising ideas, sketching in some of the essential elements such as a bridge and deflector dish.

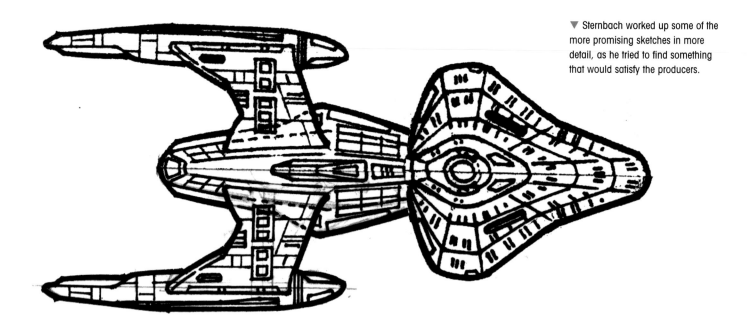

▼ Sternbach worked up some of the more promising sketches in more detail, as he tried to find something that would satisfy the producers.

visual effects producer Dan Curry about any requirements his team might have.

"Even in the first design phase, Dan Curry reminded me of the general rules of miniature design, such as making certain that motion control mount points were near the model's center of gravity, and that the belly mount be the absolute lowest part of the ship, in order to avoid problems with the bluescreen filming."

From those very first sketches

Sternbach was moving away from Andy Probert's *Enterprise*-D with its 'fat' saucer as he started to look for a more streamlined design. While he was working, the concept for *Voyager* continued to evolve as the executive

U.S.S. VOYAGER

Preliminary Discussion Concept
Rick Sternbach
30 Mar 94

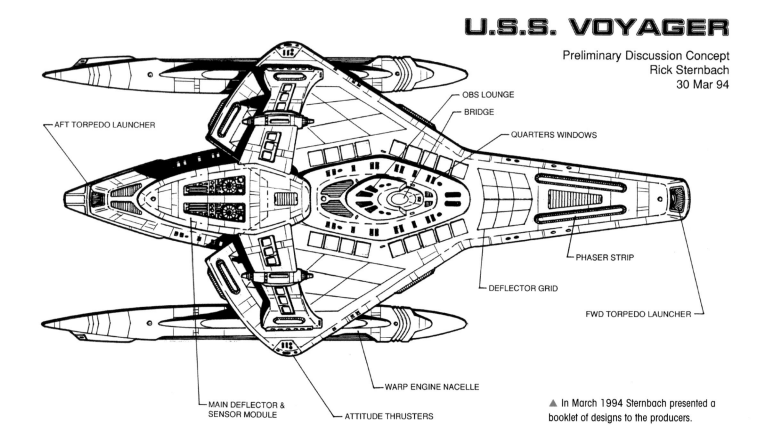

OBS LOUNGE

BRIDGE

AFT TORPEDO LAUNCHER

QUARTERS WINDOWS

PHASER STRIP

DEFLECTOR GRID

FWD TORPEDO LAUNCHER

WARP ENGINE NACELLE

MAIN DEFLECTOR & SENSOR MODULE

ATTITUDE THRUSTERS

▲ In March 1994 Sternbach presented a booklet of designs to the producers.

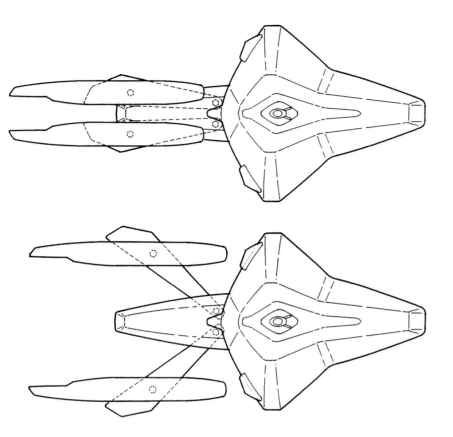

◀ It was decided that some element of *Voyager* would move. Even at the earliest stage, the warp nacelles seemed like the best candidate. This drawing shows them going through a wide arc – starting completely upright behind the saucer and swinging out as the ship went to warp.

and hull contours, both gently curved and angular, were explored in perspective. Even in the rough sketches, a lot of design ideas got worked out, concerning placement of familiar items like impulse engines and phasers."

ORGANIC INSPIRATION

As Sternbach explains, many of these early designs drew inspiration from nature, as he looked at the shapes of different creatures that moved at speed either through the air or underwater. "*Voyager* began in embryonic form by taking on the characteristics of an Orca whale, a Manta Ray and various birds," he says. "Those biological shapes were then hardened into a spacecraft structure that echoed some of the Starfleet designs that already existed. Preliminary functions, like radiators or exotic warp stabilizers were then added. Continuing to follow the Starfleet standard, the bridge was then located on Deck 1 at the top of the ship while a variety of 'placeholder' crew windows

producers continued to work on the bible. As a result, he would receive requests that changed the way he thought about the design.

"Along the way, we were told the ship would be able to land on a planetary surface. This was a real departure from the norm," he says. "So deployable landing gear and other

arrangements of resting on hull components were sketched out. The producers also wanted some part of the ship to animate or articulate either the nacelles, or a weapon array, or perhaps the navigational deflector.

"Variations filled more paper as the proportions of different parts changed, pieces were added and subtracted,

▼ One of the designs that would be pursued featured large fins above and below the ship.

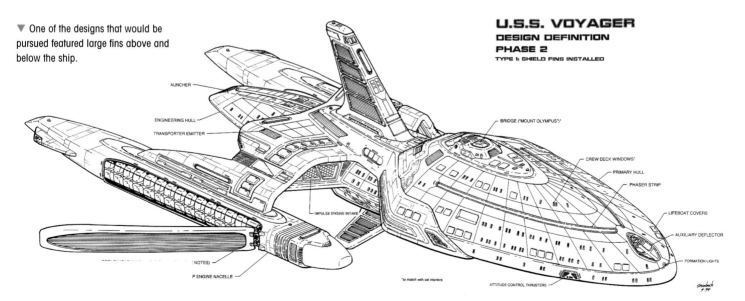

U.S.S. VOYAGER
DESIGN DEFINITION
PHASE 2
TYPE 1: SHIELD FINS INSTALLED

LAUNCHER
ENGINEERING HULL
TRANSPORTER EMITTER
IMPULSE ENGINE INTAKE
NOTES)
P ENGINE NACELLE
*to match with set interiors
ATTITUDE CONTROL THRUSTERS

BRIDGE ("MOUNT OLYMPUS")
CREW DECK WINDOWS*
PRIMARY HULL
PHASER STRIP
LIFEBOAT COVERS
AUXILIARY DEFLECTOR
FORMATION LIGHTS

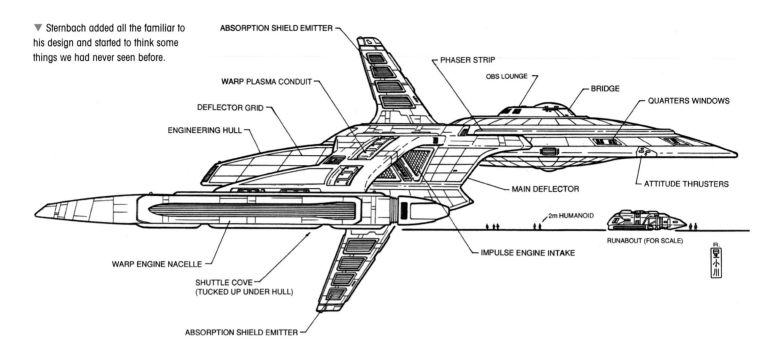

▼ Sternbach added all the familiar to his design and started to think some things we had never seen before.

ABSORPTION SHIELD EMITTER

PHASER STRIP

WARP PLASMA CONDUIT

OBS LOUNGE

BRIDGE

QUARTERS WINDOWS

DEFLECTOR GRID

ENGINEERING HULL

MAIN DEFLECTOR

ATTITUDE THRUSTERS

WARP ENGINE NACELLE

SHUTTLE COVE
(TUCKED UP UNDER HULL)

IMPULSE ENGINE INTAKE

2m HUMANOID

RUNABOUT (FOR SCALE)

ABSORPTION SHIELD EMITTER

were dotted about the hull, which from past experience I knew would most likely be built into the standing set."

One approach stood out in Sternbach's early sketches: a streamlined dart-like primary hull, which was matched to a flattened, elongated engineering hull with swept-back runabout-style pylons. Over time, the proportions of those preliminary designs gradually evolved with pieces regularly being added and then taken away. Different hull shapes were tried – both curved and angular.

FAMILIAR ELEMENTS

"Many of the eventual design elements such as the dropped nacelles, the fin (which would later disappear) and the extended arrow-shaped saucer section got worked out at this stage as well as the placement of familiar items like the impulse engines and phaser array," explains Sternbach. "Because *Voyager* was going to be so much smaller than previous ships, structures like the windows had to be made proportionately larger, which made them more visible than they had been

on the *Enterprise*-D and the design required more model details in order to match the stage sets which of course influenced various aspects of the design."

In order to work out how big the ship was Sternbach drew preliminary hull cross sections in blue pencil. This way he could check different internal deck heights, the total number of decks and the overall length of the ship. "In the past, many Starfleet ships seemed to have 13 feet between decks, an idea partially driven by set wall heights and

▼ Several versions of the design featured an AWACS style pod on the top, that could have been either a sensor palette or a separate vessel.

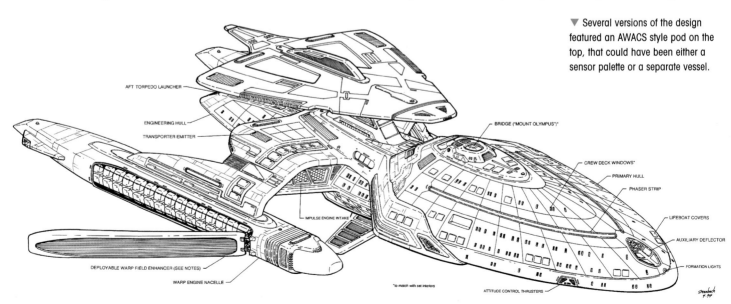

AFT TORPEDO LAUNCHER

ENGINEERING HULL

TRANSPORTER EMITTER

BRIDGE ("MOUNT OLYMPUS")

CREW DECK WINDOWS*

PRIMARY HULL

PHASER STRIP

IMPULSE ENGINE INTAKE

LIFEBOAT COVERS

AUXILIARY DEFLECTOR

DEPLOYABLE WARP FIELD ENHANCER (SEE NOTES)

WARP ENGINE NACELLE

FORMATION LIGHTS

*to match with set interiors

ATTITUDE CONTROL THRUSTERS

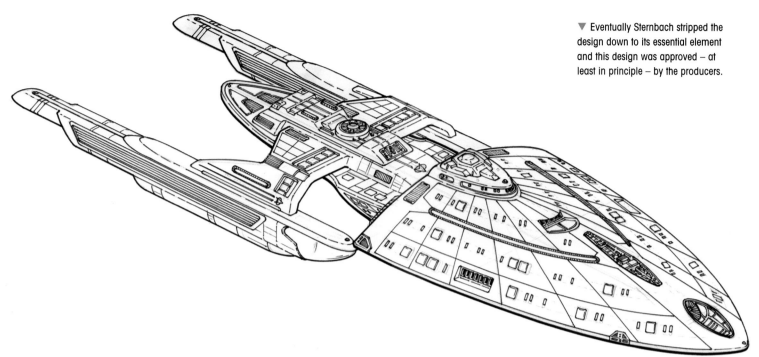

▼ Eventually Sternbach stripped the design down to its essential element and this design was approved – at least in principle – by the producers.

the idea that there was a two-foot structural thickness made of deck plating, gravity generators and various conduits," Sternbach says. "So at this stage of the design process, *Voyager* could have been anywhere between 500 to 1,200 feet long, which in comparison to the *Enterprise*-D at 2,108 feet was tiny."

MOVING PARTS

Recalling the producers' desire for the ship to have an obvious moving part, Sternbach played around with various ideas before settling on the nacelles as the most obvious choice. He then experimented with a view to making the warp nacelles swing from a curved down position up in to a horizontal position whenever the ship went into warp flight.

That first batch of hull designs was assembled into a booklet in order to give the producers an idea of what could be achieved and could serve as a starting point for discussions about what they liked or disliked or wanted changed.

"During those discussions," Sternbach says, "the producers decided they were keen on the design which featured a

▼ At this point one of the ideas was the warp field grilles might swing away from the nacelles to give the ship some kind of 'power up' before it went to warp.

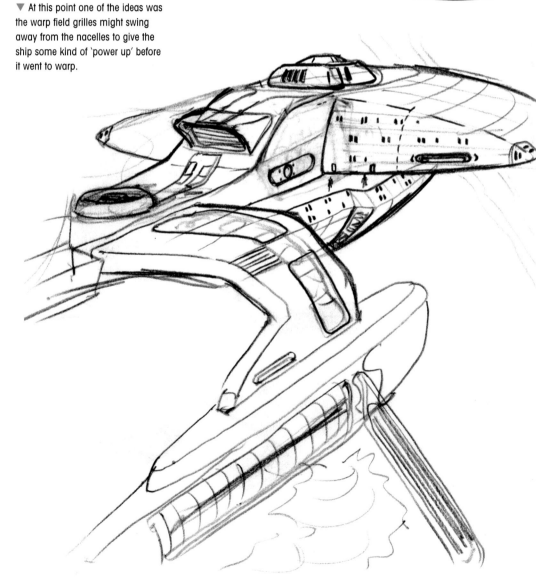

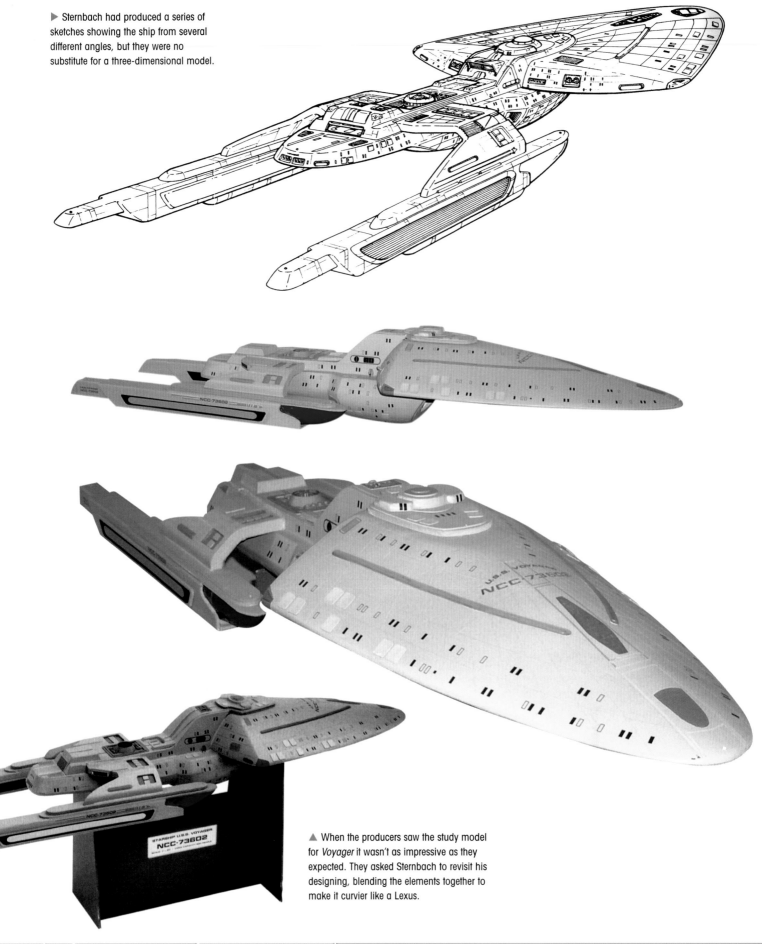

▶ Sternbach had produced a series of sketches showing the ship from several different angles, but they were no substitute for a three-dimensional model.

STARSHIP U.S.S. VOYAGER
NCC-73602

▲ When the producers saw the study model for *Voyager* it wasn't as impressive as they expected. They asked Sternbach to revisit his designing, blending the elements together to make it curvier like a Lexus.

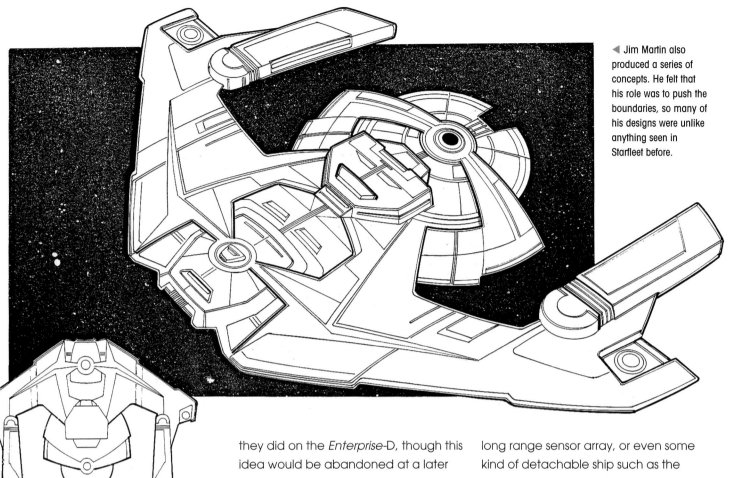

◀ Jim Martin also produced a series of concepts. He felt that his role was to push the boundaries, so many of his designs were unlike anything seen in Starfleet before.

they did on the *Enterprise*-D, though this idea would be abandoned at a later stage.

NEW FEATURES

The art team also experimented with the idea that doors on the nacelles would open to expose the warp coils for some new kind of energy jump. Impulse thrusters were buried underneath as in the runabout, and a large triangular wedge sat on top of the ship, which would possibly act as an AWACS-type of

long range sensor array, or even some kind of detachable ship such as the captain's yacht or a scout vessel.

As work continued, Sternbach produced an alternate version featuring a sleeker looking ship, which did away with the AWACS wedge and also used some shape ideas from the *U.S.S. Excelsior*. As work continued more details crept in, notably the large forward sensor cut out and a stepped engineering hull that supported a ring of large cargo bays and impulse engines. Sternbach then submitted the sketches to the producers. "The wedgeless and sleeker version was the one that received a thumbs up."

SHIP THAT NEVER WAS

At this point, everyone thought they had established the final look of *Voyager*, and a study model was built. A top plan view of the ship was scaled up to a

more streamlined dart shaped saucer section and they then requested it be used for the next phase of the process."

Around this time the slightly angular dart front was smoothed off and nestled into the engineering section. At this stage it was still assumed that the two hulls would separate in the same way

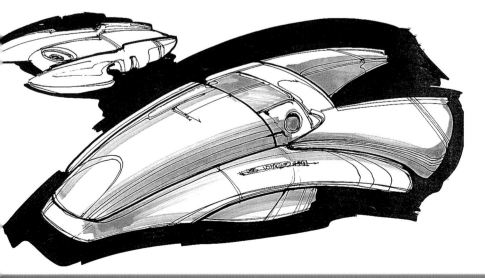

◀ Martin's most extreme concepts almost completely abandoned the familiar designs as he experimented with blended, uni-body shapes.

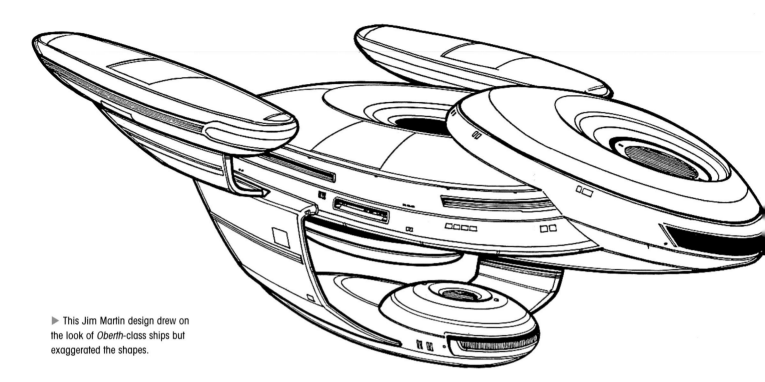

▶ This Jim Martin design drew on the look of *Oberth*-class ships but exaggerated the shapes.

length of 48 inches – the presumed size of the motion control model at that time. From the top view, Sternbach derived bottom, side, fore and aft views and worked out that the ship would have at least 14 decks and be at least 1,000 feet long. Details such as photon torpedo launchers, impulse reactors and the warp core were dropped inside, while on the outside two doors

were added forward of the warp core hatch and aft of the deflector dish allowing for landing gear so the ship could touch down on a planet. Sternbach also sketched in a hint of engine hardware on the exterior.

However, when they saw the study model, the producers weren't completely convinced. Somehow the physical reality wasn't as impressive as

Sternbach's sketches. The producers sent Sternbach back to the drawing board, tasking him with taking his design and giving it some curves, "like a Lexus."

Designing a ship for a new series is a massive undertaking, so while Sternbach had been working, Richard James and the producers had also called in some other members of the *STAR TREK* family and asked them to

▼ Martin had already designed the *U.S.S. Defiant,* and his concepts show this could have been a new direction for Starfleet design.

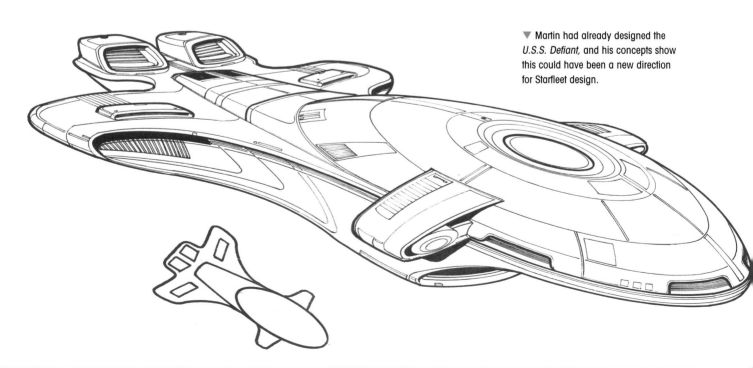

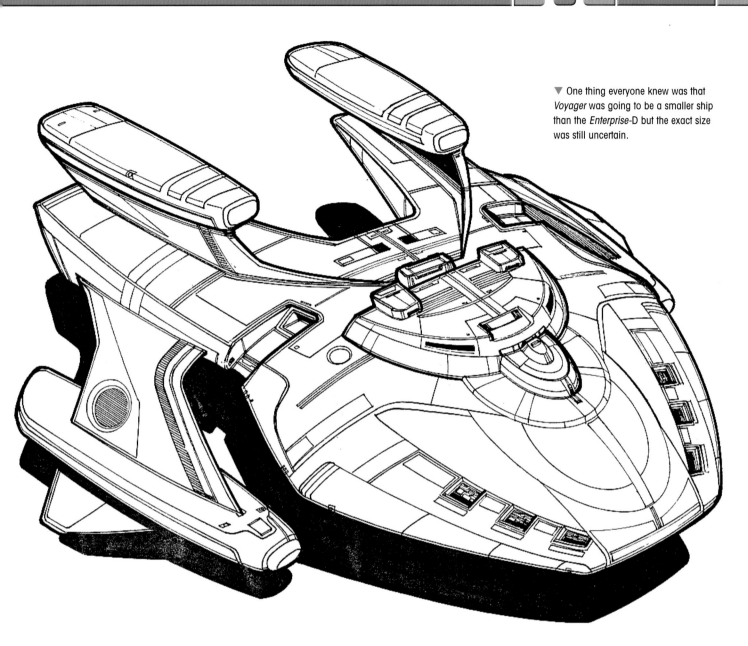

▼ One thing everyone knew was that *Voyager* was going to be a smaller ship than the *Enterprise*-D but the exact size was still uncertain.

explore different directions.

Jim Martin was working on *DEEP SPACE NINE* where he had just designed the *U.S.S. Defiant*, when he was loaned to the *VOYAGER* art department. He spent most of his time working on the sets but he also contributed some alternative designs for *Voyager*. "For a while I was working on both shows," he recalls. "I did a lot of interior bridge concept art, some other interiors, like the engine room, but I also did some *Voyager* exterior design ideas,"

RADICAL ALTERNATIVES

Rather than ask Martin to explore variations on Sternbach's work, James gave him the basic brief and asked him to come up with his own, completely new concepts. "The brief was wide open, and Richard was open to considering a range of ideas." Martin says. "I knew *Voyager* was supposed to be a newer Starfleet ship and I remember that Rick Sternbach wanted to include some type of articulation into the design. Rick was rightfully going to be the design lead for the *Voyager*, and I knew he would be the one to get it across the finish line, so I figured my role might be to push out from the norm a bit and try some more unusual directions."

The designs that Martin produced were a radical departure. They were curved and squat, and in several of them the familiar Starfleet elements such as nacelles were folded into the body of the ship.

"My designs were much more blended," he remembers. "I had already done the *Defiant*, and I think that's why I was doing uni-body ideas for *Voyager*. It was fresh in my mind. I tried a couple designs with nacelle scoops, some speed forms."

One design even resembled an *Oberth*-class ship but with all the proportions stretched and the curves exaggerated.

Martin's concepts were all produced

at the same time and presented to the producers in a single batch rather being evolutions of one another.

ANOTHER TAKE

At the same time, Doug Drexler was producing another set of concepts. Long before it was standard practice he was using 3D software to produce his designs, most of which were even longer and thinner than Sternbach's concepts.

One had a ring instead of nacelles, harking back to an idea Matt Jefferies had explored when he was designing the original *Enterprise*. Another approach had an elongated primary that was reminiscent of Uncle Martin's spaceship in 'My Favorite Martian.' One of the concepts he worked on came out of an idea he discussed with Mike Okuda, who suggested what he called the "wing ship," in which the saucer was

replaced with a V-shape that was inspired by old car aerials. The pair even produced a paper model of it, as well as the CG model that Drexler built.

The three artists were working simultaneously with Okuda shuttling between the two art departments which were in different buildings. By June, Sternbach had produced his new curvier version of his design and the producers happily embraced it as the final direction for the ship. "At the end of the day," Martin says, "Rick's command of Federation design and his experience delivered the *Voyager* design we all know and love. It's vintage Sternbach."

Although everyone had settled on the new, curvy design, as Sternbach explains, there was still a lot of work to be done. "The first clean rendition of the curvy *Voyager* allowed me to continue playing with nacelle and pylon

variations but, more importantly, it gave us a good look at how the smooth hull could still be accented with interesting bits of Starfleet hardware.

SENSE OF SCALE

"Visual effects needed subtle surface texture and shadowing to give the ship a convincing sense of scale. *Voyager* retained nearly all of the gear present in the previous angular version, only now the surface pieces hugged the hull a bit tighter. Different items were being refined every day. With the smooth hull it was finally decided that *Voyager* would be a one-piece ship, with no separation system. If there was to be a landing on a planet, it would be done with the entire vessel crunching down on alien soil."

By now it had been established that *Voyager* would be about the size of a nuclear aircraft carrier. Since it had a

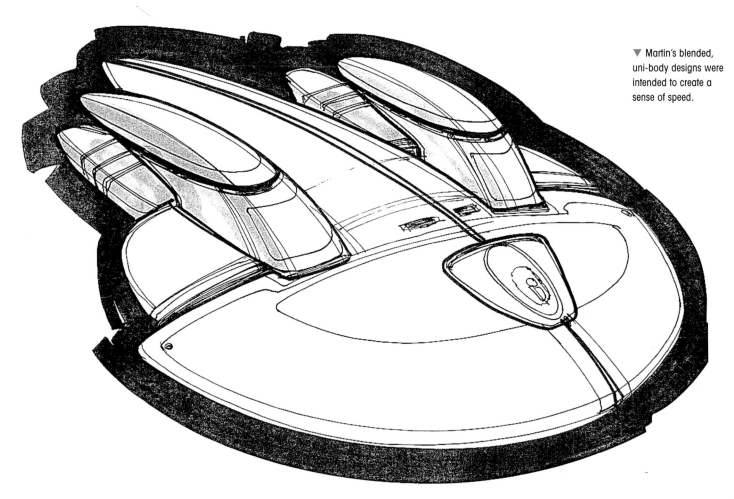

▼ Martin's blended, uni-body designs were intended to create a sense of speed.

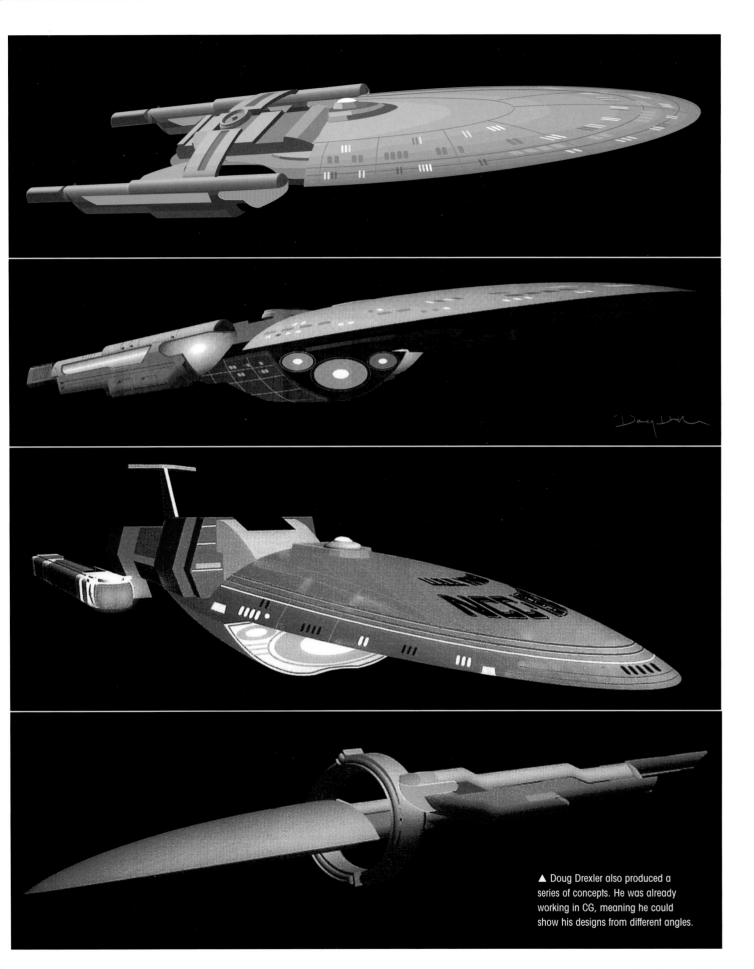

▲ Doug Drexler also produced a
series of concepts. He was already
working in CG, meaning he could
show his designs from different angles.

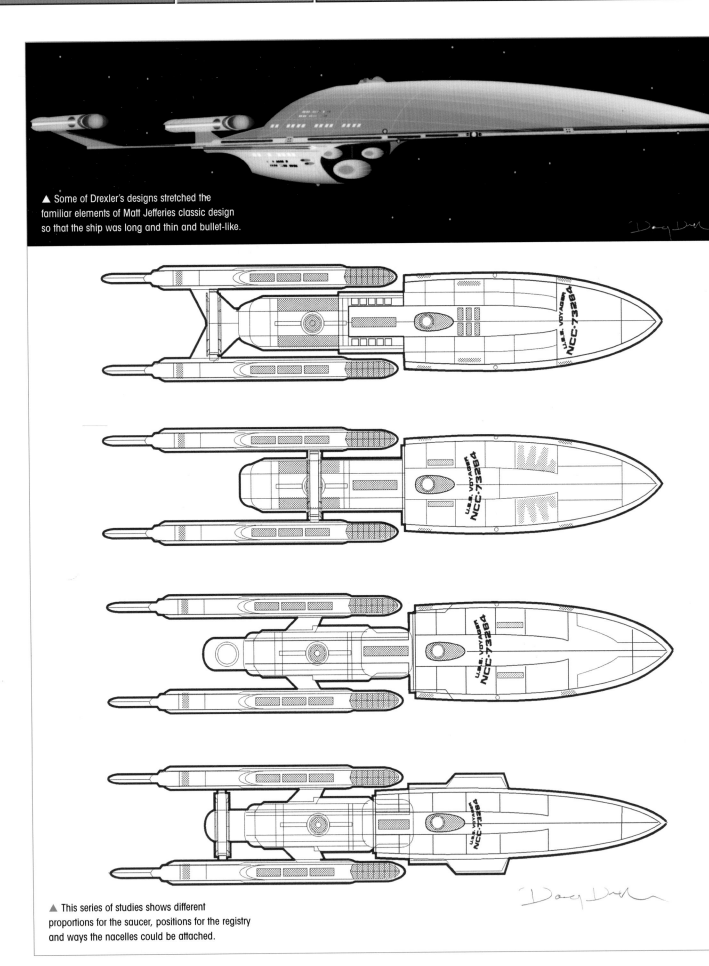

▲ Some of Drexler's designs stretched the familiar elements of Matt Jefferies classic design so that the ship was long and thin and bullet-like.

▲ This series of studies shows different proportions for the saucer, positions for the registry and ways the nacelles could be attached.

THE **WING SHIP**

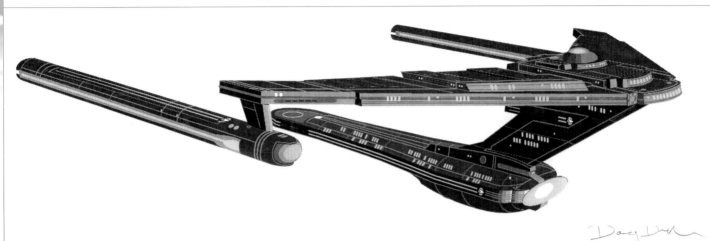

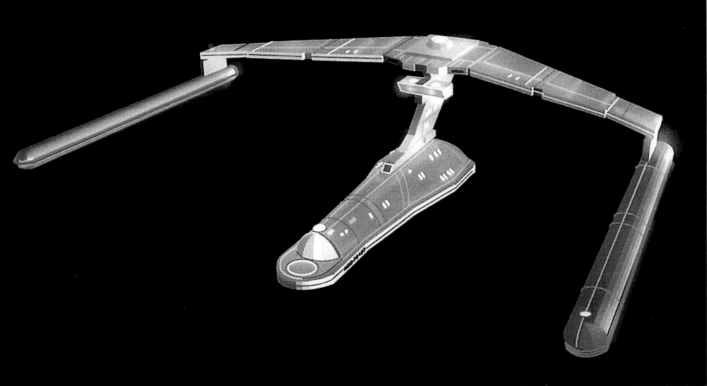

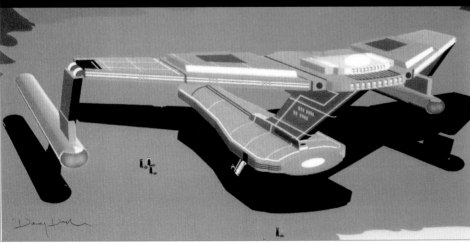

The Wing ship was a collaboration between Doug Drexler and Mike Okuda. The original inspiration came from Okuda, who suggested replacing the saucer section with a V-shape that was reminiscent of an old car aerial. Drexler worked up the design, with the two of them even going to the trouble of making a paper model before Drexler crafted a CG version of the ship. The design didn't get used for *Voyager*, but Drexler would later resurrect it for the Ships of the Line calendar.

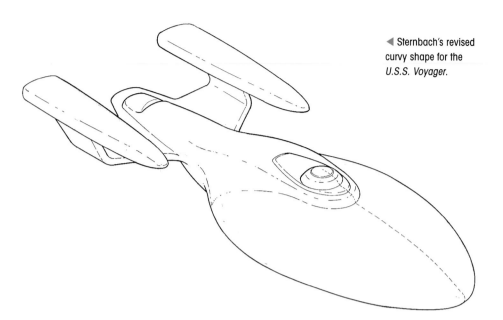

◀ Sternbach's revised curvy shape for the *U.S.S. Voyager*.

bridge module and dorsal spine airlock), I drew only half of each view across the centerline, and the full starboard elevation. Visual effects had decided on a five-foot-long miniature, and all the drawings were done full size.

FINAL DETAILS

"Most of the unique structural elements and starship systems were further detailed in another set of sketches, where all-important features were labeled as to supposed function, color, or whether a lighting effect was required."

Faxes of detailed drawings and quick doodles flashed between the art department and Meininger's workshop. By now the interior sets had been designed and built and Dan Curry sent tiny backlit film frames of the sets to Meininger so they could be placed in the model to give the illusion that there were rooms behind the windows.

Nearly a year after he had produced his first sketches, *Voyager* was finally ready to take flight.

much more blended hull and would no longer separate, Sternbach had to find new places for the impulse engines, which ended up on the nacelle support struts. He continued to add other details including the turbolift "connector tunnels" that led to the bridge on Deck 1, RCS thrusters, and a cowl over the shuttlebay doors.

GOING TO WARP

By July, the team had turned their attention back to the nacelles, which they were determined would animate in some way. Sternbach produced a series of sketches showing different ways the nacelles could be mounted on the support struts and what they would look like as they moved through different angles, even going to the trouble of producing a basic CG model that showed them in action. The producers decided that the nacelles should be mounted in the middle and rotate to a 45-degree angle when the ship went to warp.

Finally, Sternbach, was ready to produce the blueprints that would be

sent to Tony Meininger's Brazil Fabrications workshop where the physical model would be built.

"The *Voyager* blueprints consisted of five orthographic projections," Sternbach recalls, "They were drawn in a similar way to our set blueprints: top and bottom plans, and starboard, forward, and aft elevations. Since the port and starboard sides were mirror copies (the two exceptions being the

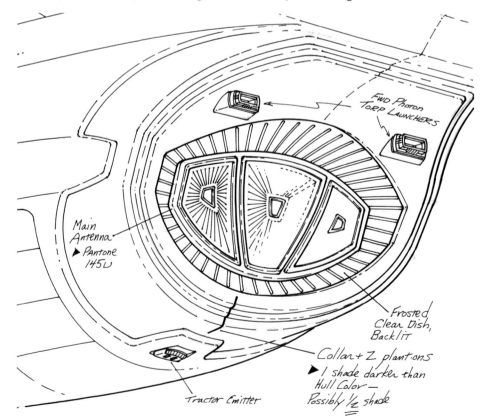

Main Antenna
▶ Pantone 145U

FWD Phoron Torp Launchers

Frosted Clear Dish, Backlit

Collar + Z plant-ons
▶ 1 shade darker than Hull Color — Possibly ½ shade

Tractor Emitter

▶ Sternbach provided the modelmakers with additional detail sketches that showed important areas such as the deflector dish.

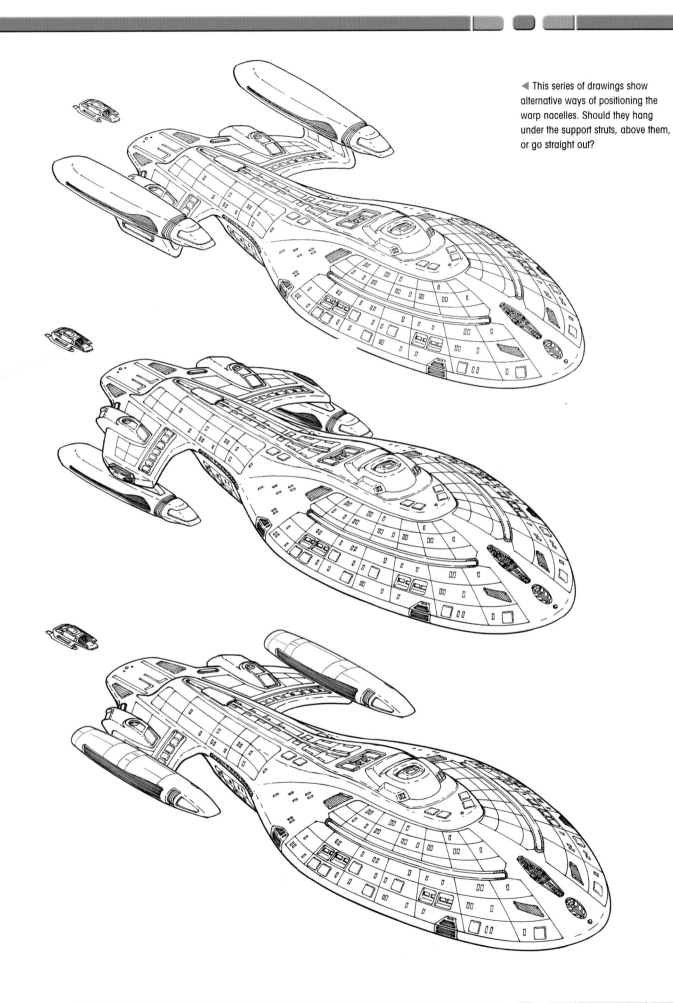

◄ This series of drawings show alternative ways of positioning the warp nacelles. Should they hang under the support struts, above them, or go straight out?

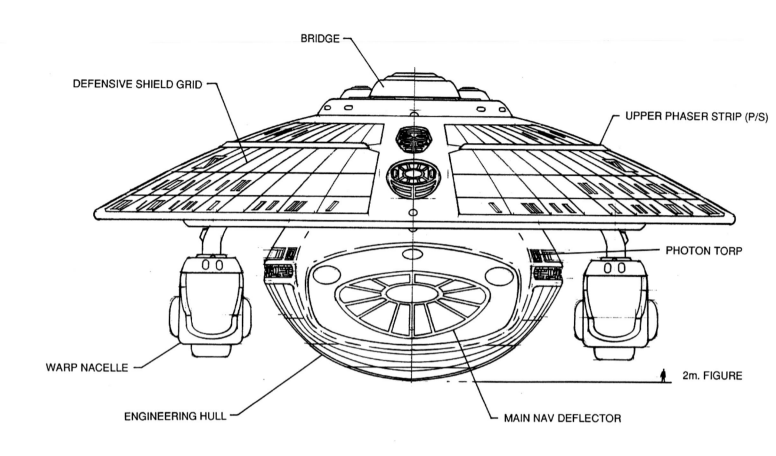

BRIDGE

DEFENSIVE SHIELD GRID

UPPER PHASER STRIP (P/S)

PHOTON TORP

WARP NACELLE

2m. FIGURE

ENGINEERING HULL

MAIN NAV DEFLECTOR

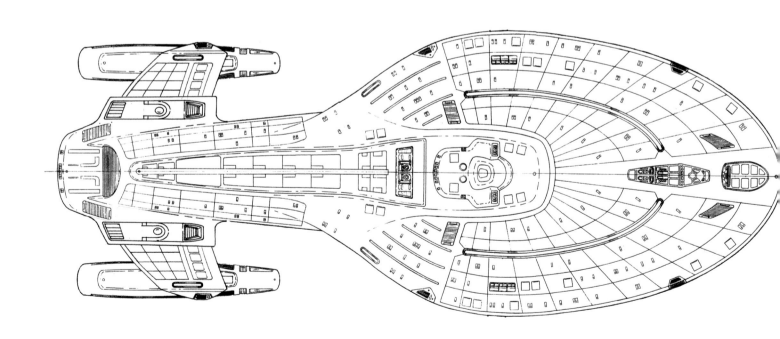

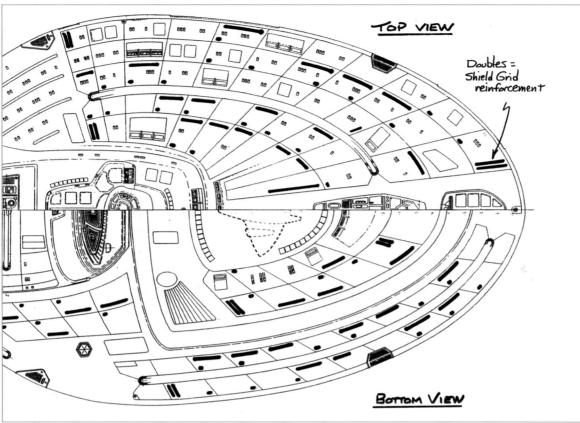

TOP VIEW

Doubles =
Shield Grid
reinforcement

BOTTOM VIEW

◀ The blueprints that
Sternbach supplied to
Tony Meininger's Brazil
Fabrications workshop
where the shooting
model of *Voyager* would
be built. The drawings
were full size, meaning
Sternbach had to
lean a long way over
the drawing table to
complete them.

S N.D. windows

Square c.s. borders

Half·rounds
¼·sphere caps

Half·round piping
▶ Pantone 145U

Thruster nozzles
▶ TITANIUM interiors

Surface within piping
▶ 145U

Thruster vents
like clapboard siding
▶ I shade darker than 145U

underside mirror
of topside

— Aft RCS Thrusters
(seen from starboard side)

Sternbach
8.94

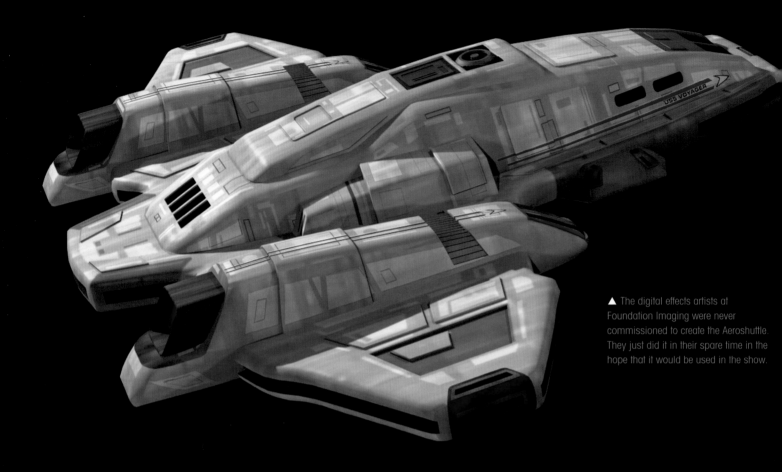

▲ The digital effects artists at Foundation Imaging were never commissioned to create the Aeroshuttle. They just did it in their spare time in the hope that it would be used in the show.

DESIGNING & BUILDING THE | III

AEROSHUTTLE

The Aeroshuttle only came about because of a chance conversation in an office, but unfortunately it did not make it into an episode.

The Aeroshuttle was developed by Adam 'Mojo' Lebowitz and Rob Bonchune, two digital artists based at Foundation Imaging, one of the special effects houses that worked on STAR TREK: VOYAGER. It was based on a Rick Sternbach illustration, but it never appeared as a separate ship in any episodes.

Lebowitz and Bonchune were already aware that a Captain's Yacht-like craft was located on the underside of the U.S.S. Voyager's saucer section. Certainly the STAR TREK: THE NEXT GENERATION Technical Manual written by Rick Sternbach and Mike Okuda had established that a UFO-like impulse craft had existed on the U.S.S. Enterprise NCC-1701-D, and it seemed logical that most fully-fledged Starfleet ships had one.

It was only when Bonchune was working on building the Delta Flyer that the idea of creating a Captain's Yacht for Voyager came up. Obviously, the people working in the same office

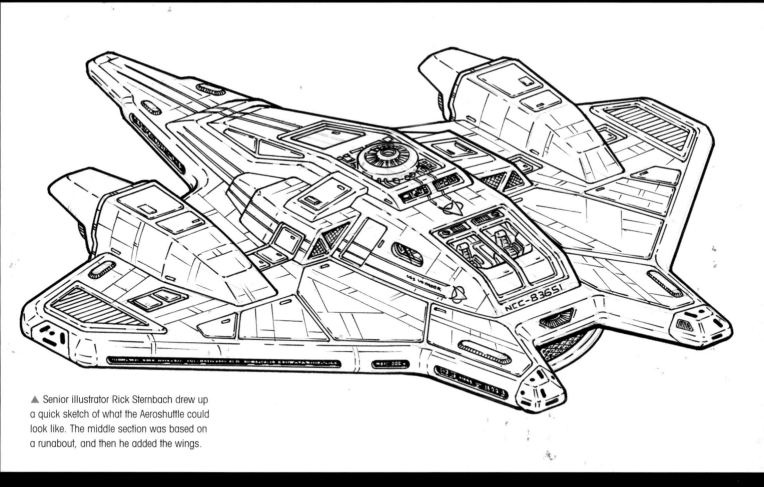

▲ Senior illustrator Rick Sternbach drew up a quick sketch of what the Aeroshuttle could look like. The middle section was based on a runabout, and then he added the wings.

as Bonchune saw him developing the *Delta Flyer*, and it was then that Lebowitz began to think out loud about a Captain's Yacht for *Voyager*. "If there'd never been a *Delta Flyer*, I don't think we would have done an Aeroshuttle," said Bonchune. "When Mojo saw it, he said, 'Why would they build a whole new ship when under the saucer of *Voyager* there's this Runabout-sized spaceship just sitting there? Why wouldn't they use that?'"

LOGICAL THINKING

This set them thinking and they came up with a perfectly logical scenario for introducing an Aeroshuttle to the show. "It could have started just as it did with the *Delta Flyer*," said Bonchune. "You'd have Tom Paris wanting to build a cool new spaceship, and as he walked around *Voyager* he'd stumble across the Aeroshuttle. When *Voyager* was launched, it wasn't quite complete. They certainly didn't expect to disappear from any Starfleet facilities for the next seven years, so they thought it didn't matter. This was why the Aeroshuttle wasn't fully complete, and maybe it

would take a month's worth of work to finish it. Paris could then have decided he was going to fix it. I believe that would have been valid – the ship was already there and it made sense. Plus I think it would have been a little treat for the audience. The Captain's Yacht was something that was never explained except in the *Technical Manual*, and if you hadn't seen that then you would have never known it existed. Don't get me wrong, I liked the

▼ Sternbach also illustrated where the Aeroshuttle would be located on the underside of the saucer section. At this point, the craft was called the 'Manta Shuttle.'

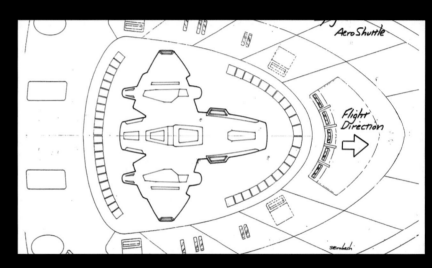

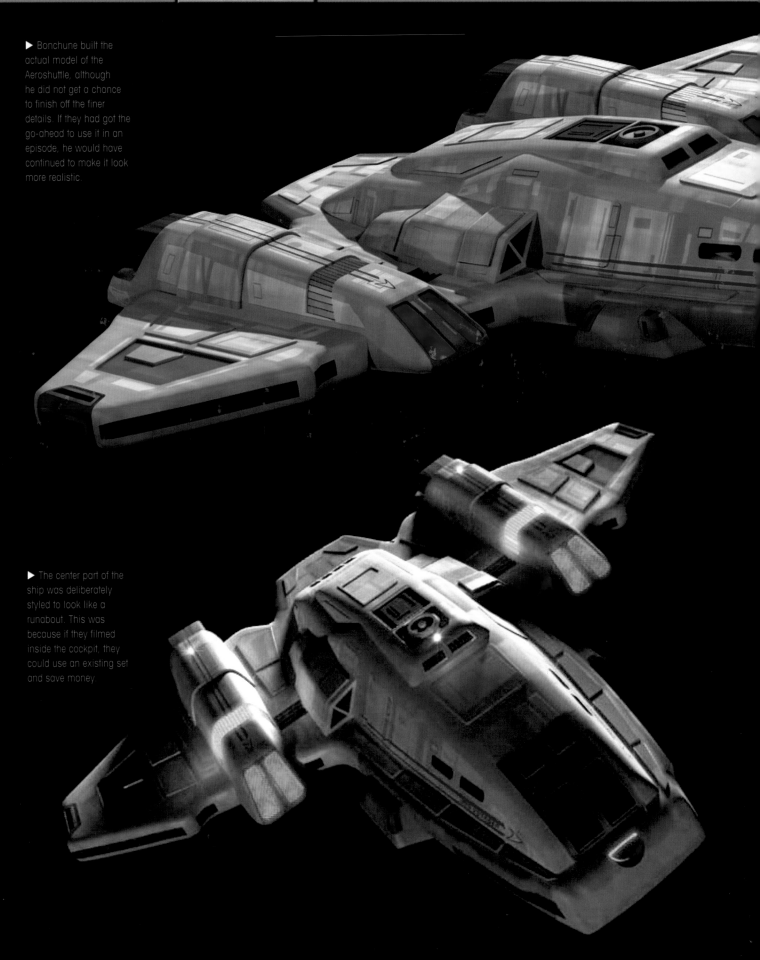

▶ Bonchune built the actual model of the Aeroshuttle, although he did not get a chance to finish off the finer details. If they had got the go-ahead to use it in an episode, he would have continued to make it look more realistic.

▶ The center part of the ship was deliberately styled to look like a runabout. This was because if they filmed inside the cockpit, they could use an existing set and save money.

Delta Flyer, but to me it was more logical to have the Aeroshuttle."

Having worked out the logistics, they decided to build the Aeroshuttle on spec. That is to say, they weren't commissioned to do it and they weren't paid. Working in their own time in the evenings and weekends, they wanted to put together a short sequence of the Aeroshuttle detaching from _Voyager_ and flying through the atmosphere of a planet. They hoped that by showing the producers a sequence of its launch that was 90 percent finished, it would persuade them to use it.

CREATING A CONCEPT

Rick Sternbach drew some concept sketches of what it could look like and labeled the design as the 'Manta Shuttle.' He deliberately designed it so that the cockpit looked like a Runabout, meaning the people building it could just adapt an existing Runabout set instead of building one from scratch.

Bonchune found that he could not build this ship exactly as Sternbach had drawn it because it did not match the existing silhouette of the craft that was already imprinted on the underside of _Voyager_. "I had to redo it," said Bonchune. "I kept the center part that was like a Runabout though. I think it took me less than three weeks to do, but I didn't fully complete all the details."

Once Bonchune had finished the model, Lebowitz animated a little sequence of it being launched from _Voyager_ and then flying through the atmosphere of a planet. He tried to show the clip to as many people as he could in the hope that if everybody liked it, maybe it could sway the producers into using it.

Eventually the sequence was shown to Rick Berman. Bonchune wasn't in the meeting, but it was relayed to him that the Aeroshuttle was not going to be used. "I heard that Rick Berman would have almost certainly said 'yes' to it but for the fact they were using a Captain's Yacht in _STAR TREK: INSURRECTION_, and they didn't want to take away from that," said Bonchune.

▲ Once Bonchune had finished building the model, Lebowitz created an animation that was nearly two minutes long showing it launching from _Voyager_ and then flying through the atmosphere of a planet.

It was a pity that the audience never got to see the Aeroshuttle in action, especially after all the work that was done. It has, however, seen the light of day in various publications and given fans a glimpse of what might have been.

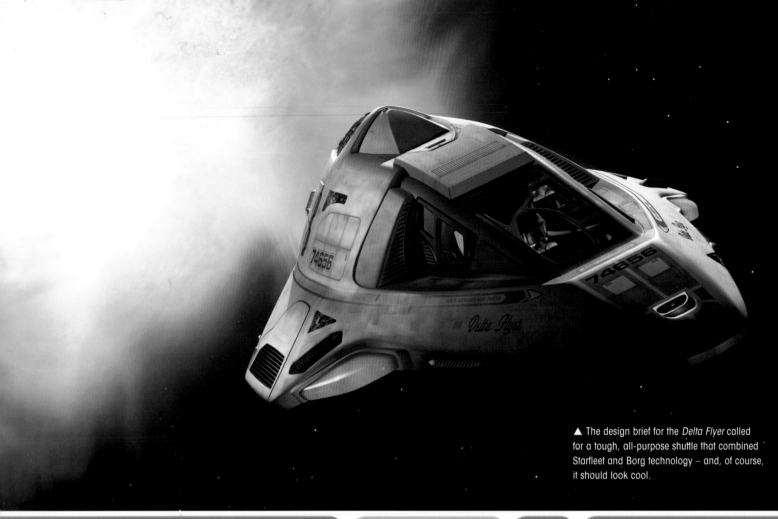

▲ The design brief for the *Delta Flyer* called for a tough, all-purpose shuttle that combined Starfleet and Borg technology – and, of course, it should look cool.

DELTA FLYER

STAR TREK: VOYAGER's resident illustrator Rick Sternbach explains the thinking behind his design process for the creation of the *Delta Flyer*.

▲ Rick Sternbach carefully worked out where all the main components should be placed when creating the *Delta Flyer*.

The *Delta Flyer* began its life as a season five writer concept for an 'all-environment shuttle,' capable of deep space missions, atmospheric flight, planetary landings and life in the hostile Delta Quadrant. As we've seen, it also made a few excursions into deep ocean water, solid rock and a graviton ellipse, recovered and refurbished each time to carry on: the 'little ship that could.'

The hull design process began in June 1998, with the usual page upon page of felt pen doodles, as I looked for visual inspirations to get a sense of the overall shape and function of the ship. Descriptions of the exterior and interior came from the writers and producers as the episode 'Extreme Risk' evolved. The crew cabin would accommodate at least four, with Tom Paris's single offset pilot station at the front, a departure from the tandem seating we knew from previous shuttles and the runabout.

With the cockpit shape and window frames determined by the set designs, the

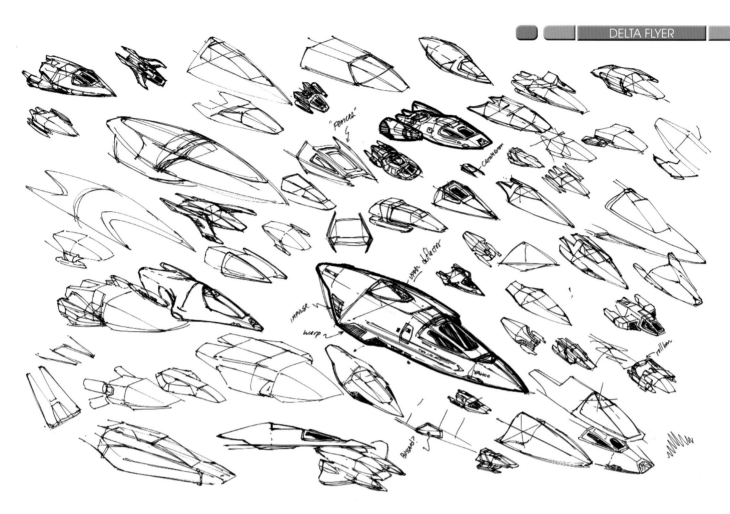

▲ In searching for the right shape for the *Delta Flyer*, Sternbach began by making a series of doodles. This helped him crystallize his thoughts as he focused in on a design that fulfilled the brief.

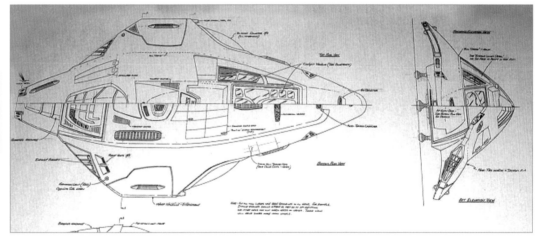

exterior hull would mirror those elements and employ that styling, with additional key bits of Borg technology.

POSSIBLE DIRECTIONS

In the doodle stage, I explored various simple shapes I thought might be plausible extensions of Starfleet hardware, from familiar wedges to streamlined darts. A few of the doodles looked like miniature *Voyagers*, others like larger versions of shuttles we already had. Some had elements of the runabout and the *Defiant* shuttle *Chaffee*.

Ideas can come from everywhere and I scribbled them down as they occurred to me, even if they didn't get included in the final design, because one never knows when some great little shape or techy idea will be useful later on.

Even in these preliminary sketches, a lot of questions popped up that helped narrow down the design: Warp pods or not? Where to put the navigational deflector. Phasers? RCS thrusters? How do you even get in? One morning, visual effects producer Dan Curry stopped by, glanced over my shoulder, and noticed a particular pointy

▲ The design for the *Delta Flyer* went through numerous stages before Sternbach drew up a set of detailed blueprints for the finished shuttle that included annotated notes on all its main features.

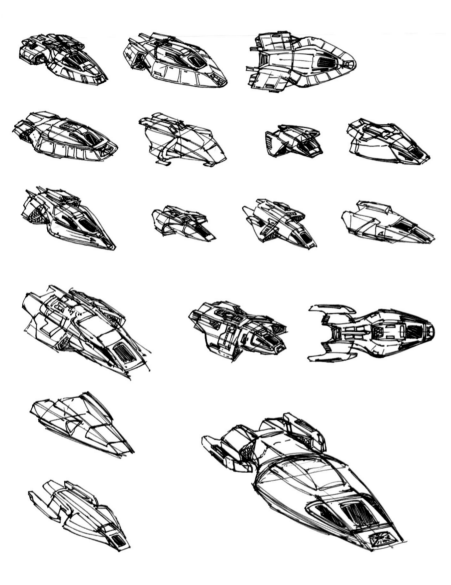

with. The approvals process proceeded with only a few additional notes from the producers and visual effects, which asked me to shorten and round off the pointy nose and widen the wings.

THINKING AHEAD

A number of features were added just in case they were needed in later episodes. Vents and hatches delineated the warp reactor on the underside; the reactor itself was a flat 'pancake' matter-antimatter chamber built into the floor. Emergency plasma flush vents were cut into the lower wings and a large drop-down Borg-style hatch in the back allowed for entry and for 'mission modules' such as the laboratory to be swapped in and out. A small escape hatch was built into the roof, should the transporters and aft hatch fail, and 'speed brakes' were scribed into the aft flanks, which could hide all sorts of new devices.

Not only did the *Delta Flyer* have all the right parts, it looked cool. Now it was more or less complete and could move to the blueprint stage.

Even though the *Delta Flyer* would be executed as a computer generated model, I worked up the blueprints as if the ship were to be built as a physical miniature, since precise orthographic views (top, bottom, side, front, and back) were often necessary for both methods. CG modeler Rob Bonchune at Foundation Imaging scanned and input the drawings into Lightwave, 'lofting' the hull into a set of smooth, 3-D, shaded objects.

▲ These early doodles saw the *Delta Flyer* begin to take shape as Sternbach experimented with different looks for the nose and warp nacelles.

MAKING PROGRESS

A few large blue pencil drawings followed, refining the original doodle into a more solid mass onto which I could add details such as impulse nozzles, blended warp pods in the wings, an entry hatch, Bussard fuel collectors, and phasers. The first few passes saw some rather heavy Klingon shield plating eliminated, and far too many Borg enhancements (mounted in small cutouts) toned down to just a few, but still nicely visible. A nose-mounted torpedo launcher was moved underneath, and two pulse cannons were scratched, but these changes were easy to deal

hull concept, and asked if I wouldn't mind developing it further. The embryonic *Delta Flyer* began to grow.

PERFECT DETAILS

Set blueprints of the cockpit windows were provided to ensure a match with the interior, and color specifications were given to Foundation Imaging for component 'painting' and building the surface texture maps, based partly on the *Delta Flyer* set walls and on existing Starfleet hulls and known Borg hardware.

I stayed in touch with Rob and our VFX supervisors during the CG process, giving notes and detail sketches on Starfleet hardware, minor changes to the set windows, and insignias and markings. A few hull parts that were somewhat difficult to convey in the blueprint views were worked out in small-scale foamcore models. Some modifications were made on the fly, such as the addition of the familiar blue warp grilles and the

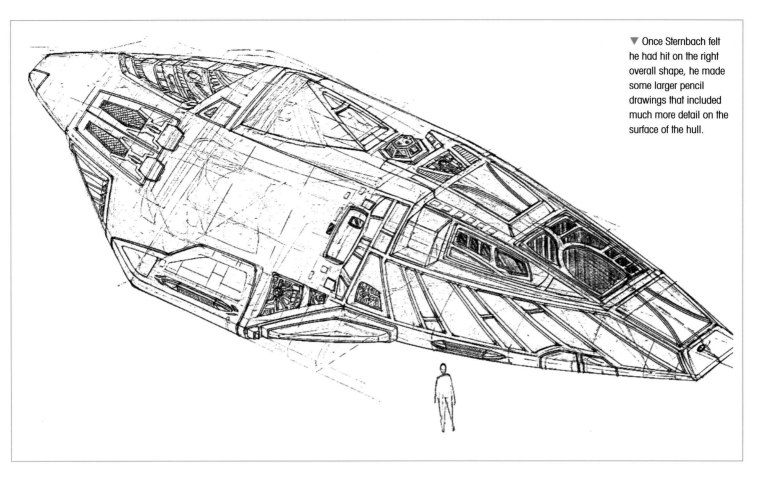

▼ Once Sternbach felt he had hit on the right overall shape, he made some larger pencil drawings that included much more detail on the surface of the hull.

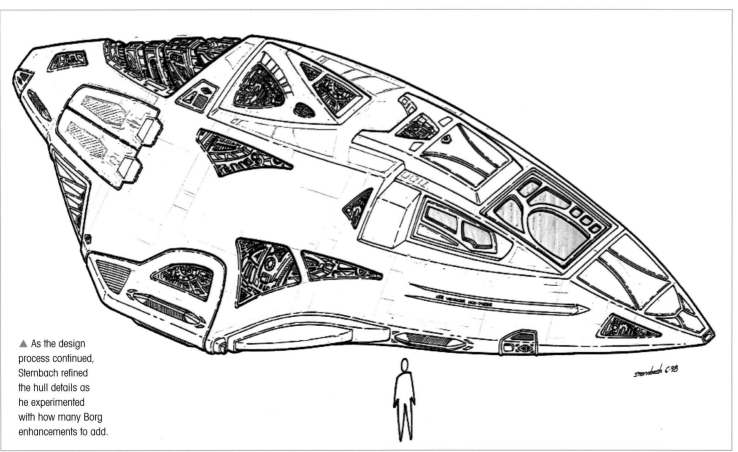

▲ As the design process continued, Sternbach refined the hull details as he experimented with how many Borg enhancements to add.

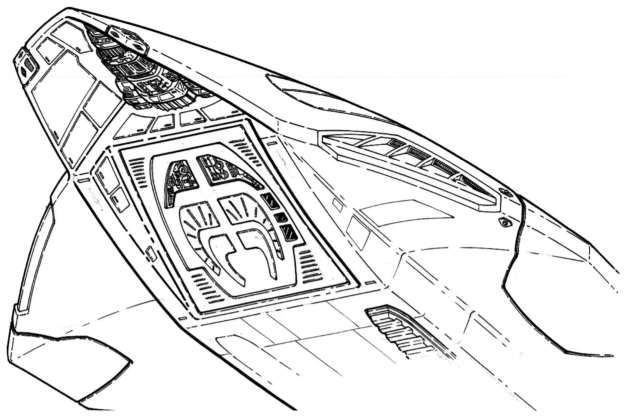

▲ All elements of the design were thoroughly thought through, and Sternbach added a large hatch at the rear of the *Delta Flyer*, which could be used to install different mission modules, such as a lab.

relocation of the wing phaser strips. In the areas of lighting and articulated parts, such as extendable landing pads, the speed brakes, hatches, and the warp pods, suggestions were given to visual effects to be passed on to Foundation.

In a reverse of the need for set drawings to make the CG parts, details of the CG model were required by the studio mill to build a pair of small walls behind the cockpit set. This served to hide a set of welded steel frames visible outside the windows, and were finished off with the proper colors and shapes to appear like the impulse intakes that would be seen looking aft.

ADDITIONS AND MODIFICATIONS

Two years after the initial inception of the *Delta Flyer*, we were still working with the ship, making additions and modifications to the two sets and the CG model. Lifeboat pods were theoretically squeezed into the aft section, and chunks of hull plating were torn away in the episode 'Good Shepherd'.

The lifeboat pods were particularly fun to invent, but difficult to place. They were supposed to be located just aft of the registry number underneath two flaps, along the same general fore-aft line as the hull curve.

I reasoned that the launch of these pods would

be similar to firing an aft torpedo tube on a submarine, so that if the *Delta Flyer* was headed towards certain destruction, the escape pod would shoot back along the flight vector.

SPATIAL PROBLEMS

The *Delta Flyer* was supposed to hold four escape pods, but they added to a well known but thorny problem. As sometimes happens with cinematic spacecraft (not to mention some cinematic boats, aircraft, and cars), the *Delta Flyer* appeared appreciably larger inside than outside. The aft cargo compartment was being cooked up separately by set designer Richard James, and there really wasn't any place to indicate entry hatches for the lifeboats. This necessitated a recalculation of the dimensions of the 'actual' *Delta Flyer* from a length of about 15 meters (49 feet) to perhaps 21 meters (69 feet). Similarly, when we built the aft lab compartment for 'Timeless,' it was a real challenge to fit everything within the conceptual space. Technically, the stasis chamber where Seven of Nine was stored stuck out into space, while the revised dimensions meant that the wingtips only just cleared the shuttlebay opening!

As an exercise in blending Starfleet and Borg styles together to make a working spaceship, the

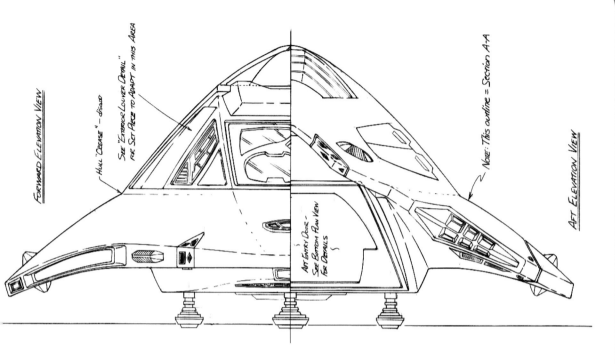

FORWARD ELEVATION VIEW

HULL "CREASE" - disolD

SEE "ENTRY/LOUVER DETAIL" FOR SET PIECE TO ADAPT IN THIS AREA

AFT ENTRY DOOR - SEE BOTTOM PLAN VIEW FOR DETAILS

NOTE: This outline = Section A-A

AFT ELEVATION VIEW

STAR TREK VOYAGER

ALL-ENVIRONMENT SHUTTLE
DEVELOPMENT DRAWINGS
PHASE II

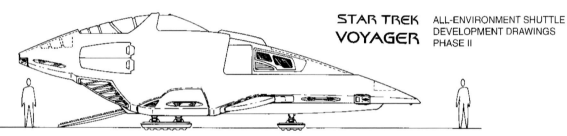

STARBOARD ELEVATION VIEW

SPECIFICATIONS:

LENGTH: 15.12 METERS (49.62 FEET)
BEAM: 9.25 METERS (30.34 FEET)
HEIGHT: 4.73 METERS (15.51 FEET)*

*LANDING GEAR EXTENDED

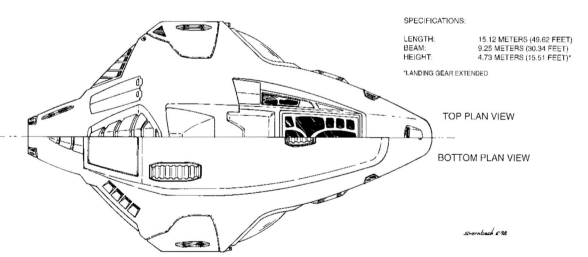

TOP PLAN VIEW

BOTTOM PLAN VIEW

Sternbach 6-98

Delta Flyer was a fun assignment and definitely one of my favorite designs when I look back on my time working on *STAR TREK*. Given the ingenuity of the *Voyager* crew at building shuttlecraft, it was not surprising that a new *Delta Flyer II* was created after the first one was pummeled into tetraburnium fragments by the Borg in 'Unimatrix Zero, Part I.'

The updated *Delta Flyer II* was almost identical on the outside to its predecessor, although we did get the chance to add some cool pop-out impulse thrusters, which boosted its sublight speeds. This feature added to the *Delta Flyer II*'s status as a 24th century 'hot rod,' and it was great to see it take a 'starring' role in the episode 'Drive.'

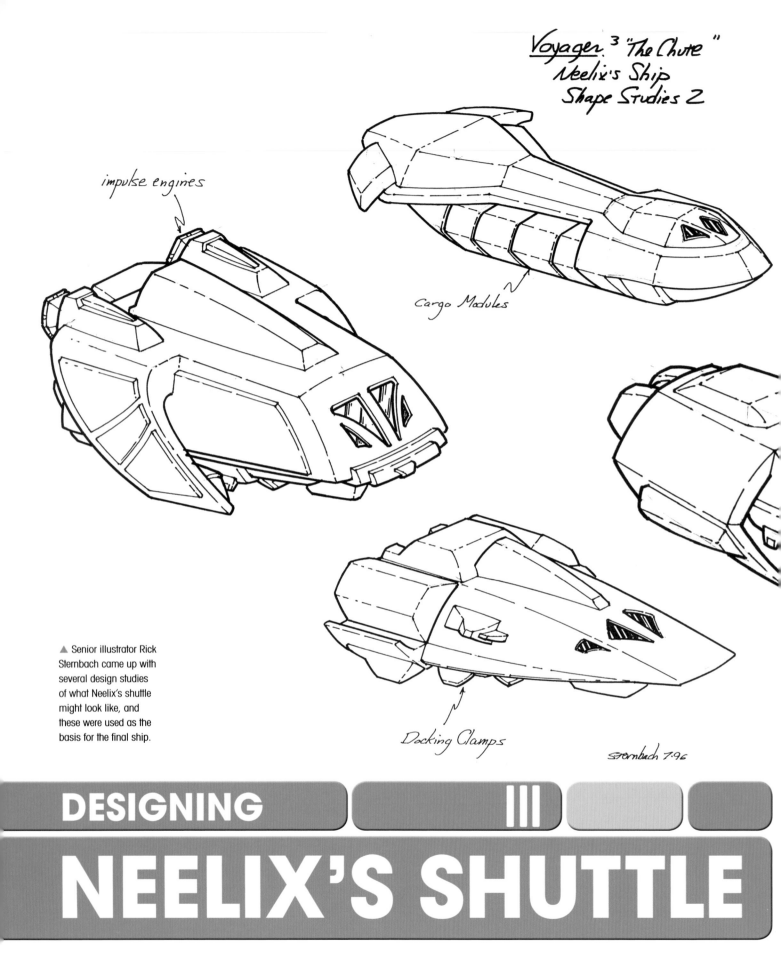

Voyager.[3] "The Chute"
Neelix's Ship
Shape Studies 2

impulse engines

Cargo Modules

▲ Senior illustrator Rick Sternbach came up with several design studies of what Neelix's shuttle might look like, and these were used as the basis for the final ship.

Docking Clamps

sternbach 7·96

DESIGNING
NEELIX'S SHUTTLE

Rick Sternbach drew several designs for Neelix's shuttle that were then worked up and adapted into the finished ship by the CG artists.

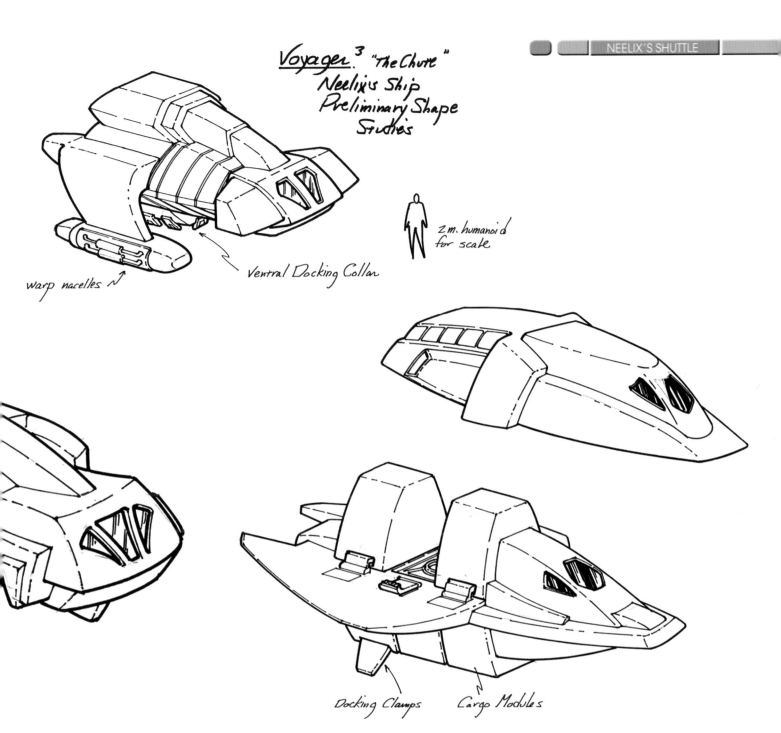

Voyager³ "The Chute"
Neelix's Ship
Preliminary Shape
Studies

2 m. humanoid
for scale

warp nacelles

Ventral Docking Collar

Docking Clamps Cargo Modules

The interior of Neelix's shuttle, the *Baxial,* appeared in 'Caretaker,' the pilot episode of *STAR TREK: VOYAGER,* but the exterior didn't feature until season three's episode 'The Chute.' Senior illustrator Rick Sternbach was asked to come up with some concepts, but he didn't have a lot to go on in terms of direction. All he knew was that the script described it as a "strange, small alien pod," and what Neelix looked like. With this in mind, he sketched out a few preliminary designs, pointing out on some of them where items such as the docking clamps, cargo modules and engines were located. All of them shared the same basic architectural language, but at the same time the individual elements were placed in different positions.

At this point in *VOYAGER*'s production, life had become somewhat hectic for the visual effects teams. The vendor that they were using for motion control photography had a mass exodus of personnel and were unable to work on the show. This meant that they had to use CG, which was the direction they were moving in anyway. 'The Chute' required a lot of CG work, including the creation of the Akritiri prison, which meant that there wasn't much time to generate Neelix's shuttle. The CG artists at the effects house Digital Muse quickly produced the *Baxial* based on the illustrations that Sternbach had provided, but it did end up looking quite different than the original concepts.

The *Baxial* was later remade for the season seven episodes 'Workforce' and 'Homestead,' when extra detail was added, including blinking lights and a blue glow from the rear engines.

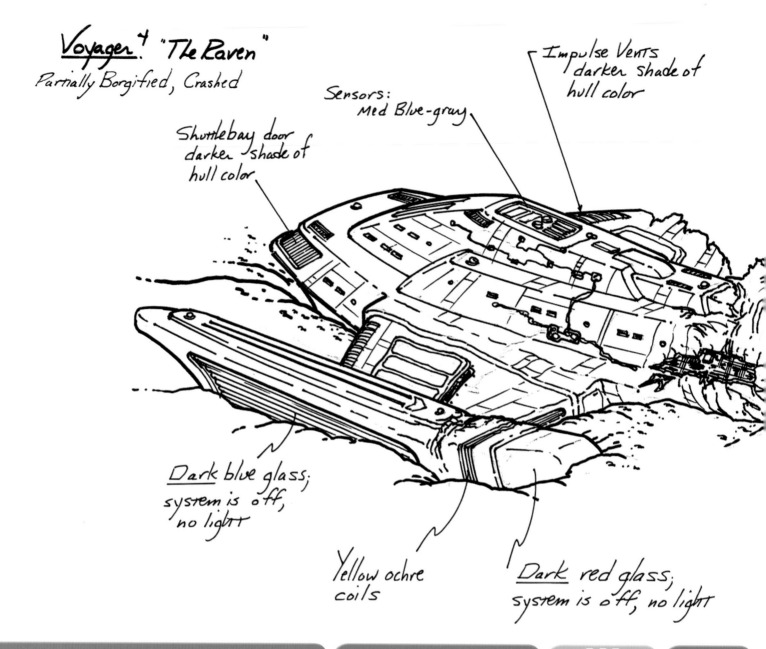

Voyager: "The Raven"
Partially Borgified, Crashed

Impulse Vents darker shade of hull color

Sensors: Med Blue-gray

Shuttlebay door darker shade of hull color

Dark blue glass; system is off, no light

Yellow ochre coils

Dark red glass; system is off, no light

DESIGNING THE
RAVEN

▲ When we first saw the ship, it was in the crashed condition in the fourth season episode 'The Raven.' As it was a wreck, it did not have to stand up to sustained scrutiny and no-one was aware that it would later feature strongly in the two-part episode 'Dark Frontier.' Sternbach based its overall look on a runabout, but made it slightly larger and more robust. It wasn't until later that it appeared in perfect condition, and Sternbach altered a few of the details.

The _Raven_ was originally designed as a wrecked ship, but when it was needed again senior illustrator Rick Sternbach had to subtly remodel it.

When the _U.S.S. Raven_ NAR-32450 was first seen, it was lying in a crumpled heap on a desolate moon in the Delta Quadrant. As far as senior illustrator Rick Sternbach was concerned, this was the only time the ship would appear. "I don't recall any hints at the time that we were going to see the ship again, either crashed or restored in flashbacks," said Sternbach.

As such, Sternbach swiftly came up with a design that he thought would be suitable for Federation scientists. "I think we were pretty certain that the _Raven_ was not a true front-line Starfleet vessel, but perhaps more of a transport or science ship that had been semi-retired and acquired by the Hansens for their research," said Sternbach. "Former U.S. Coast Guard cutters can be bought

Borg spidery "plant-ons"

▶ Hull Color should be Gray, Warm Gray, or TAN. No Starfleet Blue.

see Mike Okuda for stripes + typeface + "arrowhead"

sternbach 8·97

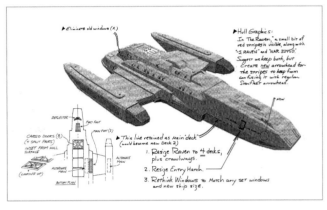

▲ Sternbach drew up these changes for the *Raven* when it was seen as a fully-functional starship. He made it slightly smaller, resized the windows and hatch, and added details to the ventral side.

through government auctions, so the *Raven* might have gone through that sort of process."

To help reinforce this idea, Sternbach decided that a runabout-like design would best represent a stylistic reminder of its Starfleet origins.

After the illustration of the wrecked *Raven* was finished, it was translated into a matte painting for its first appearance. It wasn't until about 18 months later that a fully-functional *Raven* was needed for the two-part episode 'Dark Frontier.' This time Sternbach had to slightly redesign his earlier work. "I got a printout of the ship from Foundation Imaging (the visual effects company)", he said "so I would have a three-quarter perspective. I had initially wondered if I had rendered

it a little too big. In the revision we cut it down from eight or nine decks to four decks tops. This changed the scale of the windows and the entry hatches. I drew up a few very small 'clean' top and side views of the ship, as well as inking up a few details on a paper

printout of the basic undamaged CG model. Most of that quick sketch work examined the ventral surface where landing legs and cargo doors might fit. In the world of episodic television, the sketches were likely faxed off and then it was on with other tasks."

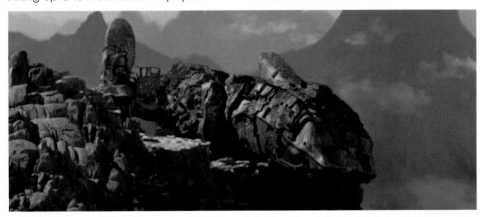

▲ Sternbach's concept illustration was translated into an elaborate matte painting for its initial appearance. The derelict hulk of the *Raven* was seen resting on the rocky outcrop of a deserted moon in the Delta Quadrant.

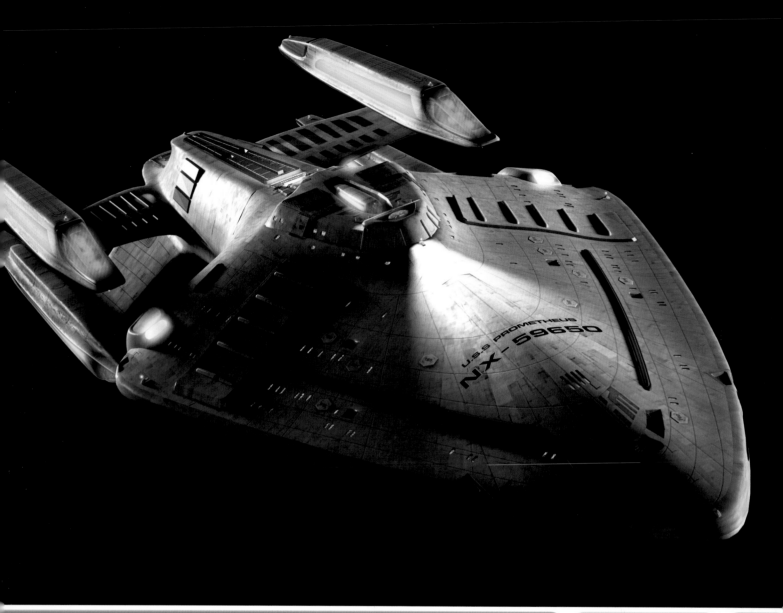

DESIGNING THE

PROMETHEUS

Designing the *Prometheus* was complicated enough but the original plans called for something even more ambitious...

Designing the *U.S.S. Prometheus* posed Rick Sternbach with several unusual challenges. The script for 'Message In A Bottle', described a Starfleet ship that "possessed a multi-vector assault mode, making it capable of separating into five autonomous pieces." It was also a prototype vessel so it had to look extremely advanced. Somehow Sternbach had to design a ship that looked good in joined form, but could also split up into five small ships that looked just as good on their own and, since this was *STAR TREK*, he was determined that the basic science made sense too. That meant that each of the five ships would have its own warp core, impulse engines, and so on.

He started playing around with various doodles and computer sketches, mostly concentrating on the standard saucer and nacelles setup. Eventually he settled on a more streamlined design, which he saw as being a sort of evolution of *Voyager's* lengthened 'saucer' and wing-like

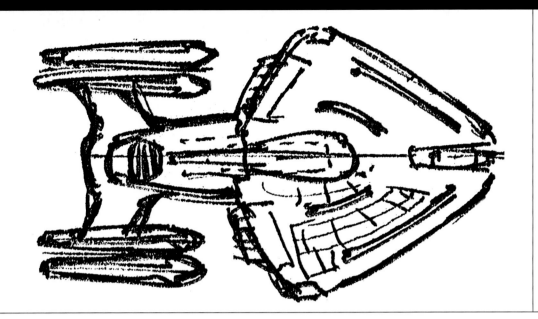

◀ Sternbach's earliest sketches show that he rapidly settled on an elongated design with four nacelles. It was a given that the saucer would separate in much the same way as it had on the *Enterprise*-D, but the question was how the rest of the ship would break up to create five independent vessels.

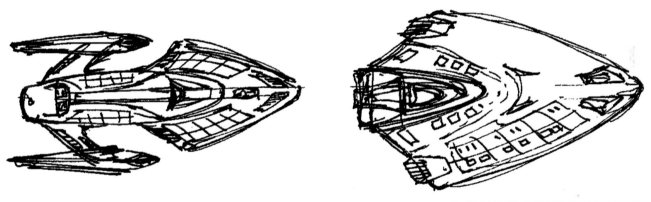

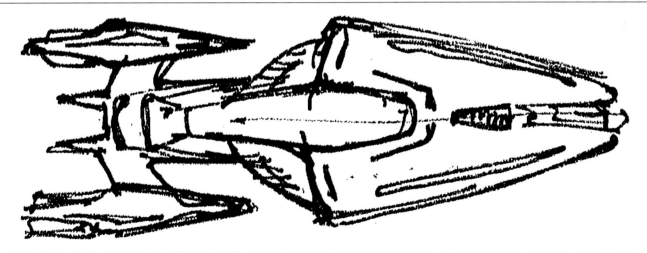

pylons. But, deciding on a basic shape was only the starting point – before anything else, Sternbach had to work out how to make the ship divide into five separate parts.

"I worked out that the aft body, that is normally the engineering hull, could be split into two, horizontally, each

section sporting two warp nacelles," he recalls. "In the sketches they were known as the Upper Warp Hull and Lower Warp Hull. This immediately required the *Prometheus* to have two separate warp cores, and more likely five matter/antimatter reactors if all parts had to do combat at warp! We

knew that even small shuttlecraft have warp engines so the small attack ships would be no problem, but the big question would be how small groups of coils would be able to drive the big forward hull? On top of that, would they also need to be hidden, to fool the bad guys?"

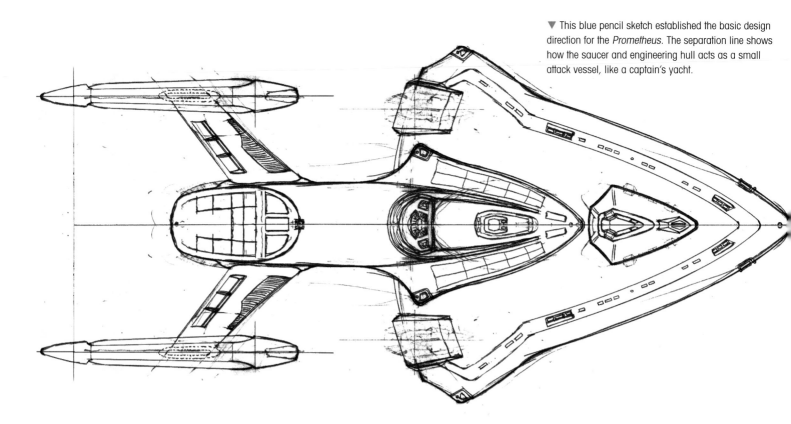

▼ This blue pencil sketch established the basic design direction for the *Prometheus*. The separation line shows how the saucer and engineering hull acts as a small attack vessel, like a captain's yacht.

Sternbach continued with his doodles and sketches and one of his first 'close' blue pencil drawings included a dart shaped main hull with single winglets. This saucer section then split up again, with smaller craft breaking out of the top and bottom. Many of the usual Starfleet details were penciled in; impulse engines, phasers, navigational deflector, RCS thrusters and tractor-beam emitters. It was at this point that it began to dawn on him that replicating all those parts five times was going to result in a very complicated vehicle. Luckily, around the same time, the producers announced they'd decided to have only three ships instead of the original five. Armed with this new information, Sternbach returned to the drawing board.

"Working primarily on the main hull, the first thing I did was remove the two little attack darts and add a pair of warp nacelles, which were on the top and bottom of the 'saucer'," recalls Sternbach. "In that way the engineering hull could then be split along a horizontal line. The next round of drawings then refined the major shapes, and included a starboard-elevation cutaway. The *Prometheus* worked out at 15 decks, and we populated the outline with lots of standard cut-and-paste elements, like corridors, shuttlecraft, tanks, sensors and turbolifts. Of course many bits came in triplicate, like the computer cores, while, outside, the nacelles and pylons were styled to reflect some of the look of the *Enterprise*-E, which was being developed at the same time."

FINAL DETAILS
However, unlike the *Enterprise*-E, the final pylons were swept forward, similar to a sleek X-29 jet aircraft. On the earlier versions of the design, the pylons had been flat and fitted together in a stacked configuration, but Sternbach made the decision to angle them, feeling that separating the nacelles gave the ship a bit more 'air' and the impulse exhaust a clear pull backward.

After getting the go-ahead from the visual-effects department, Sternbach made a series of perspective drawings that pointed out all of the surface details of the combined ships. However, since the ships were completely symmetrical, he only needed to fill in the details on one side.

Many of these elements were given a subtle redesign, since the *Prometheus* used the most advanced technology available to Starfleet. "The phaser strips were given an updated look with tapered ends," explains Sternbach. "The lifeboat hatches became elongated hexagons and the bridge dome got an armored top. Thinner sensor strips and new pop-up photon torpedo launchers were also added.

"Eventually," says Sternbach, "all the exposed surfaces of the separated ships were drawn up for the CG modelers who took into account shield grids, passageways with sealable connectors, bridge modules and docking clamps. In the split engineering hull, a unique shared warp core could be divided and sealed off for the multi-vector mode,

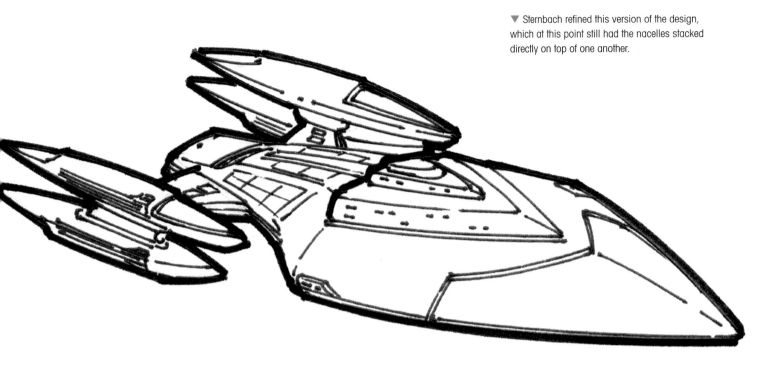

▼ Sternbach refined this version of the design, which at this point still had the nacelles stacked directly on top of one another.

giving each half its own half-sized warp core – only the upper half had the shuttlebay, however. The main hull was equipped with an enlarged deck containing the bridge, two lifeboats and a housing for one or two mini-warp nacelles."

The VFX department asked for the ship to have some kind of articulation so, after some thought, Sternbach decided to have the mini warp nacelles on the 'saucer' section extend on swing arms. The arms also contained the plasma conduits from a warp core located deep in the hull. While the dorsal nacelle extended up from its housing, the ventral one dropped down into the space previously occupied by the engineering hull.

Now it was the turn of Foundation regulars, Adam 'Mojo' Lebowitz and MacDougall to take the sketches and orthographic views and build a CG version of the ship. As the *Prometheus* was an experimental vessel, the NX-59650 registration number was added. That number is considerably

lower the original suggestion of 74913, suggesting that the *Prometheus*

development project had been in place quite some time before *Voyager*.

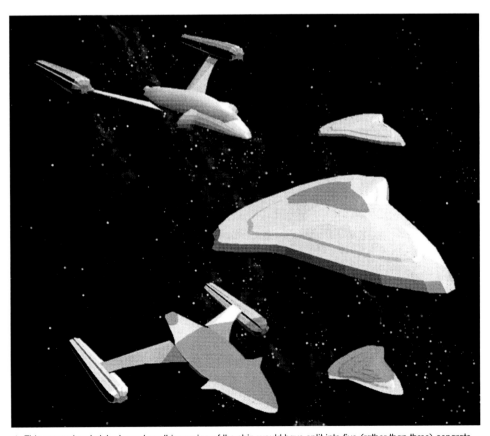

▲ This computer sketch shows how this version of the ship would have split into five (rather than three) separate vessels. The additional sections were a 'captain's yacht' and a built-up 'bridge' module.

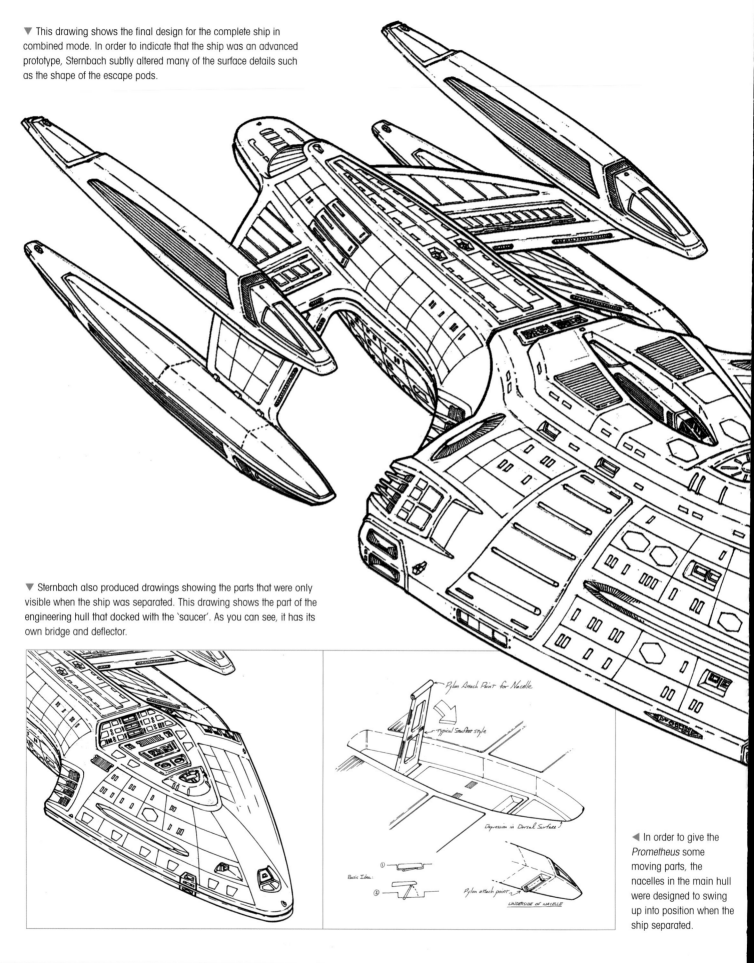

▼ This drawing shows the final design for the complete ship in combined mode. In order to indicate that the ship was an advanced prototype, Sternbach subtly altered many of the surface details such as the shape of the escape pods.

▼ Sternbach also produced drawings showing the parts that were only visible when the ship was separated. This drawing shows the part of the engineering hull that docked with the 'saucer'. As you can see, it has its own bridge and deflector.

Pylon Attach Point for Nacelle

Typical Smother style

Depression in Dorsal Surface

Basic Idea.:

Pylon attach point

UNDERSIDE OF NACELLE

◀ In order to give the Prometheus some moving parts, the nacelles in the main hull were designed to swing up into position when the ship separated.

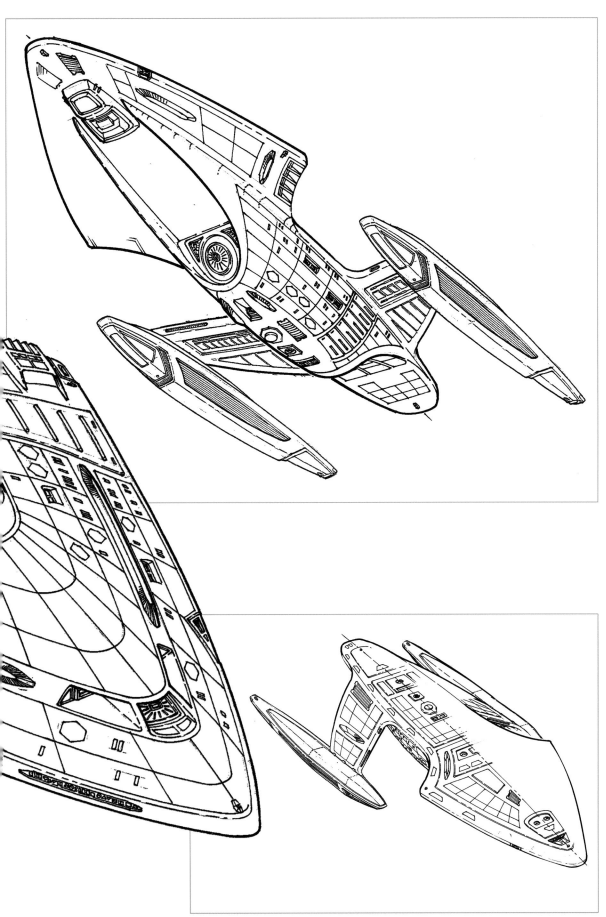

◀ This drawing shows the lower part of the *Prometheus* from the underside. This became one of the independent vessels, but the drawing also provided enough information to complete the model of the ship when it was in its combined form.

◀ This view shows the top of the lower portion of the separated engineering hull, including the concealed phaser arrays and a warp-core hatch. The same details were mirrored on the underside of the upper part of the engineering hull.

JOINED VIEW

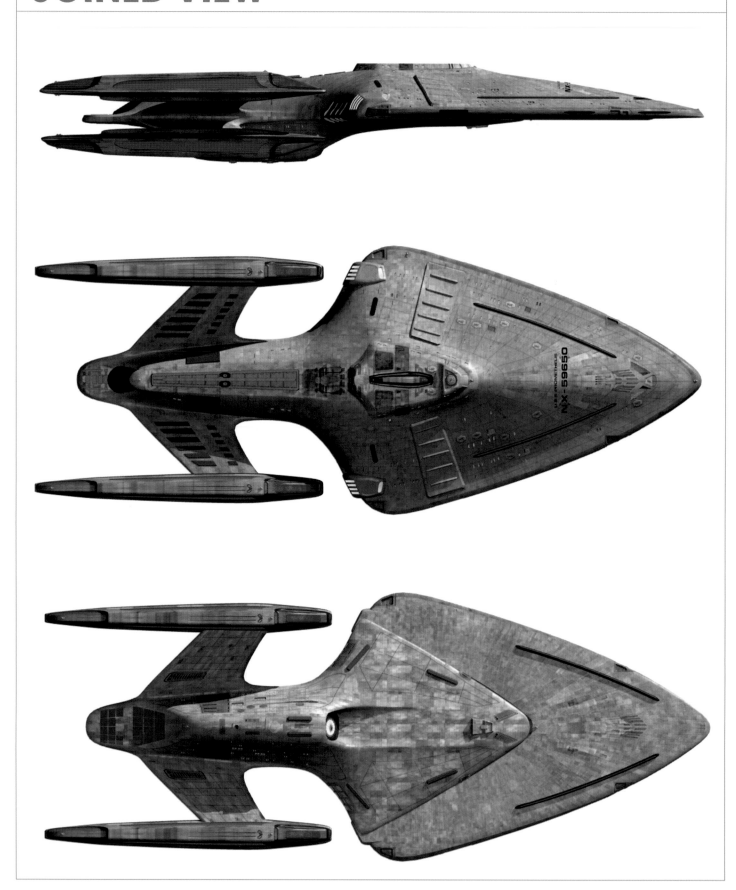

TOP SECTION

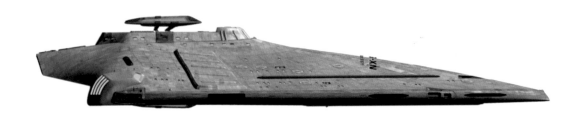

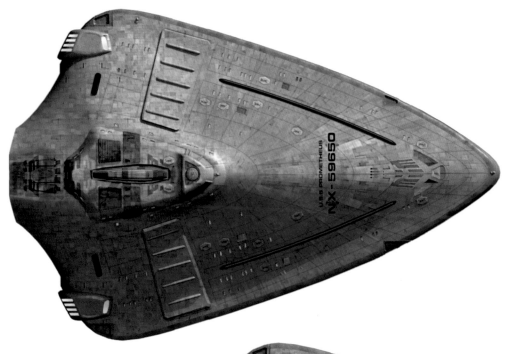

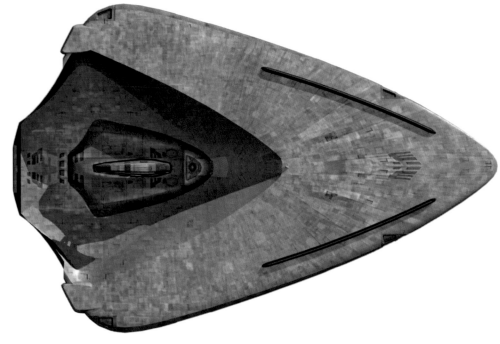

MIDDLE SECTION

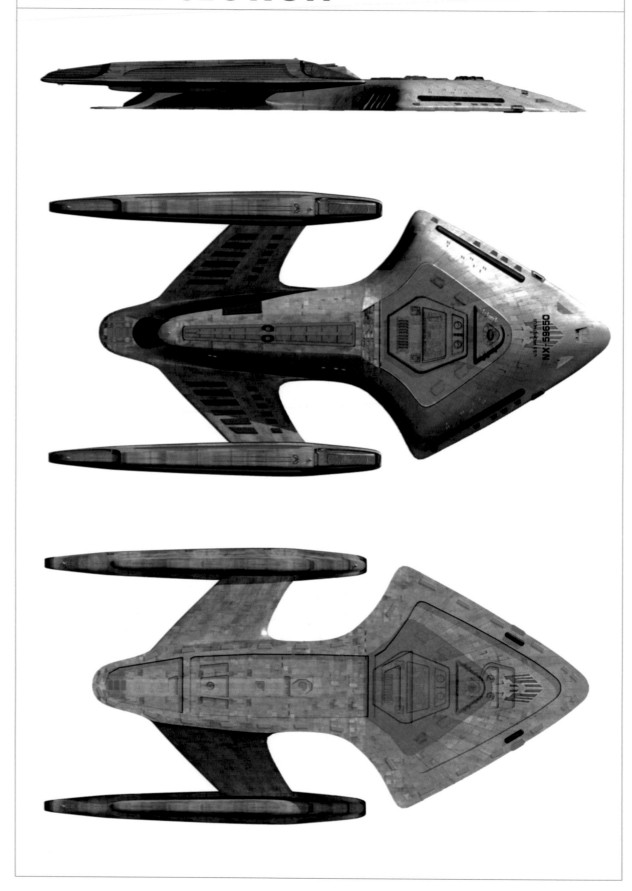

BOTTOM SECTION

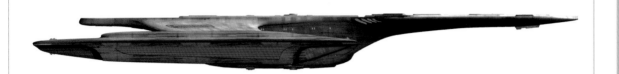

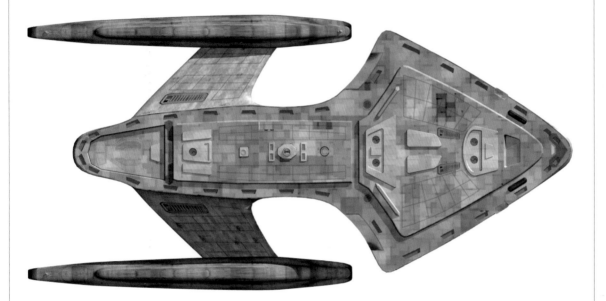

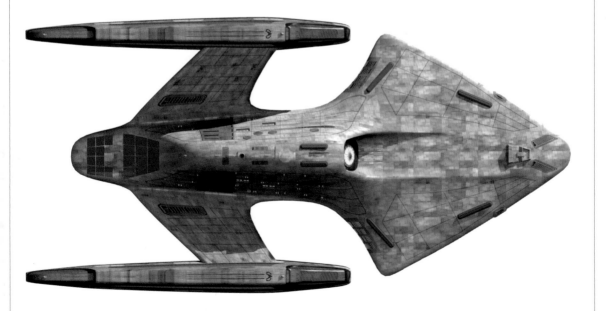

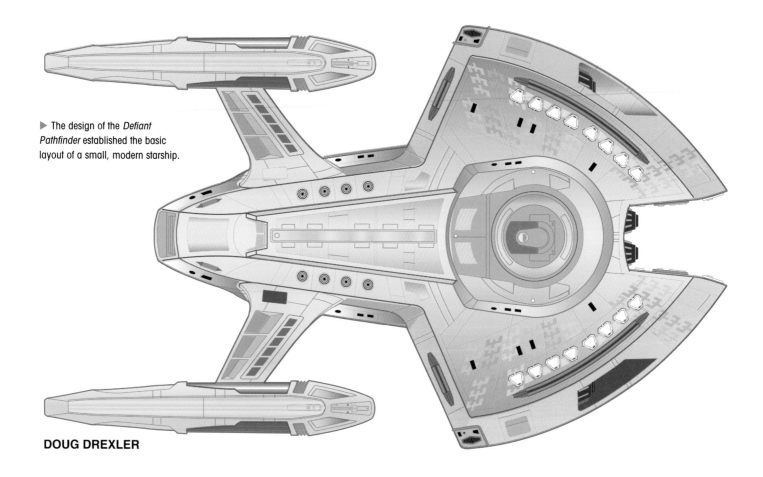

▶ The design of the *Defiant Pathfinder* established the basic layout of a small, modern starship.

DOUG DREXLER

DESIGNING THE

EQUINOX

The *U.S.S. Equinox* started out life as another, very different, tough little ship...

The script for 'Equinox' called for something that had never been seen in *STAR TREK* before: a small scientific vessel that would have been built around the same time as *Voyager* so Rick Sternbach knew that to come up with an appropriate design he would have to start from scratch. As he recalls, there was one vessel that provided him with some inspiration. "I began roughing out some basic shapes using the *Oberth* class as a starting point. That was a

small Federation starship used as both a scout ship and research vessel, but as it was at least 80 years old, it didn't look as modern as I knew the *Equinox* needed to be. So I started thinking about other small ships that I could study instead and then it dawned on me that I'd actually already designed a ship that fit the criteria and which had never been used before."

The ship in question was the *Defiant Pathfinder*, which Sternbach had

▲ The original design appeared in the *STAR TREK: DEEP SPACE NINE Technical Manual,* and was illustrated by Doug Drexler based on Sternbach's concept. The *Technical Manual* is one of the few books that is accepted to contain canon information about the *STAR TREK* universe.

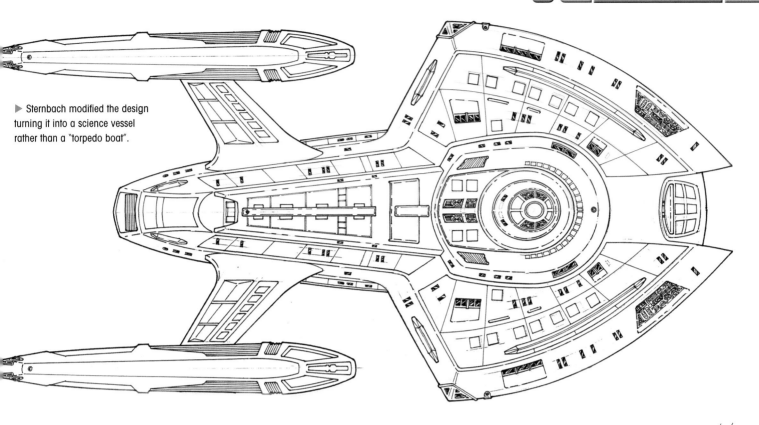

▶ Sternbach modified the design turning it into a science vessel rather than a "torpedo boat".

sternbach 3·99

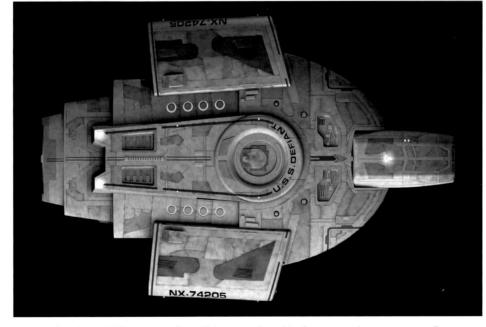

▶ The design for the *Defiant Pathfinder* was reverse engineered from the finished *Defiant,* and Sternbach deliberately retained elements such as the protective wall around the bridge.

developed whilst writing the *STAR TREK DEEP SPACE NINE Technical Manual.* He had wanted to come up with a backstory explaining how the design of Starfleet's first warship had evolved. So, working backwards from Jim Martin's finished design, he had created a new prototype version that had a more conventional shape with two nacelles.

BORG BUSTER

"I'd held onto some of the well-known shapes from the *Defiant,* such as the two rows of circular widgets behind the bridge, the bridge area itself, and the forward curve of the hull just behind the

nose extension. At the same time I'd theorised that the admirals in the Advanced Starship Design Bureau needed a fast torpedo ship, something along the same lines as the 'Borg Buster' we heard the writers were at one time looking for. At some point in the process the mission requirements changed. The basic specs were sound but modifications were needed to protect

the ship from massive weapons fire, hence the tucked in look of the nacelles and the big shells around them on the finished *Defiant.*"

Deciding that the size and shape of the ship made it the ideal starting point for the *Equinox,* Sternbach now needed supervising producer Peter Lauritson to sign off on the idea. Taking a photocopy of the *Defiant Pathfinder,*

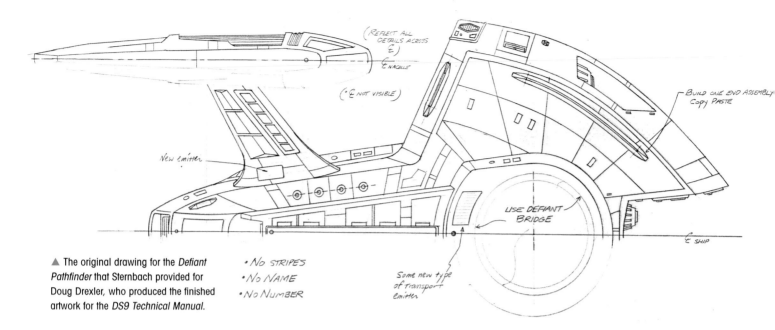

▲ The original drawing for the *Defiant Pathfinder* that Sternbach provided for Doug Drexler, who produced the finished artwork for the *DS9 Technical Manual*.

Sternbach placed it next to a top view of the *Voyager* in scale and presented it to Lauritson, who quickly gave it his seal of approval. It was now left to Sternbach to turn his design for a heavily armed warship into a science vessel. It proved to be relatively simple process, mainly involving replacing the six torpedo launchers with the large

sensor arrays commonly found on science ships. However, Sternbach opted to leave in place the recessed bridge, which on the *Defiant* was protected by a circular wall. That done, he turned his attention to the underside of the ship which in the original drawings contained very little in the way of detail.

"I decided to continue the trend of

giving some Starfleet ships a large shuttle-like embedded craft, such as a the captain's yacht on the *Enterprise*-D and the aeroshuttle on *Voyager*," says Sternbach. "I placed an arrow-shaped craft on *Equinox*'s underside which was known as a hypersonic *Waverider shuttle*, a highly fuel efficient vehicle at Mach 5 and above."

▼ Tim Earls provided this drawing that shows the front and side elevations, which had not been worked out for the *DS9 Technical Manual*. He also calculated the size of the ship, giving it eight decks.

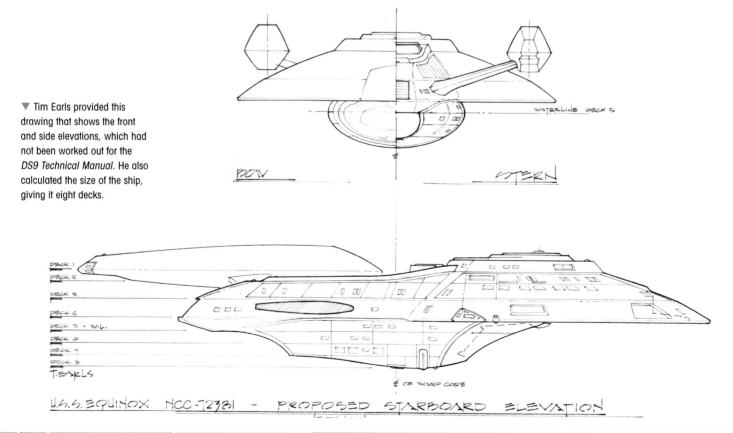

Once the changes had been made, it was then the turn of Digital Muse to turn Sternbach's sketches into a computer generated model.

"Orthographic views were definitely needed to build a CG model of the ship, so I worked those up on tracing vellum," recalls Sternbach. "All the typical Starfleet hull parts were called out, and colors and lighting specs were furnished to visual effects. Eddie Robinson from Digital Muse built the model based on my drawings, and after a couple of over-the-shoulder sessions, and discussions on colors and markings, the ship came out of LightWave almost exactly as it went in."

IN THE WARS

Sternbach and the VFX team were then faced with one final challenge – to take a pristine looking ship and smash it up. It had to look like a vessel which had been under attack for a long time and, while looking battle scarred, was still able to make its way through space.

Fortunately, according to Sternbach, as far as CG programming was concerned creating the right kind of damage was child's play. "From what I've seen," Sternbach explains, "in LightWave you can remove or distort groups of polygons until they look twisted, vaporized and so on."

Understanding that some fans might wonder how a prototype warship and a science vessel could end up looking so similar, Sternbach went to the trouble of creating a backstory that linked the *Equinox* and the *Defiant*.

"To my way of thinking, Starfleet looked at a number of possibilities for the *Nova*-class science vessel and dug out the design for the *Pathfinder*. Then maybe some ASDB officer said, 'Say Bob, since you're not going to use this one, can I have it for the *Nova* development cycle?' That being the case, both the *Nova* and *Defiant* classes could have been in service in plenty of time for Ransom to take command and get yanked into the Delta Quadrant."

▼ The final CG version of the *Equinox*, complete with the damage it suffered on its journey through the Delta Quadrant.

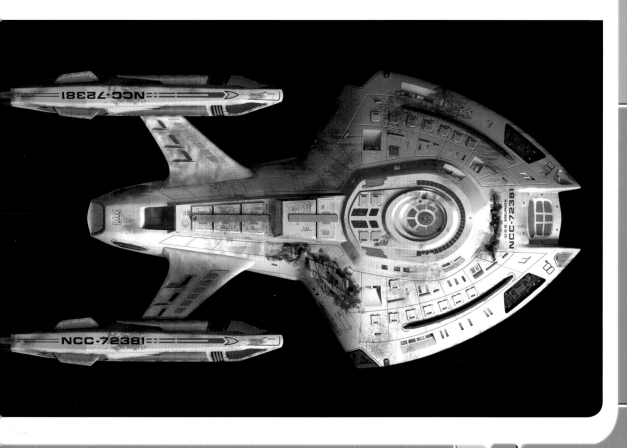

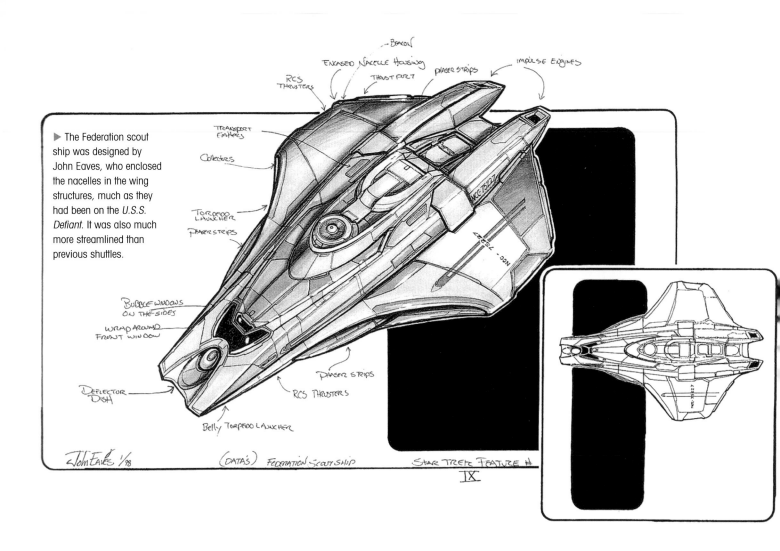

► The Federation scout ship was designed by John Eaves, who enclosed the nacelles in the wing structures, much as they had been on the *U.S.S. Defiant*. It was also much more streamlined than previous shuttles.

Image labels: BEACON, ENCASED NACELLE HOUSING, PHASER STRIPS, IMPULSE ENGINES, RCS THRUSTERS, THRUST PORT, TRANSPORT EMITTERS, COLLECTORS, TORPEDO LAUNCHER, PHASER STRIPS, BUBBLE WINDOWS ON THE SIDES, WRAP AROUND FRONT WINDOW, DEFLECTOR DISH, PHASER STRIPS, RCS THRUSTERS, BELLY TORPEDO LAUNCHER, John Eaves 1/98, (DATA'S) FEDERATION SCOUT SHIP, STAR TREK FEATURE # IX

DESIGNING & FILMING THE ||| FEDERATION SCOUT SHIP

Illustrator John Eaves explains his thoughts behind the design of the scout ship, and we take a look at how the CG ship was used to create a spectacular dogfight in the skies above the Ba'ku planet.

One of the big action set pieces in *STAR TREK: INSURRECTION* featured Data piloting the Federation scout mission ship in a dramatic skirmish against Captain Picard and Worf in a shuttlecraft. The process of creating this aerial battle began with illustrator John Eaves devising a look for these two ships.

Eaves knew that for the scenes to work, the ships had to look distinct from each other, yet both be of the same design language. Eaves began by looking at the commonality between the two ships. "I repeated certain shapes throughout the Federation designs, so the ships all seemed to extend from a single technological base," said Eaves. "The scout ship was a good example, as it used the cowled enclosed engine nacelles seen on the *U.S.S. Defiant* from *DEEP SPACE NINE*."

Basing the scout ship on the *Defiant* was a good idea, as it immediately separated it from the shuttlecraft that featured the more traditional external nacelles that hung below the main body. This meant both ships were recognizably of Federation design, but the differences were also obvious.

Eaves went on to say that while the scout ship had echoes of the *Defiant*'s design, it had more of a streamlined, high-performance fighter appearance. The addition of a wraparound canopy also gave it an aerodynamic look, and made it easier to see that it was Data who was in the cockpit. "The smaller cockpit area was script driven," said Eaves, "although it was nice to have a smaller piloting area unlike so many of the other ships that have huge amounts of room, but with very little glass to see outside."

DOCKING CHOICE

From the script, it was not easy to tell if Picard's shuttlecraft would dock with Data's scout ship from the top or the bottom in the dénouement of the battle, so Eaves placed docking hatches on both the dorsal and ventral sides of his ship. "We designed the same types of emergency hatches, which were based on circle hatches like manhole covers, on both ships," said Eaves. "That way, no matter how they wanted to put it together visually, they could dock on the top or bottom, whichever way was more exciting."

Once Eaves had completed the design of the scout ship, it was turned over to the visual effects team so they could put together the exciting battle, almost entirely in CG. Co-producer Peter Lauritson said, "One of the things we wanted to do was have these ships doing a lot of intricate maneuvers and swoops and spins, and things like that. And that was something that would be extremely difficult with motion control photography. Normally we were up in space with these ships and we could create whatever background we wanted. In this case we were coming down into the atmosphere, so we hired a jet with a camera rig and went up on a semi-stormy day to photograph these cloud backgrounds. We had to

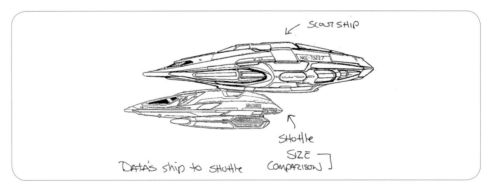

▲ Eaves also illustrated the emergency docking hatches that would be used to lock the two ships together as they battled it out over the Ba'ku planet.

guesstimate the kinds of moves we would want to see in the background of these ships, so that it would help sell the CG ships in a real atmosphere."

They also captured additional dramatic footage to use for the moment when both ships almost crashed into the planet. Lauritson explained, "When the ships went into a spin, going down toward the surface, some of it was CG, but it was all created by referencing the real landscape. For that final shot, where the ships came very close to the ground, we had a helicopter do a swoop pass, as if it were

these ships. We did not come as close as them, of course, but it did make the grasses move the right way."

In the end, the visual effects company Santa Barbara Studios (SBS) had to perform a number of color corrections for this maneuver. Cloud elements were combined with digital matte paintings to create the background environment on which they could composite the ships flying inches from the ground, making for a thrilling and realistic ride.

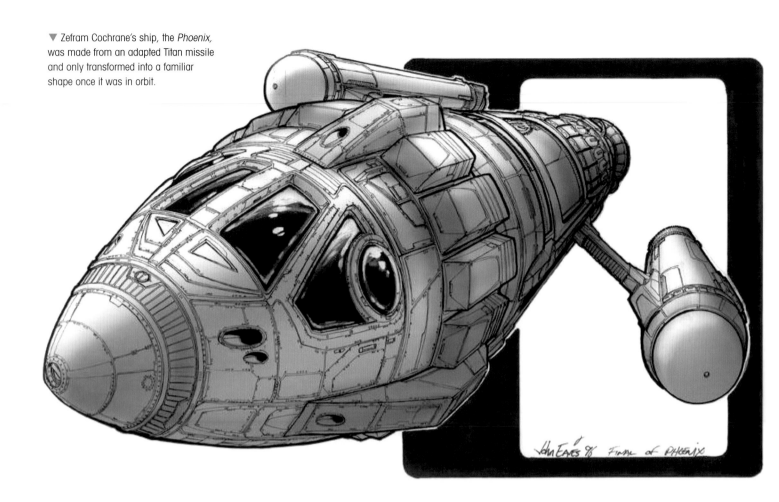

▼ Zefram Cochrane's ship, the *Phoenix*, was made from an adapted Titan missile and only transformed into a familiar shape once it was in orbit.

John Eaves 98 Final of Phoenix

DESIGNING THE

PHOENIX

The *Phoenix* was the most important ship in *STAR TREK*'s history and the design had to provide a bridge between today and the future.

When concept artist John Eaves began work designing Zefram Cochrane's famous warp ship, the *Phoenix*, he found himself faced with multiple challenges: he had to come up with a design that would be convincing as mankind's first faster than light vessel, that looked as if it was designed in the present, but that would also suggest the design of Starfleet vessels in the future. On top of that he

knew that it had to be adapted from a Titan missile. The production had even found a real Titan missile in a silo that they would redress for the movie and Eaves began work by getting to know it. As he recalls, "I think I climbed about every ladder and poked through every hole I could find. The missile had been decommissioned. It had been stripped back and the main thrusters removed from the bottom. There were holes in

the center of the body and you could peer right in and see that the whole thing has been dismantled. The hatch on the top of the silo was half glass and half solid so a satellite could fly over and tell that there was no nozzle on the bottom. So straightaway we knew that we were going to have to fill in the holes."

It helped that scenic artist Mike Okuda had an extensive library of books

▼ The first sketch that John Eaves produced showed the nose cone, which he based on lunar landing modules.

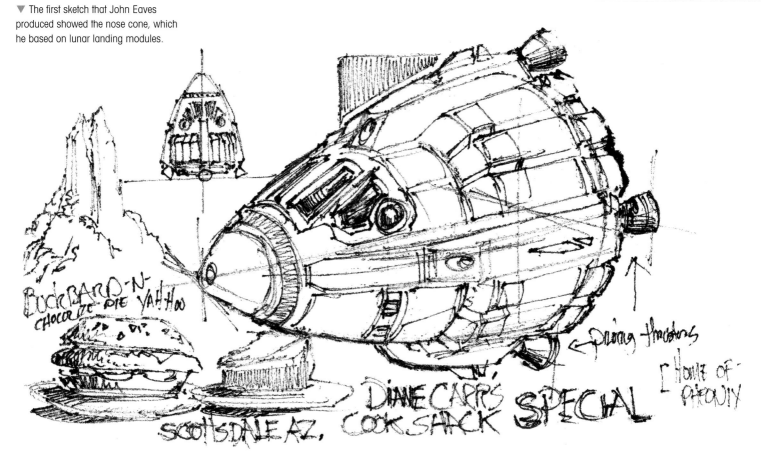

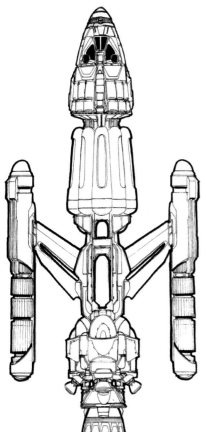

▲ In early versions of the design the *Phoenix* had a much more involved shape under the missile's plating but this was rejected in favor of a simpler approach.

▲ The exhaust nozzle on the real missile had been removed so this had to be designed and built from scratch.

about NASA that detailed just about every rocket ever made, including one that showed the dimensions of an intact Titan missile. Eaves decided that there were three major factors that needed to be addressed. "We needed a nozzle that could go down the tiny elevator and be built on the bottom of the missile, because basically there was nothing down there. And then in the very center there were huge holes cut all the way round in a circle, so we had to build a centerpiece to fill it in. Once that was done, we built a cone to go over the existing one, or at least what remained of it. I actually made the new cone longer than the original one and gave it an outward curve as well as adding four riblets that ran from the wider base right up to the nose."

Eaves also wanted the capsule to look as if its creators had used existing

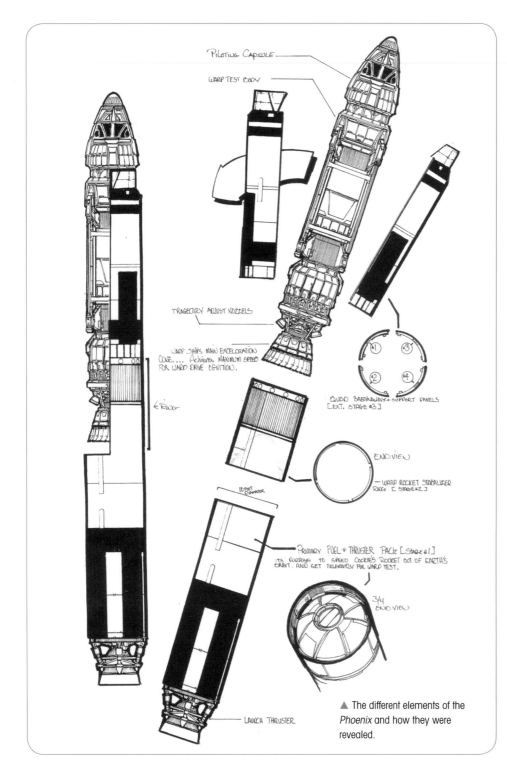

PILOTING CAPSULE

WARP TEST BODY

TRAJECTORY ADJUST NOZZELS

WARP SHIPS MAIN EXCELERATION CONE.... Achieves MAXIMUM SPEED FOR WARP DRIVE EGNITION.

RING

QUAD BREAKAWAY + SUPPORT PANELS [EXT. STAGE #3]

END VIEW

WARP ROCKET STABALIZER RING [STAGE #2]

10 FOOT DIAMATER

PRIMARY FUEL + THRUSTER PACK [STAGE #1]
ITS PURPOSE TO SPEED COOKIES ROCKET OUT OF EARTHS ORBIT. AND GET TELEMATRY FOR WARP TEST.

3/4 END VIEW

LAUNCH THRUSTER

▲ The different elements of the *Phoenix* and how they were revealed.

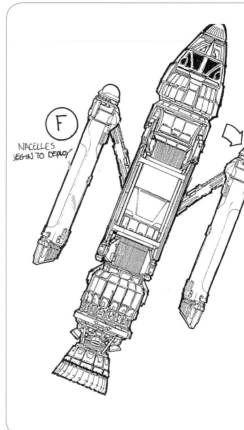

F

NACELLES BEGIN TO DEPLOY

an idea of what they thought the *Phoenix* would look like years earlier when they wrote the *STAR TREK Chronology* and Greg Jein had even built a model for them. "We started working with that design originally," explains Eaves. "But, after some thought, (VFX producer) Peter Lauritson decided it would be a struggle to fit that ship into what was obviously a pretty confined place. For me it was a real wrench as the stuff they'd done was beautiful but in the end we agreed it just wasn't going to pan out."

NEW DIRECTION

Eaves went back to the drawing board in particular concentrating on how the ship, which the script described as having nacelles, would actually fit inside a missile and how, having broken loose, it would then convert into a vessel capable of warp speed.

"I took the plans of the missile and tried to work out what a good length of

technology that happened to be at hand and that over time extra bits had been attached as needed. A 'bubble' window was added to enable the crew to look out and around.

After Eaves' design was approved, a model of the cone was constructed by Clete Cetrone using sketches which showed the top, side and a three-quarter view, together with the actual specs of the original nose cone. He also added detailing to the surface. This dealt with what the missile would look like in the silo, but it was clear that the *Phoenix* would change shape once it had been launched.

Mike and Denise Okuda and Rick Sternbach had actually come up with

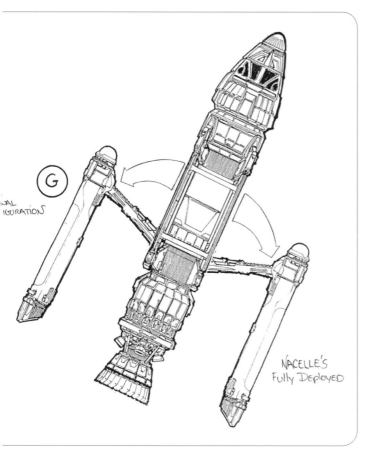

G

NACELLE'S
Fully Deployed

▲ Eaves had designed the warp nacelles so they could hinge out of the body of the missile in the most obvious way. One of Rick Berman's requests was that the nacelles were moved back to give a better sense of balance.

framework. The nacelles would then fold out of the sides of the missile. Eaves made a point of making them as big as possible within the extremely narrow of the real-word missile. Production Designer Zimmerman wanted the ship to look as if it had been built from parts that had been salvaged so it would also have areas that looked almost skeletal. Finally, Eaves worked on both a longer and shorter version of the missile paying special attention to the warp drive.

"I saw a documentary about the atom bomb and one of the early bombs had a ring of triggers. They all had to go off simultaneously for it to work. I thought wouldn't it be cool if that is the premise behind this unit – that all these triggers needed to fire to make the warp action come into play."

All that was then left to do was fashion the nacelles to look similar to the versions on the original *Enterprise,* in a bid to make a visual connection between the time periods before the designs were submitted to Zimmerman and producer Rick Berman, who picked the shorter version of the ship, and moved the nacelles a little further to create a more balanced (if mechanically challenging) design.

rocket versus a solid rocket fuel base would be. From there I pulled the *Phoenix* idea out and tried to figure out the details."

Eaves came up with a design, which featured large thrusters on the bottom and a solid fuselage with an open

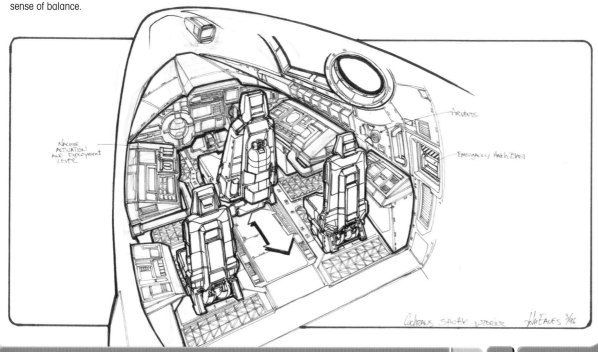

NACELLE
ACTIVATION
AND DEPLOYMENT
LEVER

AIR VENTS

EMERGENCY HATCH BLAST

◄ Eaves also designed the interior of the nose cone. He remembers being surprised that the script called for three people to be seen in it. The solution was to put Cochrane's seat in front with two seats behind, which could be occupied by Riker and Geordi La Forge.

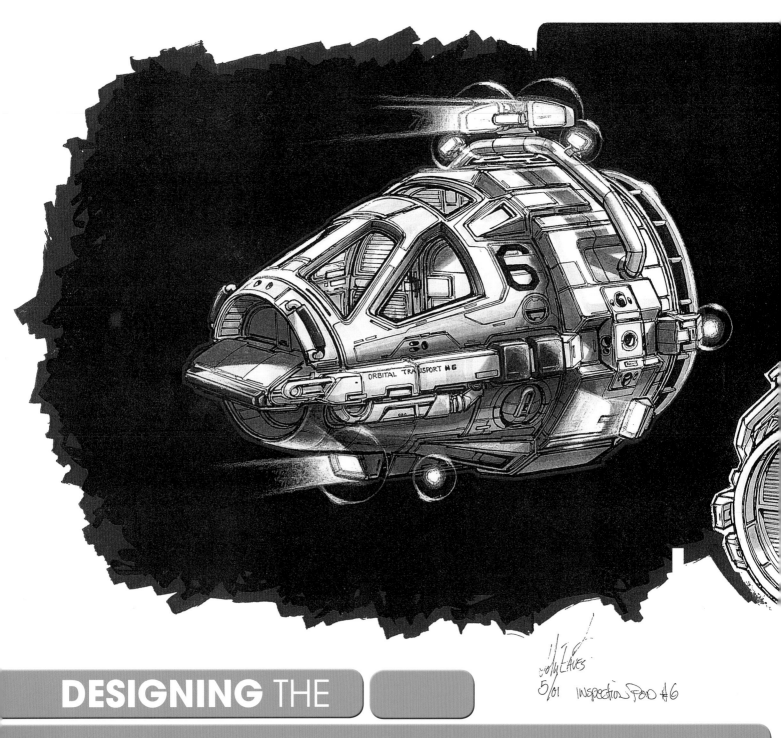

ORBITAL TRANSPORT #6

John EAVES
5/01 Inspection Pod #6

DESIGNING THE
NX INSPECTION POD

When the art department had to create a pod to inspect the NX-01 they decided the best solution was to cannibalise the *Phoenix.*

Most of the Starfleet equipment featured in *STAR TREK: ENTERPRISE* was clearly designed with an eye on the technology we saw in Captain Kirk's day. However, as John Eaves explains, many of the designs also built on the 21st-century equipment that had been in *STAR TREK: FIRST CONTACT.* The most obvious example of this is the inspection pod, which is closely related to the nose cone of the *Phoenix.*

While it's logical that Archer's technology might have a lot in common with Cochrane's, there was a practical

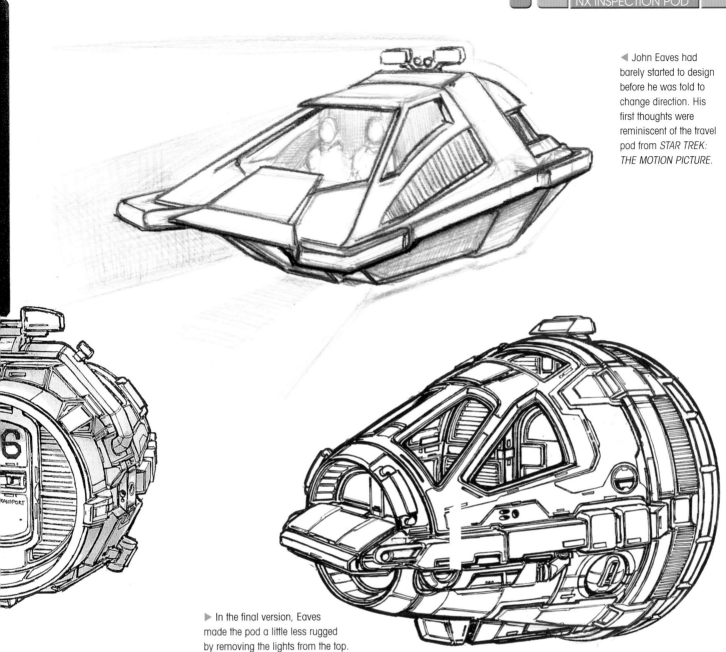

◀ John Eaves had barely started to design before he was told to change direction. His first thoughts were reminiscent of the travel pod from *STAR TREK: THE MOTION PICTURE*.

▶ In the final version, Eaves made the pod a little less rugged by removing the lights from the top.

reason too: building sets is expensive and the art department already had the nose cone of the *Phoenix*.

Eaves says that the script originally called for a barrel-like craft that was so cramped it was claustrophobic. The idea of the scene was to show how big the *Enterprise* NX-01 was. He started to sketch something but he'd barely started when Herman Zimmerman told him to stop. "Herman always knew we were going to reuse the *Phoenix* capsule for the inspection pod," Eaves

recalls, but he goes on to say that even though they were reusing an existing set, Zimmerman still wanted to make some significant changes. "We changed the windows; the *Phoenix* had a little round window on the side, so we got rid of that and put a third window on top. And we changed the seating inside – cut it down to two seats."

The pod is also related to the vehicles that we saw in *STAR TREK: THE MOTION PICTURE*, in particular the travel pod, and there are some very deliberate

echoes of these in the design. "It's like the Work Bee of its time," John says. "Its whole function is pretty much service; you've got little robotic arms underneath. It also has the same docking ring as the pod in the motion picture on the back. Mike Okuda put the door from the international space station on it. That technology might be just on the edge of retiring at that point." So the inspection pod sits neatly between Cochrane and Kirk, linking the two eras to one another.

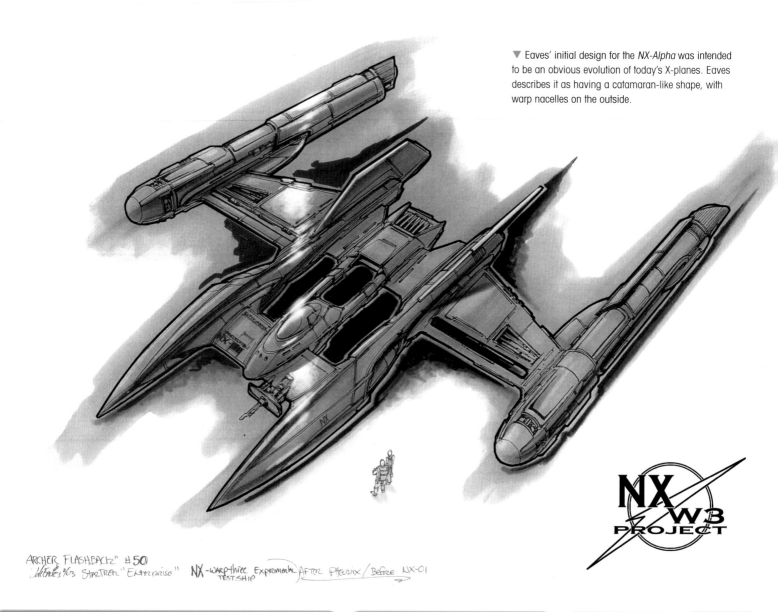

▼ Eaves' initial design for the *NX-Alpha* was intended to be an obvious evolution of today's X-planes. Eaves describes it as having a catamaran-like shape, with warp nacelles on the outside.

NX
W3
PROJECT

ARCHER FLASHBACK" #50
"... 9/03 STARTREK "Enterprise" NX - WARP-three Experimental AFTER Phoenix / Before NX-01
TEST SHIP

DESIGNING THE III

NX-ALPHA

Earth's first Warp 3 ship went through some surprising changes before it finally got off the ground and took flight.

Designing the *NX-Alpha* was one of concept artist John Eaves' favorite assignments. The script called for an experimental ship that was more primitive than the *Enterprise* NX-01. Like most of the rest of the art department, Eaves was deeply interested in real space flight and fascinated by everything that had ever been done by NASA, so he was delighted that this ship represented a bridge between today's experimental spacecraft and Matt Jefferies's *STAR TREK* aesthetic. "My first pass was very plane-like," Eaves recalls. "It had warp nacelles and a twin fuselage, like a catamaran, with the capsule suspended in the center. It's got all your *STAR TREK* elements on it but it was also an evolution of an X-plane. It was kind of where those two things met"

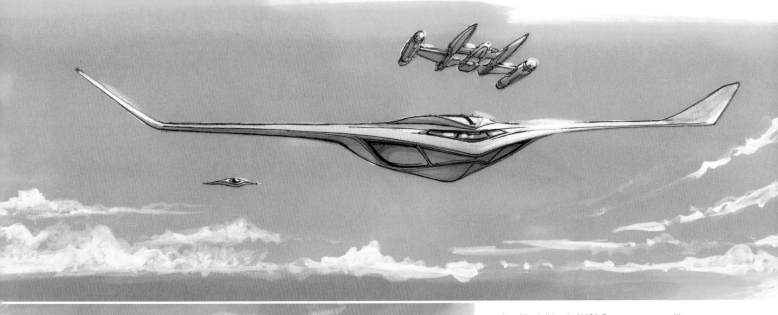

◀▲ After talking to NASA Eaves came up with a system for launching the *NX-Alpha* that involved a second craft, with a blended body, that carried it into the upper atmosphere.

This first design was approved without any serious alterations, but now the art department had to work out how it would be launched. The script made it clear that the experimental NX base was on the ground so somehow the ship had to get into orbit. Massive rocket boosters didn't seem appropriate. Eaves thought the answer might lie with NASA so he called them up.

"We went out to Edwards Airforce base to visit NASA and to research all their plans for that kind of spaceship. Two gentlemen named Tony Moore and Pete Merlin invited me up and we went through all of the NASA stuff at that time." Moore suggested that the *NX-Alpha* could be carried into the

upper atmosphere by another ship, in much the way that the space shuttle had been mounted on the back of a 737. "It was kind of like a Spaceship One scenario," Eaves says "there was a mothership and then the *Alpha* would piggy back on the top. The mothership would get it off the ground then it would break off when it went into space."

Moore also provided Eaves with inspiration for the design of the ship that would carry the *Alpha* into near-orbit, when he pointed him towards the design of an experimental craft called the X-48B. "It was a future ship idea," Eaves explains, "NASA does this unusual thing where they make quarter-scale

models. The X-48B was one of these model tests that we used as the basis of our design. It had what they call a blended body, with little wingtips at the end. We came up with this kind of smooth, limping body and detailed that into a futuristic version with the Alpha on the back."

Eaves produced a drawing showing the two ships together but around this time it became clear that the production couldn't justify the cost of building two ships instead of one. There was another problem: the art department had to show the outside of

▲ The badge for the experimental project was designed by Mike Okuda.

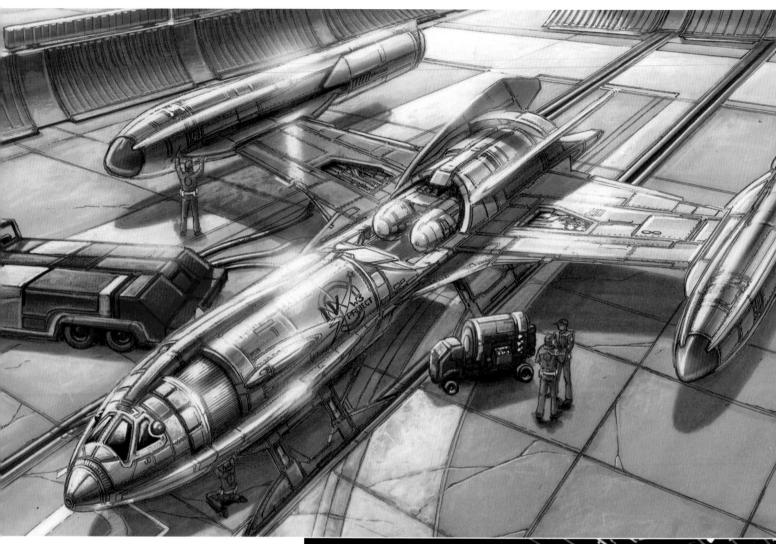

▲ When the producers decided to reuse elements from Earth's first warp ship, the *Phoenix,* Eaves redesigned the *NX-Alpha* to look more like its illustrious predecessor, using elements of his original design for the *Phoenix* that had been rejected.

the ship and to build a set showing the interior. It was decided that in order to make the most of the budget they should reuse the *Phoenix* nose cone that had been built for *STAR TREK: FIRST CONTACT.* It was an elegant solution: the production already had a model of the exterior and a set for the interior. And, all-importantly, it made sense that the *NX-Alpha* would be a direct descendant of Earth's first warp ship.

This meant that both of Eaves designs would be lost. Instead he returned to his design for the *Phoenix.* "I pulled the *Phoenix* up and tried to move it ahead. Some of the earlier *Phoenix* designs had

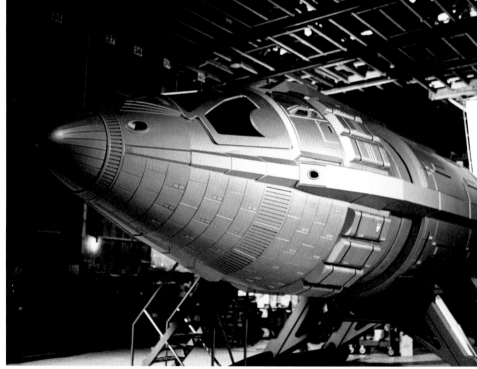

▲ The decision was taken to reuse the nose cone and cockpit of the *Phoenix* because they had already been built and would allow the art department to put more on screen for the same budget.

◄ The *NX-Alpha* was an experimental ship and didn't have the kind of engines it would need to get into orbit. This meant it needed some kind of launch system. Eaves' second suggestion was that it would be launched by magnetic rails.

a lot of open framework, with exposed tanks, fuselage and engines, so we carried a lot of those design elements over to the *Alpha*."

This still left Eaves with the tricky issue of how to get the *NX-Alpha* off the ground and into orbit. Again the solution was to be found at Edwards Airforce Base. "We went for an idea where it was launched from a testbed. They built a test track out at Edwards in the 50s and the 60s that was on the lake bed. They'd accelerate these little nose capsules up to super speeds to do the tests. It was a magnetic system and we thought we could launch off of that."

Eaves produced drawings showing his new ship launching from the kind of flat terrain that can be found at Edwards but the process had a few last twists for

him. A change in the script called for the base to be in a forest, so the massively long track he'd designed was no longer practical. "We did another version where you have a track with a ramp on it and that's what we used in the final rendition."

A final change came about because of the practical needs of the set that the art department had designed for the hangar bay. The ship Eaves had come up with simply couldn't get out the doors. "The wings I designed were fixed and it made it too big so Doug (Drexler) designed these hinge points for the wings – it was a weird kind of L-kink so they folded up like an accordion."

Finally, after all the twists, turns and redesigns the *NX-Alpha* was ready for its first flight.

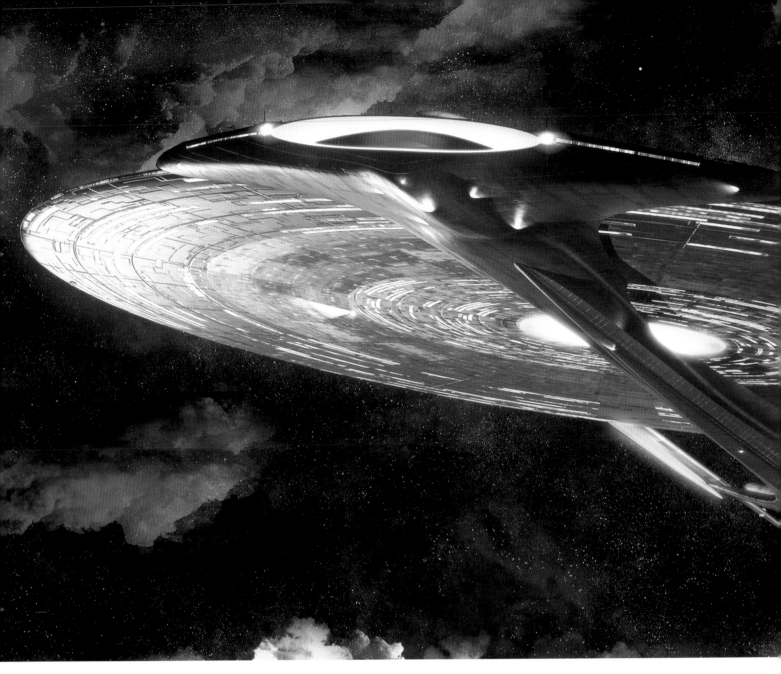

DESIGNING THE

It's the most futuristic *Enterprise* ever – an impossible ship that was grown in the 26th century and it only made a single appearance.

Doug Drexler is very clear that if the design of the *Enterprise*-J was going to be a success, it had to look ridiculous. "Its structure had to be impossible. It had to be impossible in overall size, mission, and facilities. I knew that if someone looked at it and didn't say, 'That's ridiculous! One photon torpedo would knock off a nacelle like a soap bubble!' I'd failed. I knew it had to break ape-brain rules in order to

fulfill the order of far-flung future."

As Drexler recalls the brief was pretty basic, and all he really knew was that the *Enterprise*-J had to look futuristic and that it had to be ready in two days time. "I remember Herman saying, 'Mister Berman would like to see designs for a starship at least four hundred years ahead of where we are now. I'll need some sketches to take to him the day after tomorrow.'"

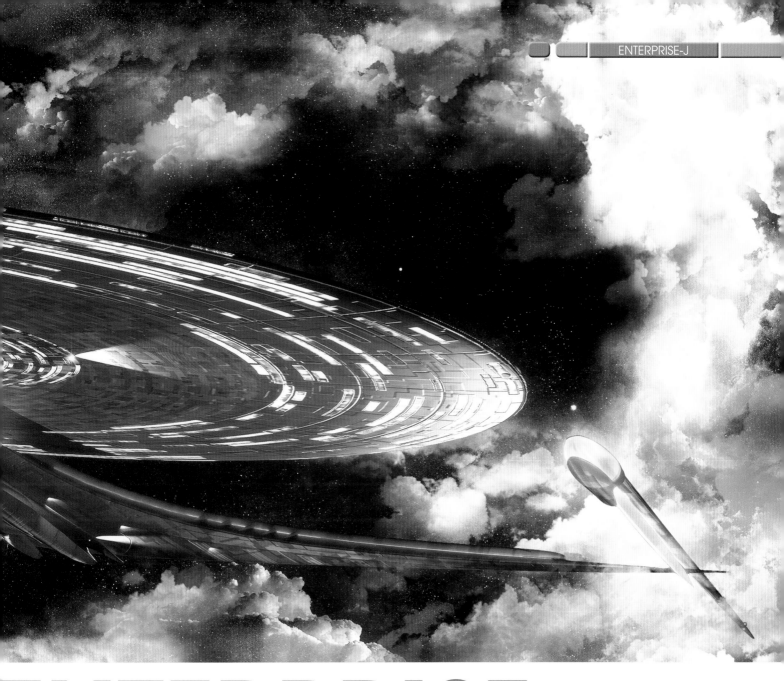

ENTERPRISE-J

The need to look even more futuristic than all the other *Enterprises* was what made Drexler feel it had to look ridiculous. "We've been designing starship for decades," he says, "How do you say futuristic, when you have been living the future for that long? Where do you go? In a way it is very similar to the problem that Andy Probert was given when designing the *Enterprise*-D. Gene Roddenberry was looking for a 'recognizable' *Enterprise* that was unquestionably different. That's a real challenge. You're stepping into a minefield. Dedicated fans would see it as an affront to their

beloved *Enterprise*. Like what had gone before 'wasn't good enough.'"

Drexler firmly believed that in order to look futuristic, the *Enterprise*-J had to break the rules – to do something that seemed impossible. "The status quo," he insists "was our enemy."

He started the process by producing a series of quick pencil sketches that gave an impression of the kind of shape he was looking for. At this stage he says the idea wasn't to come up with a polished drawing, but just to establish a design direction and to find a distinctive shape. "This

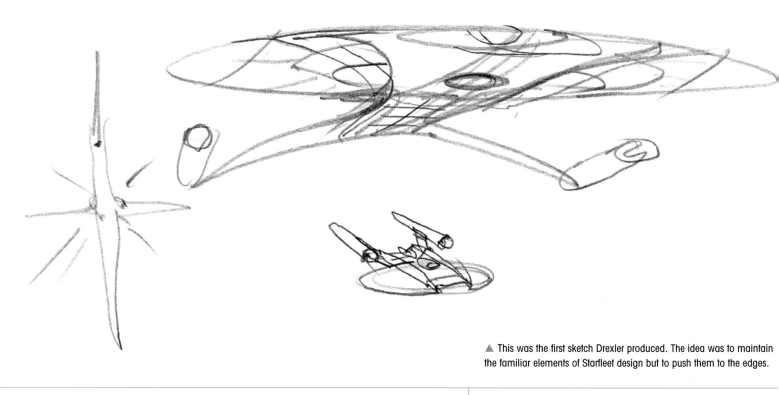

▲ This was the first sketch Drexler produced. The idea was to maintain the familiar elements of Starfleet design but to push them to the edges.

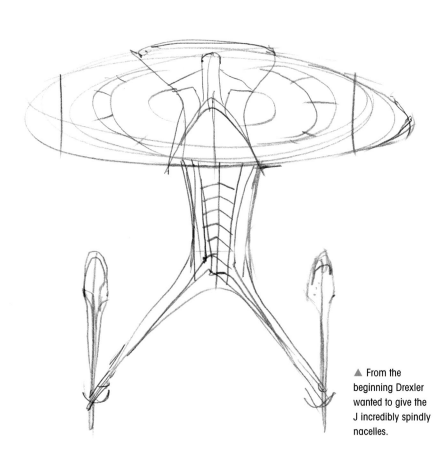

▲ From the beginning Drexler wanted to give the J incredibly spindly nacelles.

was especially important with the *Enterprise*-J, because I knew that we would only being seeing it for a second or two. It had to have a dramatically different signature, yet it still had to be an *Enterprise*."

SOLID FOUNDATIONS

Drexler believes that a good design shouldn't just spring from a 'nice' shape but should be rooted in an understanding of how the ship functions and what is inside it so, like an actor preparing for a role, he developed a backstory for his ship.

"It was important that the basic mission profile, and its capabilities be developed before I went too far with the design. Even if people hated it at first, once they found out that it was all built around a real skeleton of imagination, and thought that respected the world they loved, they would get behind it 110%. If they find out that you've built it on farts, you're doomed."

Drexler figured that by the 26th century the way we build things will have changed radically and this would have implications for the shape of the ship. "The *Enterpise*-J would not be welded together. The very idea that a ship of this

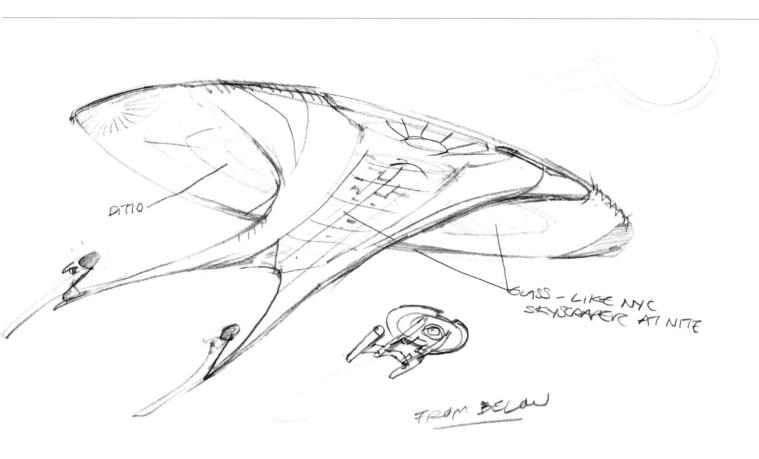

DITIO

GLASS - LIKE NYC
SKYSCRAPER AT NITE

FROM BELOW

magnitude would be built like a 20th-century trestle was absurd. Sparks spewing from welding torches? Positively laughable! More ape-brain thinking that had no place here, and honestly, to my way of thinking, had no place on any of the *Enterprises* after the NX.

"No, the *Enterprise*-J would be 'grown,' like an organic animal. Even today we are printing parts for machine. SpaceX is printing rocket engines. What's it going to be like in 500 years, and on a grand scale? Starships will be printed. Structural members will not be trusses and girders. Not by a long shot."

IMPOSSIBLE SHAPES

Advances in materials would also mean that the ship's designers wouldn't be concerned with the kind of limitations we face today. "Its elegant curves are based on the optimal shape to support itself with a minimal amount of building material," he explains, "Because structural members will be 'printed,' we will be able to custom design every individual part to cater to gradient stress distribution. This will allow us to take advantage of fractal patterns in the construction of the

Enterprise-J. Not only is this mathematically more advantageous than standard truss construction, but it will give the ship a heretofore never seen design ethic."

Another decision Drexler made was that the ship would be massive. "You know how the original *Enterprise* was described to Charlie X as 'a whole city in space'? The 1701 was really a village compared to the J. At two miles in length, it even dwarfed the D.

"You can live in an 'apartment' similar to what we have seen on the D, but imagine that there are suburbs on the ship, that are like living in a valley on Earth, with a sky, and a sun.

"Your starship, would have large parks, entertainment zones, and entire universities on board. The ship is so large that turbolifts would be replaced with site-to-site transporters. If you're not in a hurry, you can catch the Grand Concourse Freeway, and drive your 20th-century Maserati into the 'Urbs.' Sometimes a holo experience gets to be psychologically unfulfilling. The same would go for rock climbing, and skydiving. On this ship you can do the real thing."

In another effort to move into the future, Drexler

▲ The early sketches were only meant to establish rough shapes, but most of the important ideas were already present.

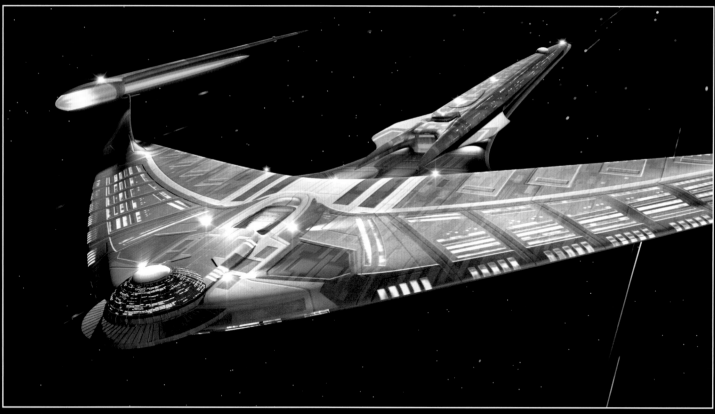

▲ One of the designs Drexler worked up was a rejected concept for the *U.S.S. Voyager*, the *Altair* class.

▲ The *Altair* class was based on an idea that Mike Okuda suggested and was inspired by an aerial.

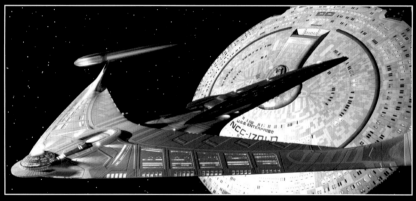

▲ Drexler would later use the design for this image from the *Ships of the Line* calendar.

figured that the inside of the ship would abandon the traditional concepts of up and down, which, after all, were redundant in a zero gravity environment.

"The ship also had prominent, HUGE windows that covered large parts of the hull. Most people imagine that these would be ceilings and floors, meaning that our feet are always pointing 'down' in relation to the ships direction of flight. But why? We control gravity and energy fields. There are large areas where your feet are pointed toward the center of the saucer, and the supposed ceiling and floor windows are actually walls. Now you're doing some stuff that a lot of people will crinkle their nose at! Good job!

"What is it like living on a starship that is a quantum leap beyond everything that we have seen so far? Of course, if you do live in 'quarters' that are an apartment, you can change the holosettings to make it anywhere, or anything you want.

"What about the ship's bridge? In truth you don't need to ever leave your cabin. It can all be 'conferenced' wherever you are. You will go to a location that is physical, but is physically malleable, to be any bridge that is the 'Bridge Of the Day.'

In this version, which Drexler called the *Congo* class, he added a saucer to the *Altair* class, which became the engineering hull.

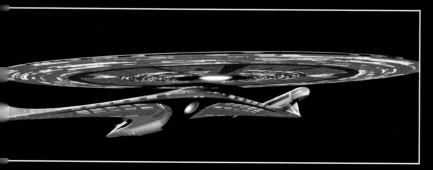

Drexler's CG models were only designed to be quick 'sketches' and weren't detailed but by working in 3D he was able to show them from different angles.

The bridge crew on the *Enterprise*-J can fly any bridge in history. It's part of their training, and it's incredible fun."

ALTERNATIVE DESIGNS

Armed with these ideas about how the *Enterprise*-J worked and what life aboard was like, all Drexler had to do was decide what it looked like. Because television is made at high speed – remember that he had a little over two days to develop his design – he started by pulling out an old design that he had always liked.

"When *VOYAGER* was in pre-production, and a ship search was in progress. I asked Mike (Okuda), "is there a pet idea of yours you'd like to see developed that we could pitch to the producers? Mike rubbed his chin thoughtfully. 'You know those V shaped television antennas you see on automobiles? That.'"

Drexler had worked the idea up but it had been rejected as too much of a departure from conventional Starfleet design, but since the *Enterprise*-J had to be so advanced, it seemed like a good option.

"I took that and fleshed it out. We both like this design because it broke from the saucer, yet still

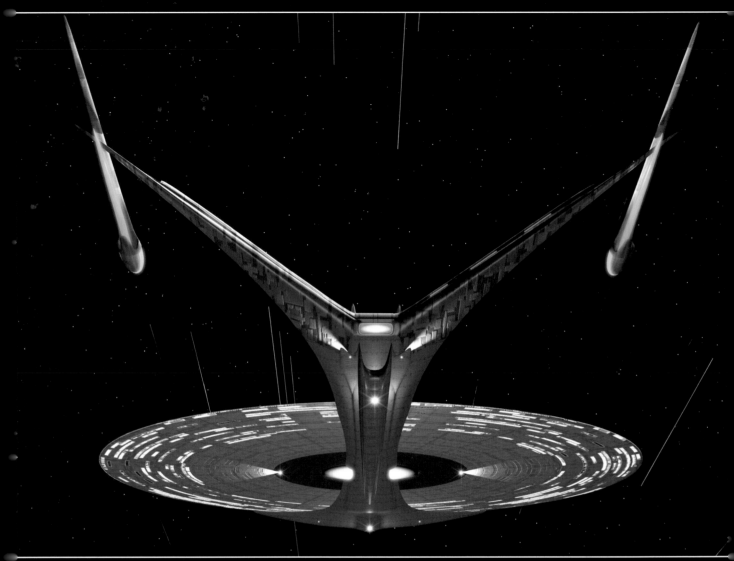

▲ Drexler wanted the ship to be massive – he says that it is two miles long and is so large that it has highways inside it.

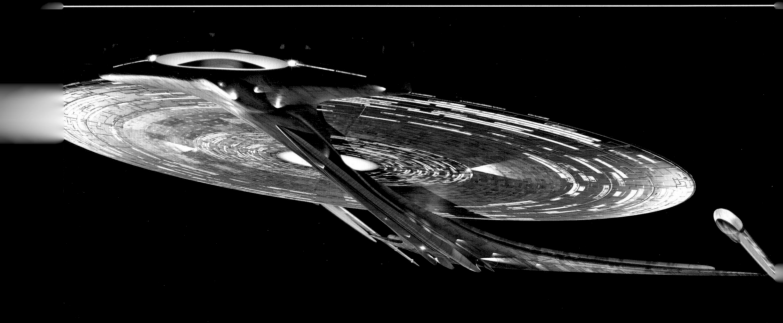

▲ Drexler later decided that the J would belong to the *Universe* class and theorizes that it moves between Galaxies by folding space.

◀ The original plan was for the *Enterprise*-J to be seen fighting the battle of Procyon V, but this was abandoned for budgetary reasons.

felt starfleet. It would evolve into what we called an *Antares* Class ship, and was used in the *Ships Of The Line* Calendar. The design had been submitted as an idea for the NX but once again it was considered too different. For the *Enterprise*-J I would sleek it somewhat, and rebuilt it in Lightwave.

"So I had that, and I had some sketches. Now it was time to go to the computer and explore. I only had a matter of hours to stretch some polygons fueled by all the preparation. But this kind of pressure creates a creative zone in your head that is a blend of conscious and subconscious. Then you need to blend all of that with equal parts of terror. The preparation is the fuel, the spark that ignites it is fear. It's an unbeatable combo. If you're not scared, you're missing one of the most powerful creative ingredients. I start modeling, and I mean fast. It's a gesture sketch, but this time in the computer. I don't worry about details, and I know I can suggest a lot in the texture with fast graphic maps made in Adobe Illustrator."

THE CLOSING STRETCH

Within a matter of hours, Drexler had developed three serious alternatives: the rejected *Voyager* concept now dubbed the *Altair* class, a version where a saucer was added to that design,

which Drexler called the *Congo* class and finally the design that would be chosen, which would eventually be named the *Universe* class."

Zimmerman looked over the finished designs and gave his input before Drexler finally produced a series of short animations, which, as he explains, was radically new territory in 2004.

"Back then, designing in the computer was revolutionary. Suddenly we could size up a design by being able to turn it in 3D space, and see how light plays across the shapes. We may have been the first television art departments to make use of such technology. After I'd talked to Herman, the machine spat out a series of images. I feel positive, but I know that anything is possible. What a great feeling handing Herman a VHS tape to show the producers. Unheard of! After the meeting Herman came back with a big smile, and pointed to the approved *Enterprise* J. 'No notes,' he said. Send it to Dan Curry!'"

But as can also be the way in television, the *Enterprise*-J was a victim of budget cuts. The script had originally called for shots showing it fighting in the Battle of Procyon V, but it was decided that the story could still be told without seeing the J in action. Instead we saw Archer and Daniels inside the ship with a graphic behind them on the wall. It simply wasn't the *Enterprise*-J's time.

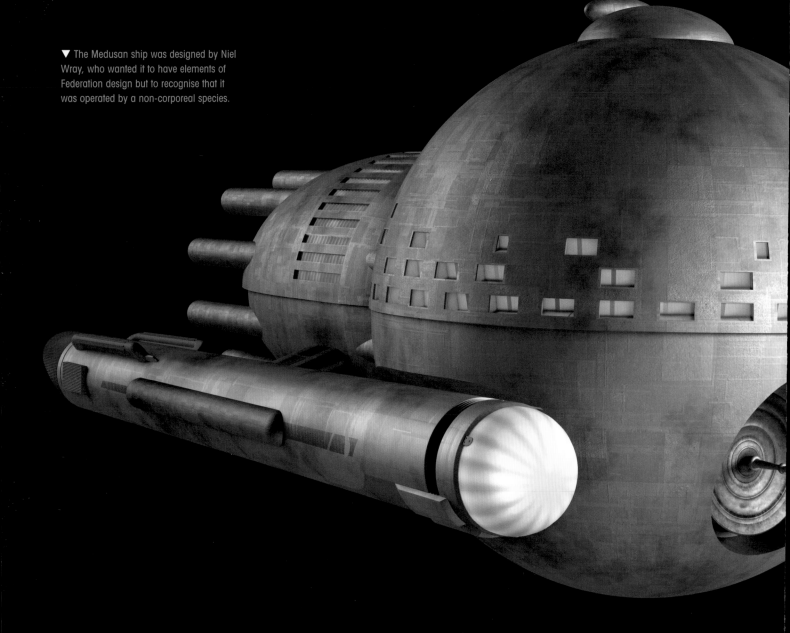

▼ The Medusan ship was designed by Niel Wray, who wanted it to have elements of Federation design but to recognise that it was operated by a non-corporeal species.

MEDUSAN SHIP

In 1969 the budget for *STAR TREK* rarely stretched to alien vessels. But when the show was remastered the Medusans finally got a ship.

When *STAR TREK* was remastered in HD, all the effects had to be recreated. As Mike Okuda explains, the goal was almost always to create painstakingly accurate digital copies of the original effects, but just occasionally there was

an opportunity to add something new. "In a few cases," Okuda explains, "an episode's dialog suggested that we should be seeing a guest ship, even though none was actually shown in the original version of the episode. In such cases, we often asked our VFX producer

Niel Wray if he could add it into the effects, and he'd strive mightily to make it so. The Medusan ship in 'Is There In Truth No Beauty?' was one of those additions."

As Wray remembers, the process began with a conversation that involved

▲ The Medusan ship appears in a single shot at the end of the remastered version of 'Is There In Truth No Beauty?' before the *Enterprise* turns around and pulls away.

him, and the other VFX producers, Dave Rossi and Mike and Denise Okuda. "We'd start by talking about what the ship should be. This was more about the capabilities, crew species and intended use of the ship than the actual shape. I would then create rough sketches until I came up with something that I liked, then create that design in 3D."

In this case Rossi had some ideas about what kind of ship the Medusans would use. "The Medusan ship was interesting," he recalls "Here you have this non-corporeal life-form that had no need for a conventional design of starship, as they had no bodies. Their ships could have looked completely alien, and weirdly unlike anything we

recognize as a ship. While that was tantalizing from a design aspect, we hypothesized that once they began interacting with the Federation, having ships that were able to service humanoid needs would become more of a necessity. We postulated that Starfleet was brought in to design functional ships for the Medusans, hence the standard nacelle designs and ship alloy materials seen in the episode. Once we had laid down our parameters to Niel, and explained who the Medusans were, he set off and designed what you see on screen."

The next step was for Wray to produce a rough digital model of the ship that he could discuss with the team. The design

he came up with had a sphere rather than a saucer and a ring of blue lights around the engineering hull.

"If I remember right," Wray says "my original design didn't have the horizontal shafts running through the ship, this was added later. The blue band of lights was my idea. I thought the Medusans would have incorporated a observation area for themselves into the design of the ship. Since the Medusans were without form they didn't need to follow typical Federation ship design so that was the thinking with the sphere." It was also a tribute to Matt Jefferies, who in some of his early designs for the *Enterprise* looked at using a sphere instead of a saucer.

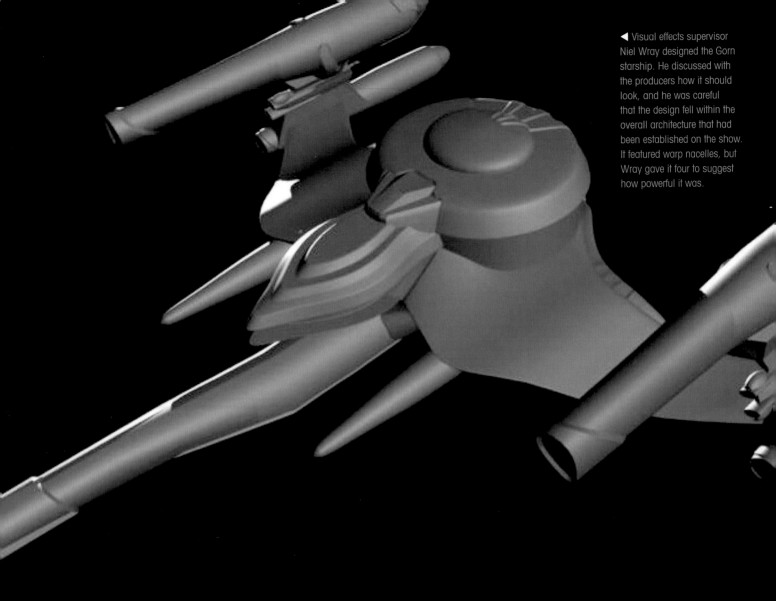

DESIGNING THE

GORN STARSHIP

STAR TREK remastered offered the chance to create a Gorn starship for the first time, an opportunity which its producers could not pass up.

The Gorn ship never appeared in the original version of the *STAR TREK* episode 'Arena.' It was not until the remastered episode first broadcast in 2006 that it was seen at a distance in

space and on the viewscreen of the *U.S.S. Enterprise* NCC-1701.

Back in the 1960s, there simply was not the budget to create a physical studio model of the Gorn ship, but when

THE ORIGINAL SERIES was remastered, the producers thought it would be cool to devise a CG version, as long as it stayed consistent with the story's intent. Normally, Mike Okuda, the visual effect

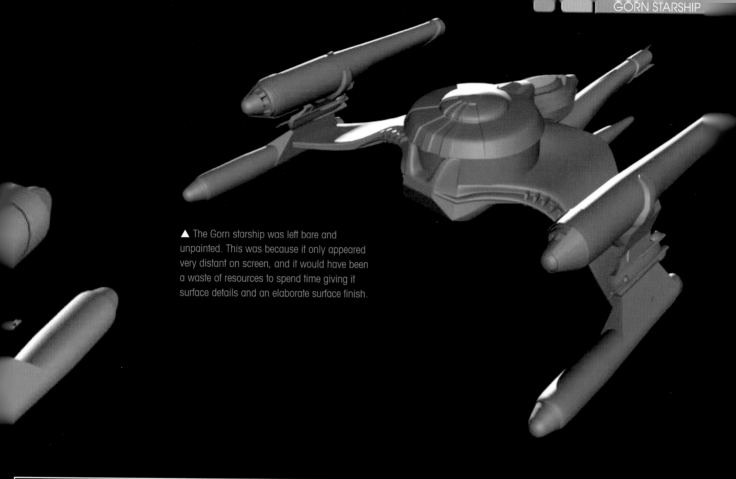

▲ The Gorn starship was left bare and unpainted. This was because it only appeared very distant on screen, and it would have been a waste of resources to spend time giving it surface details and an elaborate surface finish.

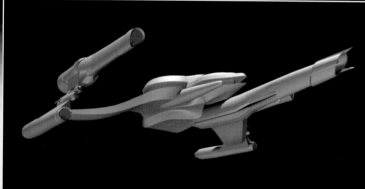
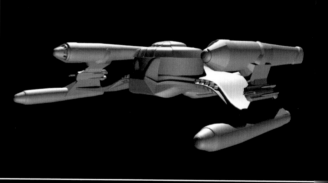

▲ Wray was thrilled to be given the chance to design a new starship for a series as iconic as *STAR TREK*. With the agreement of producers Mike Okuda and Dave Rossi, Wray made the ship look aggressive and threatening.

producer for the remastered series, designed the new ships for this project, but in this instance he gave the task to visual effects supervisor Niel Wray.

GREAT OPPORTUNITY

The chance to design a new ship for *STAR TREK* was one Wray jumped at, and he discussed with Mike Okuda what it should look like. David Rossi, another visual effects producer and architect of the remastered series said, "We told Niel that the Gorn ship was military in nature.

It was an assault ship meant for coming in, kicking ass and getting out. It should be fast and deadly. Niel, using the design mantra of the series, gave the ship nacelles, but four instead of two, to illustrate the ship's speed and power generation. We never got close enough to see any real detail, but Niel's concept to bristle it with weapons was exactly what the doctor ordered. I think we all wish it would have played a bigger part, and allowed us to see it close up!"

Indeed, the Gorn ship was only see at a distance, and because of that i was not necessary to 'skin' the CG model. In other words, the CG mode was not 'painted,' nor was it given much surface detail as it would not b seen close up, and this saved costly computer rendering time.

Some of the money saved on the Gorn ship allowed the producers to spend their budget elsewhere, and c nice touch was with the Gorn creatu "We gave him an eye blink," said Ro

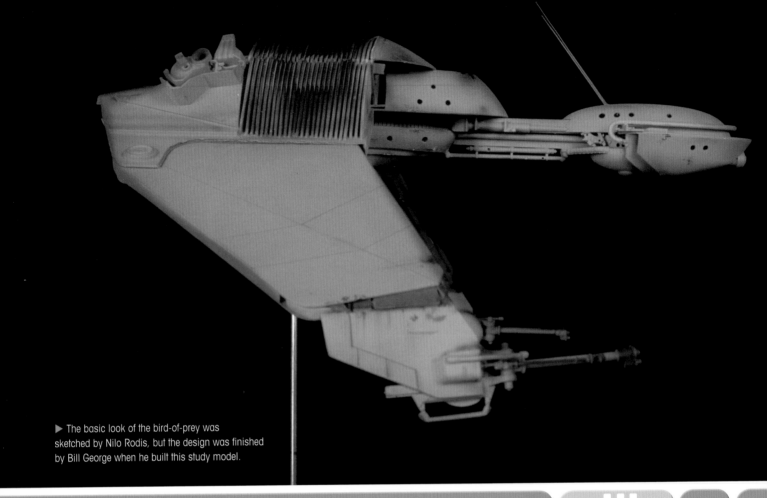

▶ The basic look of the bird-of-prey was sketched by Nilo Rodis, but the design was finished by Bill George when he built this study model.

DESIGNING THE

BIRD-OF-PREY

The look of the bird-of-prey presented a challenge as it was one of the first *STAR TREK* ships that wasn't designed for the original TV series.

With its huge articulated wings, sleek frame and distinctive painted underbelly, the Klingon bird-of-prey is easily one of the most recognizable of all *STAR TREK* ships. From its debut in *STAR TREK III: THE SEARCH FOR SPOCK* it has become a mainstay of the Klingon fleet but things could have been very different. The earliest story outlines for the movie featured the Romulans as the enemy. But director Leonard Nimoy decided

that since the Klingons had played a much bigger role in the original series they would be a better choice as the movie's villains.

Even though the Romulans had been dropped, Nimoy and producer Harve Bennett were still keen to use the name bird-of-prey since they felt it was evocative and gave a strong direction for the design. Even so, coming up with a ship that looked different to anything that had come before, while at the

same time being as visually striking as the *Enterprise,* was far from easy. The original Romulan bird-of-prey had featured in the original series episode 'Balance of Terror' but its design had been too simple and couldn't be used for a movie, so no one knew what this Klingon bird-of-prey should look like. Nimoy was keen for a brand-new design which would look like a bird on the attack – threatening and frightening. He even demonstrated the swooping

▶ The study model established the proportions and the basic shape but left the surface details, such as the raised plating on the wings, for the final filming model.

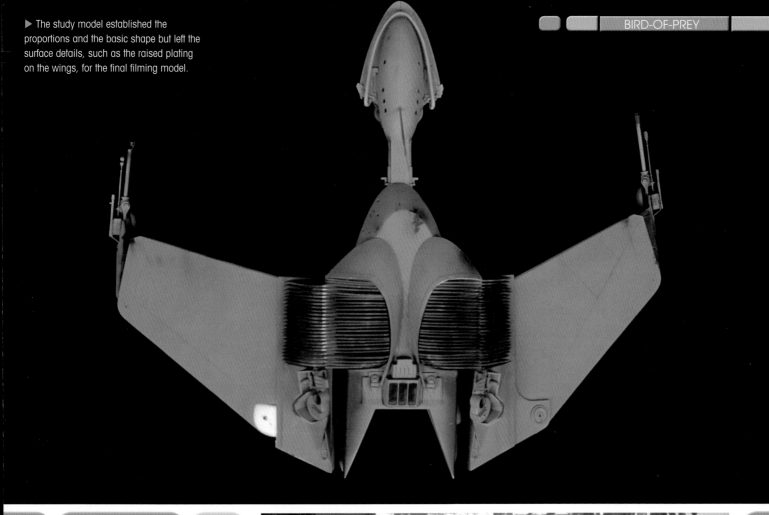

▶ Nimoy and the ILM team discuss the design of the bird-of-prey, while examining Nilo Rodis's concept drawings. Sadly the drawings have disappeared from the ILM and Paramount archives.

motion with his arms to the design team at Industrial Light and Magic.

MOVING TO ATTACK

At that same meeting the idea came out that the ship's wings should move into different positions — from cruising and then into an attacking position. Nimoy added that he wanted the ship to have an outstretched neck to add to the impression of a bird swooping down into the water in pursuit of its prey.

Visual effects art director Nilo Rodis, was shown both the Romulan bird-of-prey and the original Klingon battlecruiser and asked for a design.

At that point he'd never seen an episode of *STAR TREK* and knew next to nothing about Romulans, Klingons or their ships. He didn't feel particularly inspired by anything in the material until Nimoy handed him a picture of a Klingon warrior in full battle gear. Things then started to fall into place. Seeing the leather, metal and piping that made

up the elaborate Klingon uniforms, Rodis felt it was likely that Klingons would take a similar approach to their ships. To achieve the look he added a textured quality to the exterior of the ship that not only echoed the decorative uniforms but also gave the impression of metallic feathers lending the ship a somewhat gothic or art deco feel. It

also served to make the ship look as different as possible to the *Enterprise*, whose outer hull was smooth. To further emphasize the differences, Rodis gave the ship a bright green color, which again contrasted with the blue/grey of the *Enterprise*.

READY FOR WAR

Rodis got to work on a series of design studies incorporating both his and Nimoy's ideas. Being a war-loving species, he decided it was likely that Klingons would ensure that ships built for the purpose of raiding would carry as much weaponry as possible. So instead of just one gun, he placed weapons on either side of the wings and also in the nose. When Bennett explained that like the Romulans, the Klingon ships would also use a cloaking device, Rodis pitched the idea that when the ship decloaked the weapons would be the very first thing that materialised enabling the Klingons to appear with their guns blazing.

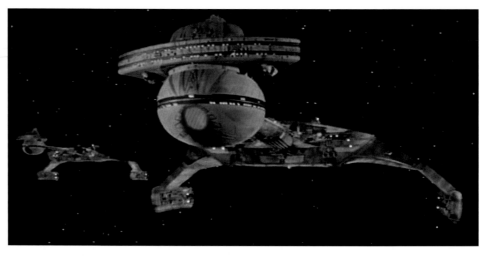

▲ The only established Klingon design that Nilo Rodis and Bill George could draw inspiration from was the Klingon battlecruiser, which had been upgraded for STAR TREK: THE MOTION PICTURE.

Once Nimoy and the rest of the production team had approved Rodis' sketches, modelmaker Bill George was then tasked with creating a study model. Although Rodis had established the bird-like proportions of head, neck and body, the design was far from complete, and Rodis had left plenty of room for interpretation, wanting George to bring his own particular brand of creativity to the project.

Along with sketches of the bird-of-prey, Rodis had also added a quick doodle of a big muscleman flexing his biceps in a downward motion. He explained to George that he wanted the finished ship to look something like a bodybuilder flexing the muscles in his biceps, or a brawny football player getting ready for a play. According to George, this abstract approach had a profound influence on

◄ ▲ Early versions of STAR TREK III had the Romulans as the villains, not the Klingons, so Bill George painted a wing pattern on the ship's underside as a tip of the hat to the original Romulan BIRD-OF-PREY.

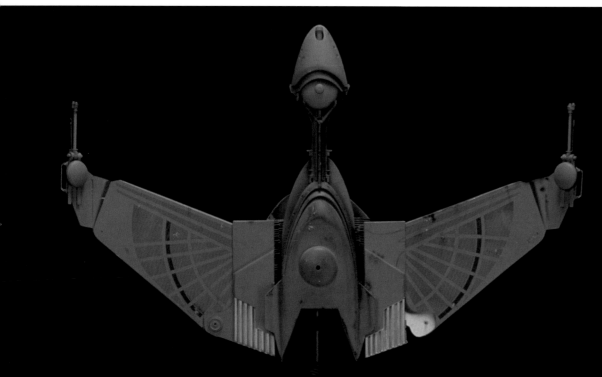

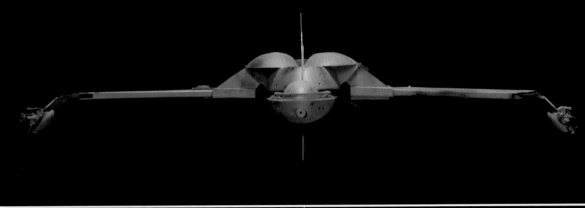

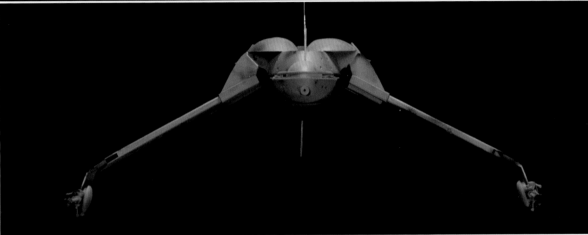

the design and he didn't hesitate to incorporate this idea with the basic proportions that he had been given. Running with the football theme, George added a chin guard to the ship's nose as well as massive shoulder pads to the base of the wings where they attached to the ship.

MUSCLEBOUND DESIGN

The wings were then placed in an attack position looking very like Rodis' idea of a posing muscleman. But while the 'shoulder pads' fitted in with Rodis' football concept, they made it difficult for the wings to move into the swooping and attack positions. George solved the problem by borrowing the interlocking 'radiator' feature found on old style radio sets. Acting as giant hinges, they enabled the wings to move up from a downward 'posing' position to that of a bird in full flight.

As a final touch, George, a long-time fan of the original series painted a

graphic on the underbelly as a tribute to the original Romulan bird-of-prey.

George's final model solidified the design, and he and Rodis shared the credit for the eventual design, which George describes as basically being three things in one "a football helmet, muscleman body and suitably threatening wings."

For Rodis what really mattered is that the design was so simple the basic shape could be drawn in only a few seconds and, as a result, it has gone on to become one of the most memorable ships in the *STAR TREK* universe.

▲ This angle with the wings down shows how the design was influenced by the silhouette of an American football player. The 'radiators' are the shoulder pads, the nose section is shaped like a helmet and even has a chin guard, with the wings echoing the shape of a muscleman flexing his arms.

" I was very interested in the idea that it should have this outstretched neck as though you would see a bird flying to attack a creature. "
Leonard Nimoy

DESIGNING

V'GER THE LIVING MACHINE

The massive alien craft around *V'Ger* was designed by the legendary Syd Mead, and was his first work for the big screen.

Syd Mead pulled into the Paramount lot in his Lincoln town car, a 19-foot-long, black and chrome monster that shone in the sun. As usual, he was dressed immaculately in subtly varying shades of beige, with a narrow tie and suede buckskin shoes. Once he'd parked, he made his way to the *STAR TREK* production offices. The movie's credits listed him as a production illustrator, but Mead (as everyone called him) didn't have much in common with the movie's other artists.

Today Mead is famous as the man who designed

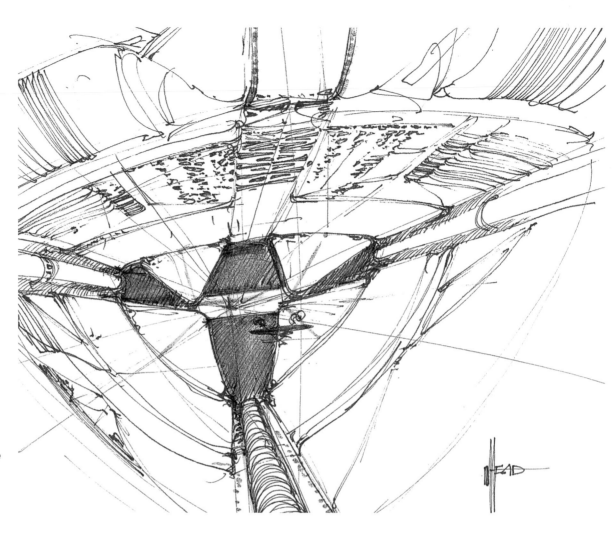

▶ The first sketch Mead produced showed *V'Ger* swallowing the *Enterprise* like a "giant tapeworm."

the spinner cars for *Blade Runner* and the spaceship Sulacco in *Aliens*. But in 1978 he had never worked on a movie. Instead he was one of the world's most admired industrial designers and architectural illustrators. His work for US Steel had caught visual effects supervisor John Dykstra's attention, inspiring him to ask Mead to join the *STAR TREK: THE MOTION PICTURE* design team.

Mead thought it would be a "nice side job," so he accepted Dykstra's offer.

Mead's task was to design *V'Ger,* the giant 'starship' that was destroying everything in its path as it headed toward Earth. He remembers that he had started work even before he came out to the studio. "In the very first phone call, Bob Shepherd (Dykstra's partner at Apogee) said, 'We

▶ A version of *V'Ger* had already been designed by the original VFX house, Robert Abel and Associates. It was long and squidlike, but would be abandoned in favor of a new design.

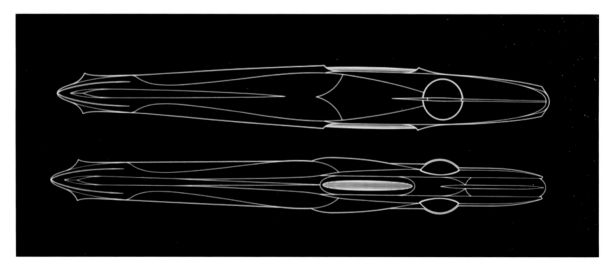

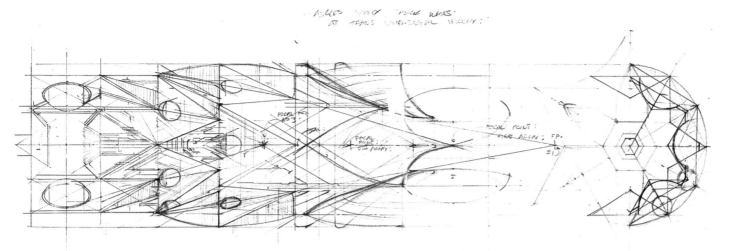

got this thing coming; it's got a big mouth and it swallows the *Enterprise.'* After I hung up the phone I did this triangular sketch; I thought how cool it was to have this triangular (thing), which was sort of like a tapeworm, if you take insect morphology and expand it to a huge, huge size."

That first sketch was abandoned as soon as Mead met with Dykstra, director Robert Wise, and the movie's producers. They explained that work had already begun on *V'Ger,* but they weren't happy with the direction that the original effects house, Robert Abel and Associates, had taken. "Abel were going to do something with vector graphics, a kind of primitive computer animation," Mead explains. "Wise wanted something more solidly visual. When you photograph a real object, the film picks up perspective and the slight depth

of field shift, which computers have only recently been able to do.

STRANGE CREATURE

"I never saw the computer-generated stuff; I did see a very curious clay model which they had. It was about two feet long. It looked like this sort of stretched-out squid thing. It didn't look very impressive to me. So John said, 'Let's see what you can do.'"

The Abel version of *V'Ger* only provided Mead with an idea of what Robert Wise didn't want; fortunately Trumbull – who was heading up the movie's VFX – had commissioned something that was more promising. This was the *V'Ger* maw, which literally swallows the *Enterprise.* It was a series of interlocking cardboard cones that rotated

▲ Mead's concept was based on a hexagon which he twisted to produce a variety of interesting shapes.

▶ *V'Ger* in its entirety. The *Enterprise* approaches it from the right and flies over the top before turning around and entering through the maw on the left.

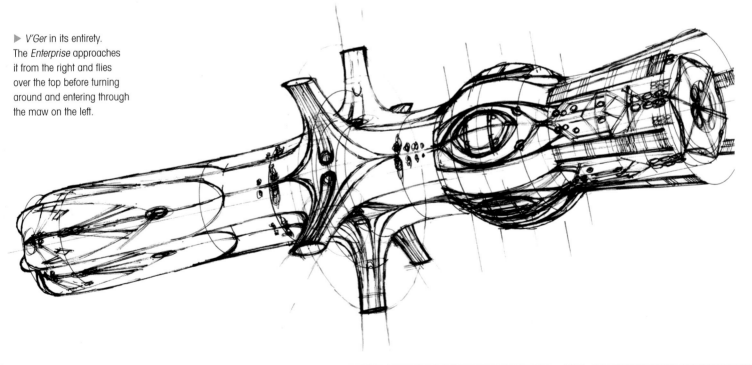

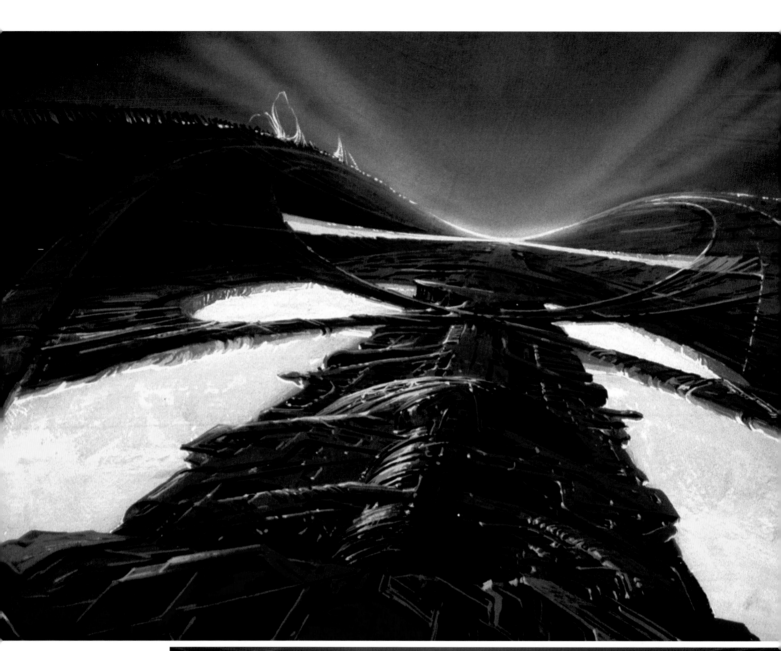

▲▶ Mead labelled this artwork "forward valley." The fins and walkways were all spun off the basic hexagonal shape. As the image on the right shows, Mead's artwork was closely replicated in the movie.

to create an opening, and it was designed by Ron Resch. Mead says this was all the inspiration he needed. "John said, 'Well, we got this mechanical device that Paramount had paid for.' I saw it and I thought, 'That's fascinating. This hexagon opens up as six cones revolve together. I thought, 'That's really hot.'

"So I went back to my beach house. I was thinking about this thing all the way as I was driving along; I thought, 'The secret is to keep this hexagonal geometry intact, because it is one of nature's natural composites anyway.' Then I thought about twisting it. So, using that hexagonal geometry as a section, all I did really was determine a nice proportion for *V'Ger*, then I twisted that hexagonal axis one complete turn

from front to back. That generated all the arches, curves, and the fins, all of that, for the design."

A few weeks after he'd started work, Mead came to Paramount for a meeting. He says that at this point he had no idea that the producers were under such incredible pressure to get the movie ready for its December release, and adds that he knew very little about the movie business.

WORLDWIDE POWER

"I was in a meeting. There was Robert Wise, and (producer, Jeffrey) Katzenberg, and John and all these other people. John said, 'Mead can have the sketches ready by next week.' I said, very matter of fact, 'Well, I'm leaving for Europe tomorrow.' And, they said, 'How long?' I said it

▲ Mead called this area the "power valley." It has glowing lakes of energy that indicated the vast amounts of energy generated by the mysterious vessel.

▲ In the middle of *V'Ger* there was a giant sphere, which housed the original probe that had left Earth.

would be probably a week or two. Katzenberg, without dropping a beat, turned around to some minion and said, 'Have our Amsterdam office send a courier down to Mead's hotel, pick up the sketches every other day, and bring them back here.' So I thought, 'Well, this is how it works,' and I flew off to Amsterdam. I'd work for Philips,

Eindhoven all the day, then come back and do *V'Ger* sketches at night in the hotel room. Then I'd leave them with the concierge and they'd be picked up and couriered back to Hollywood."

Over the next few months, Mead continued his regular career, producing illustrations for his established clients and generating *V'Ger* concepts

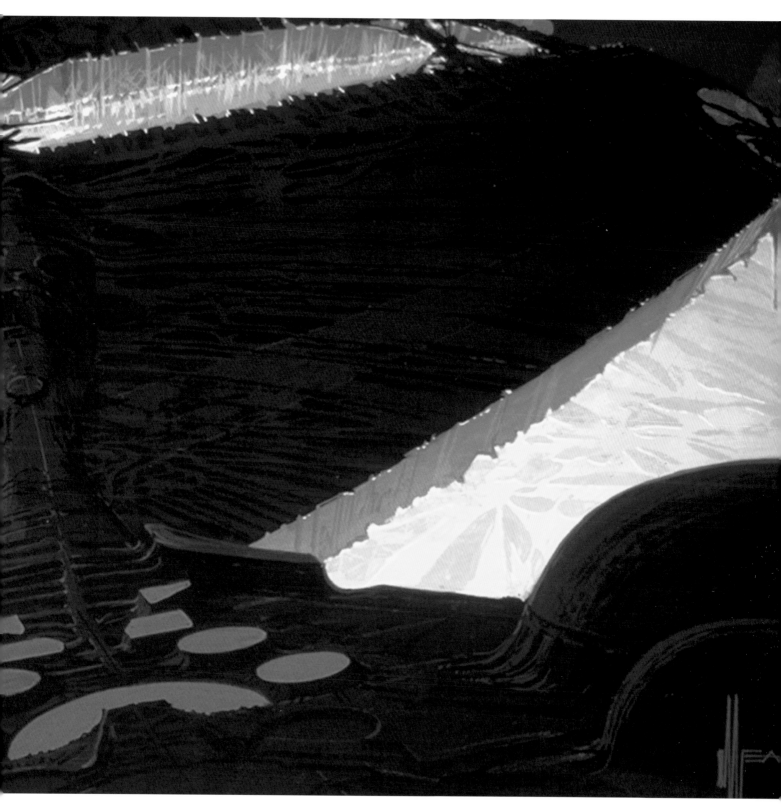

in his spare time, sometimes in hotel rooms, sometimes at his home, sometimes even on his lap on an airplane; in fact, he points to one sketch that has an ink blot where the plane hit a little turbulence and he spilt his drink.

Normally, a concept artist will only produce a handful of quick sketches that can be used as an inspiration for model builders, but Mead remembers that, since *TMP* was his first movie, he produced far more than was strictly necessary. "I'm hired essentially to cook up ideas that are tailored to a very specific demand. In the movie industry you are working with people who can look at a drawing and actually know what it is. You can

▲ The maw had already been designed when Mead joined the production but he incorporated in his paintings, which showed the *Enterprise's* entire journey around the machine.

show them a sketch and they get it right away, then you can track in the direction everyone is happy with. I've done those kind of sketches on napkins; just with Pentel pens, as those can be faxed because they are black and white. Then you go to the next stage, which is probably an accented shaded drawing using felt tip markers. Then, if they pay me, I'll go to full color.

"This was my first movie, and I just went ahead and did the color. I was painting all day long on other jobs. Now, because I don't paint all day long, every day, I have to get back into the synaptic brain-to-hand thing. Back then it was so fluid and easy, and I was being paid by other agencies a lot to do renderings, so I wasn't losing money in terms of the corporate income stream."

Despite the unorthodox working conditions, Mead is full of praise for the people he worked with, from John Dykstra to Robert Wise. As he explains, the vital thing was that they were very clear about what they wanted. "The nice thing about all the movies I've worked on is that I get accurate information, which is usually the script, and a one-on-one with the director and the primaries involved. On all the movies I've worked on to date, there have only been one or two changes ever in the presented sketches. Second pass for sure you'd get it.

"The interesting thing on this movie was we had a meeting after I got back from Holland; I'd brought some sketches with me, which were the early stage of designing the surface – it's actually

the part I call the valley. Because of the hexagonal geometry, I had ridges that separated the six surfaces, which were all identical. Of course, John only had to make a model of one of them. We were sitting in the meeting. Robert Wise had seen the sketches, but it looked too mechanical to him. He said, 'It looks like a bridge or ironwork or something.'

"Robert Wise is the grand gentleman director of Hollywood. He's very quiet, and never screams or hollers like some people; he's very soft-spoken. He handed out little slips of paper from the script to remind people what we were after. The slip I got said, 'They were looking at something no man had ever seen before.' That was my job to invent that! It drove me to invent the eventual look, with the organic and mechanical combined."

INSIDE THE BEAST

Mead responded to Wise's request by increasing the sense of 'layering' in his concepts. As he explains, the idea was that the original *Voyager* VI was being transported by an enormous craft that had been built for it by a race of machines. "During the journey it had added to itself in some abstract rule geometry-wise," Mead says. "That's why it was a combination of organic – sort of splattered – detail wrapped over curved, warped surfaces. That was the final design."

Mead produced a number of finished paintings that showed the surface of *V'Ger* in considerable detail. Rather than simply showing the shapes and forms on *V'Ger*'s surface, they were used to show what kind of impression the enormous ship would make. When he was finished, Dykstra asked him to turn his attention to the chambers inside

◀ Mead produced this vertical piece of artwork before he knew how the *Enterprise* would approach *V'Ger*. In the final movie the image was turned through 90 degrees.

V'Ger, which were being supervised by Trumbull. Mead says that, basically, his approach was just an extrapolation of his designs for the exterior.

"I thought, 'I've got the outside, and obviously you'd repeat the same hexagonal geometry inside.' Reading the script, you had an entry chamber, which was apparently the largest of the chambers, then you had another chamber, and finally the sphere where *V'Ger* was docked. So I just started to design something that was supposed to be a wide array scanner and signal interceptor and gatherer. That's why I came up with the interior geometry, which was essentially, in section, a series of moving focal points for a focusing signal at one end."

In the Director's Edition of *STAR TREK: THE MOTION PICTURE* (released in 2002) we actually got to see *V'Ger* in its entirety, but in the 1979 release the audience was never given a clear idea of the overall shape. At least in part this was because *V'Ger* was so large that it would be impossible to stand far enough back to see it all. However, Mead remembers that he had actually developed a solution to this problem.

"I did a special effects shot for Doug Trumbull toward the end of post production. He said, 'Wise wants to show how big this thing is relative to Earth,' so I did a picture of *V'Ger* floating in space throwing its shadow across the surface of the moon to show how big it was." Sadly, the schedule was so tight that the shot couldn't be completed in time, and even the painting itself was lost – Mead hasn't seen it since he handed it over to Trumbull.

MOVIE HISTORY

Mead never worked on *STAR TREK* again – though he remembers that he almost agreed to design the *U.S.S. Enterprise* NCC-1701-D for Gene Roddenberry – but *STAR TREK: THE MOTION PICTURE* did introduce him to the movies, which have provided him with "nice little side jobs" for the last 20 years.

His work can be seen in the movies *Tron, Blade Runner, Aliens, 2010, Johnny Mnemonic, Mission to Mars* and *Tomorrowland*. But it all began with *V'Ger* and Robert Wise's request for "something no man had ever seen before."

DESIGNING THE
TRIP INSIDE V'GER

When Spock steps inside *V'Ger* he takes a trip through the countless worlds the machine has visited on its quest to find its creator.

While John Dykstra and Syd Mead were working on designing *V'Ger's* exterior, Doug Trumbull was concentrating on Spock's journey inside the "living machine." To help him develop the concepts, which needed to be visually stunning, Trumbull called upon one of the most admired illustrators in America.

Robert McCall, who died in 2010, is best known for his work illustrating the real-world space program, but over the years he had also contributed to several films including *2001: A Space Odyssey.*

It was when he was working with Stanley Kubrick that he first met Trumbull, and the two men became firm friends. *McCall* enormously

enjoyed his work on *2001,* so he was delighted when Trumbull called and asked him to join the team in Santa Monica that was creating the visual effects for *STAR TREK: THE MOTION PICTURE.* He was given his own studio on the second floor of the building, and spent three months or so working on concepts for the space walk.

◄▲ McCall started by producing a series of quick sketches which he later worked up into fully developed paintings. And (left) the *Enterprise* inside *V'Ger* near the gateway that Spock will journey through.

'maw' was often used, these were the entranceways Spock would travel through to whole new universes."

In addition to these 'gateways', McCall produced paintings showing the 'digitised' Klingon ships, and a massive replica of Ilia with the sphere that Spock eventually uses to mindmeld with *V'Ger*.

FINISHED PAINTINGS

McCall added that he and Doug Trumbull had enormous mutual admiration for one another, and that he was determined to produce something spectacular. "I was so motivated and so anxious to create some really special and unique stuff. I think it was

"I was creating other worlds – and especially other universes – that could be part of the trip that Spock takes," he recalled in an interview conducted for the Director's Edition of the movie. "He approaches several of these doorways to other worlds, other universes. I saw the rushes each day and participated in every way that I could. I just provided

them with a profusion of ideas. It was an intense few months.

"Robert Wise would drop by from time to time, but I worked directly with Doug; he was the man I was trying to please. I knew what we were looking for, which was these entities that were hovering in space – huge, baby – they could have been a thousand miles across. The word

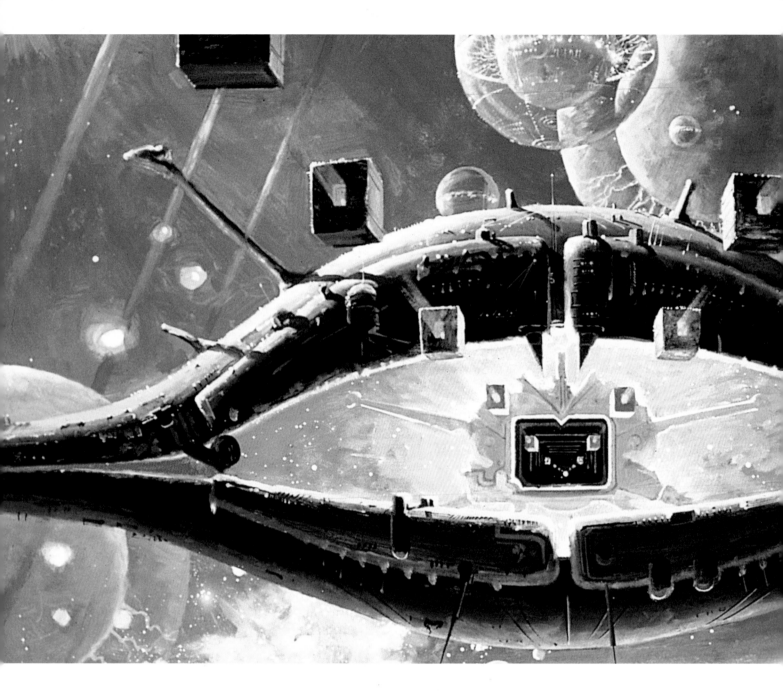

aesthetically a very high level of work."

In fact, the high standard McCall was working to is quite unusual in movies. Concept work is normally generated at speed, and consists of little more than quick sketches that can be produced in an afternoon. McCall, however, created fully painted images in acrylics, two of which are now in the Smithsonian Air and Space Museum.

WORKING QUICKLY

Despite this approach, he said that he worked at great pace. "They were very spontaneous; I would spend maybe just two days on some of them. I was trying to paint in a way that would be provocative and fascinating and I was amazed at how successful – color-wise and aesthetically – they were. I had a lot of masonite panels prepared. The surface was colored: I had some that were black and some that were white, which is what I usually paint on. I had a whole bunch of them so I would always have a clean canvas, if you will, to start a new painting whenever an idea came along."

These unusually finished paintings were intended to provide inspiration to the modelmakers, and McCall recalled that he was always careful to paint things that could actually be built. However, Trumbull was so impressed with some of the paintings that he tried filming them to see if he could use the actual paintings in the movie. Sadly, this approach proved to be impractical. "It just did not work," McCall remembered, "because my paintings aren't like matte paintings – they're freer, the brush work is visible, so the only

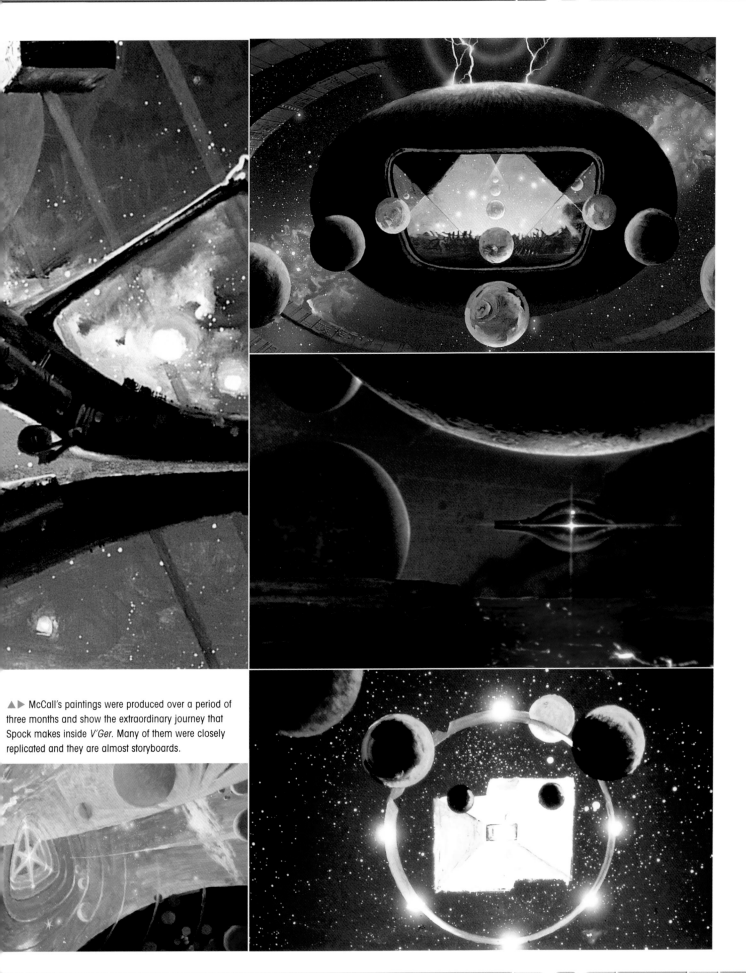

▲ ▶ McCall's paintings were produced over a period of three months and show the extraordinary journey that Spock makes inside *V'Ger*. Many of them were closely replicated and they are almost storyboards.

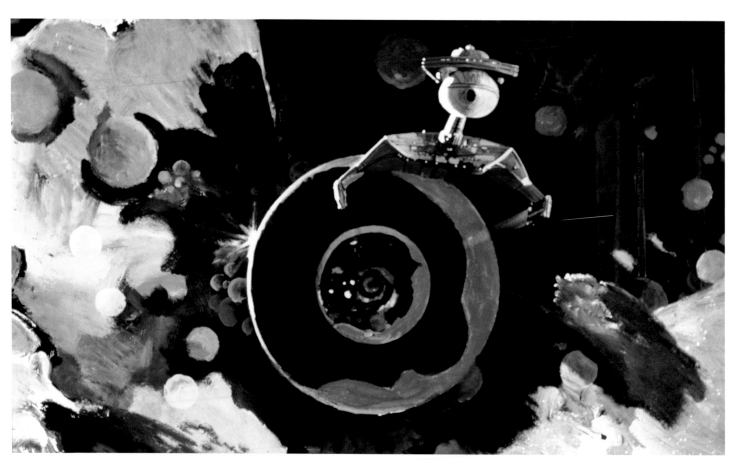

▲▼ On his journey Spock encounters many of the things that *V'Ger* has recorded on its journey, including the three Klingon ships that were 'destroyed' in the opening sequence.

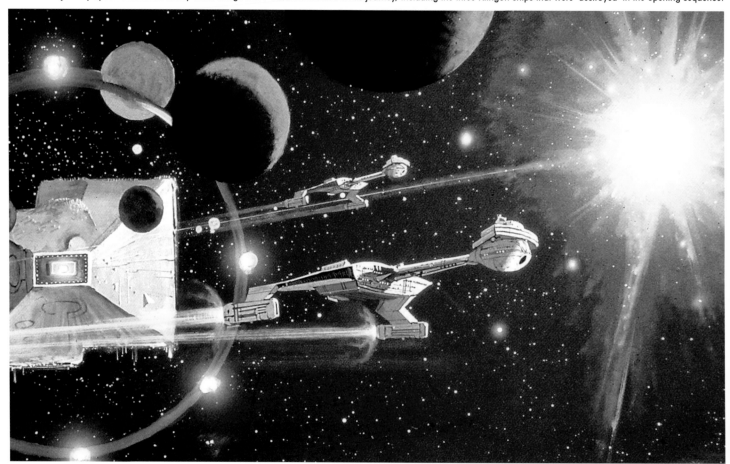

▲▼ Much of what McCall designed was a series of gateways that transport Spock through different worlds inside the massive *V'Ger*.

way my work was used was as an inspiration for the model makers. I think two, maybe three of my paintings were actually translated into 3D models, which were maybe 10 feet from tip to tip, with a bizarre, exotic entranceway that I thought was really neat. There was one in particular that was quite close to my painting. They appear in the film so briefly that one really doesn't get a chance to see them successfully."

Given that his work spends so little time on screen, McCall said he thought that the studio might find another use for some of the paintings. "I kept thinking 'They're going to pick up these images and make some of them into posters,' but it never happened, to my amazement, because they are superb pieces and spontaneously created. I'm not being immodest when I say these are powerful images."

Many of the paintings were eventually

published in McCall's book, *Visions of the Future,* and some of them were part of a traveling exhibit of his work.

For more information about Robert McCall and his work, visit www.mccallstudios.com

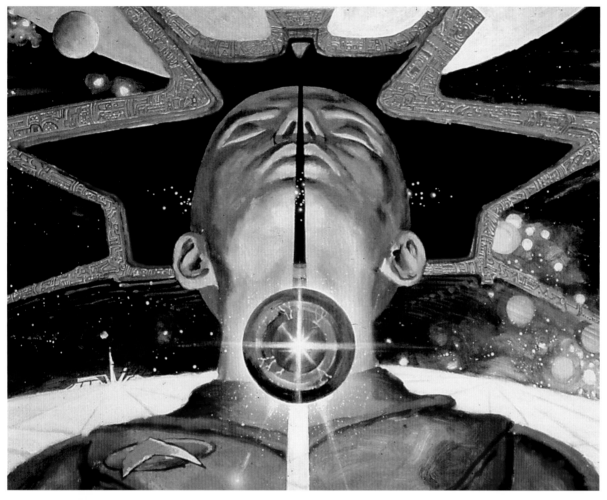

◄ At the climax of his journey, Spock encounters a massive, digitised record of Ilia, who *V'Ger* has scanned and replaced with a probe.

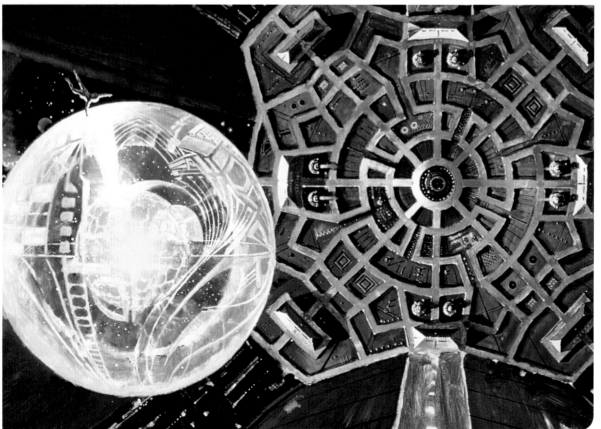

◄ Look closely and you will see a tiny Spock mind-melding with the spherical probe.

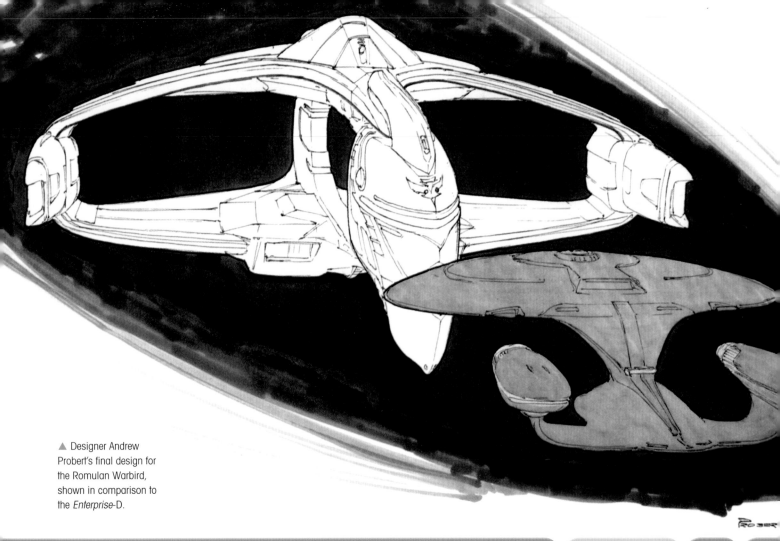

▲ Designer Andrew Probert's final design for the Romulan Warbird, shown in comparison to the *Enterprise*-D.

DESIGNING THE
ROMULAN WAR

The Romulan Warbird was one of the first major alien ships to be designed for *STAR TREK: THE NEXT GENERATION*. The menacing vessel made its debut in the closing moments of the first season, as the Romulans shimmer into view in front of Picard and announce that they are back.

Like almost every other ship in *TNG*'s first season, it was designed by Andrew Probert. At such an early stage in *STAR TREK*'s rebirth he had relatively little to work with, so he began by sketching the basic shapes of the few established *STAR TREK* ships – the Romulan and Klingon birds-of-prey, his own designs

for the Ferengi *Marauder* and, of course, the *Enterprise*-D. These ships all had some basic elements in common: twin warp engines separated from a command section by a long neck.

STAR TREK PHYSICS

Probert also had certain rules for starship design that he had discussed with Gene Roddenberry. One of these rules was that a starship's warp engines always operated in pairs. This 'rule' was never formally established on the show, and would be broken in the future, but at the time it was used to inform all the designs. Probert added another twist

to the rule by deciding that the warp engines should always be able to 'see' one another. In other words, there should be nothing between them. He theorised that this was necessary for them to generate a warp field.

After sketching the established ships he started to doodle various possible shapes as he looked for a direction. Probert had a long-standing interest in experimental aircraft where the wings were connected to the tail section, and from the very beginning he was interested in the idea that the engines might be contained on a ring. Whether deliberately or not, this approach

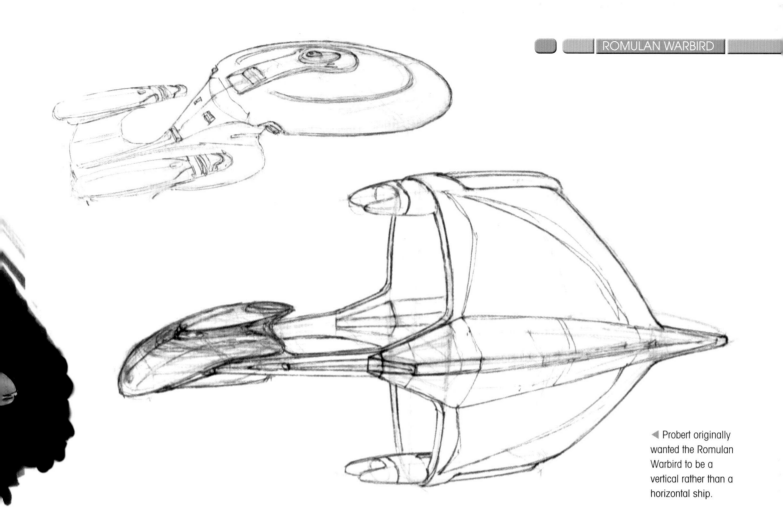

◀ Probert originally wanted the Romulan Warbird to be a vertical rather than a horizontal ship.

BIRD

◀ One of the ideas that Probert explored was that the engines would be arranged in a ring, which was something Matt Jefferies had experimented with when he designed the original *Enterprise*.

▲ Probert's first set of doodles as he tried to find an interesting shape for the Romulan ship. The top left of the page shows the shapes of the handful of ships that existed at the time.

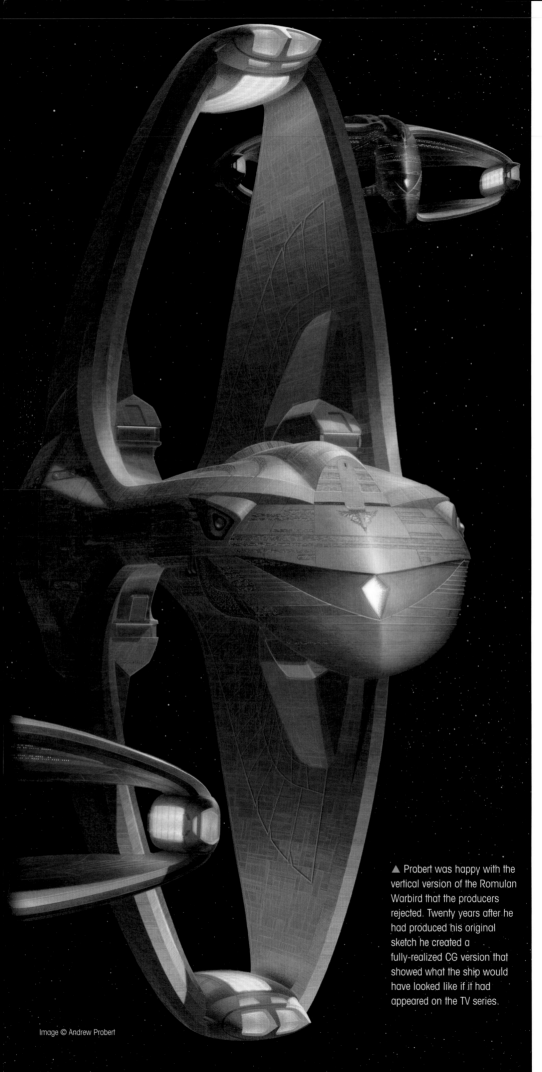

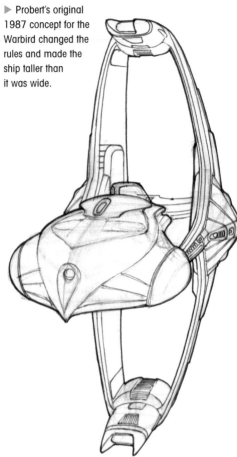

▲ Probert was happy with the vertical version of the Romulan Warbird that the producers rejected. Twenty years after he had produced his original sketch he created a fully-realized CG version that showed what the ship would have looked like if it had appeared on the TV series.

▶ Probert's original 1987 concept for the Warbird changed the rules and made the ship taller than it was wide.

echoed some of Matt Jefferies early thoughts about Kirk's *Enterprise*. Nearly 25 years after he produced the drawings Probert is fascinated to see a doodle that looks like one of Matt Jefferies's early designs for the *Enterprise* snuggling in the centre of his early Warbird sketches. He doesn't recall having consciously echoed Jefferies' design and thinks it is equally likely that he and Jefferies shared a fascination with experimental aircraft. However, Probert is something of a *STAR TREK* aficionado, and remembers taking great pains to tie his designs for *TNG* to the original series wherever possible.

As he worked, Probert realized that the rules he'd discussed with Roddenberry didn't say anything about ships having to be wider than they were tall. This idea fascinated him and he started to work up a design where the engines were positioned above and below the main body of the ship

rather than on the left and the right. He combined this with the idea of the engines being on a ring and soon produced a design that he liked. In order to give the Romulans a real sense of menace, the Romulan ship absolutely dwarfed the new *Enterprise.*

However, Probert's design was a little too radical for *TNG*'s producers. They liked a lot of what they saw but wanted the Romulan ship to have roughly the same proportions as the *Enterprise*-D. So Probert took his drawing and turned the engine section through 90 degrees. He then carried on working up details, altering the shape of the head so it became a little less obviously birdlike.

HIDDEN FEATURES

Looking back over his drawings he explained the intention behind several design features that were never actually used on screen: the V-shape on the front of the nose was meant to be the navigational deflector (an essential element of any faster-than-light ship that sweeps a path in front of it); the indentations on the bottom of the ring were twin cargo bays. The 'hump' on the top of the ring was main

engineering; the 'scales' that run down the back of the ship behind it were escape pods; and the notch at the top of the back was the shuttlebay.

MISSING IN ACTION

Time was short by now as the season was drawing to a close and a few details were left off Probert's drawings, including the impulse engines, which he explained would have been on either side of the spar at the rear. One other detail was lost when the drawings went over to Greg Jein, who built the model. If you look at Probert's drawings you can see that the *Warbird* has a cyclops-like eye at the front of the nose. This was meant to be the bridge.

The *Warbird* went on to become one of the most used ship designs in the history of *STAR TREK*, making appearances in both *STAR TREK: DEEP SPACE NINE* and *STAR TREK: VOYAGER,* but Probert always had a fondness for his original vertical design. Years later he got the chance to take it a stage further by creating a fully-realized version of it for the *STAR TREK: Ships of the Line* calendars, finally bringing his original concept to life.

▼ The final Andy Probert design for the Warbird that was approved by the producers.

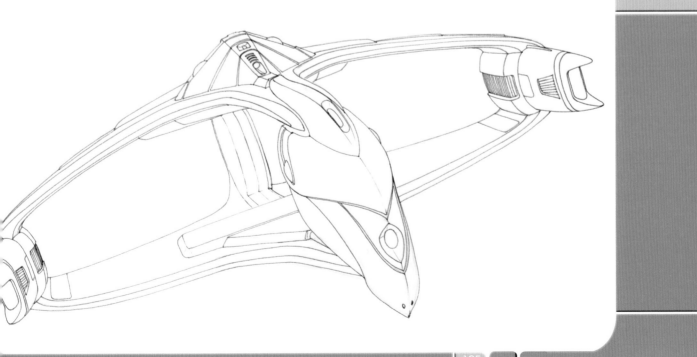

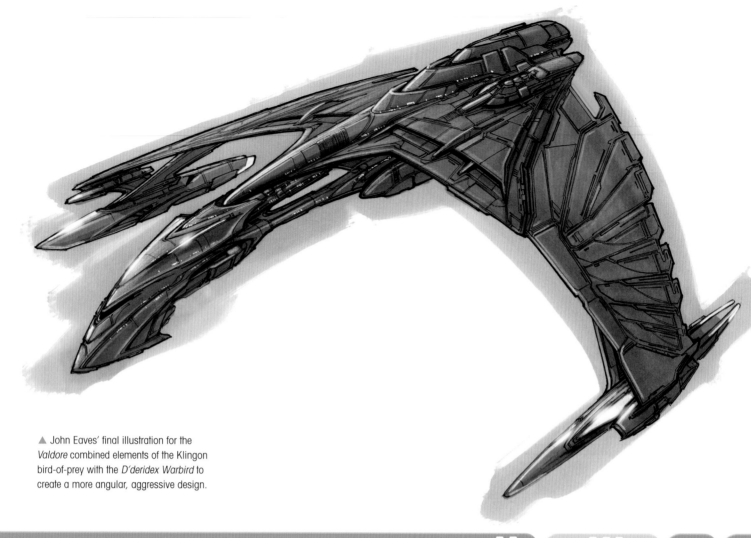

▲ John Eaves' final illustration for the *Valdore* combined elements of the Klingon bird-of-prey with the *D'deridex Warbird* to create a more angular, aggressive design.

VALDORE

A new design of Romulan warbird was required for *STAR TREK NEMESIS*, and as John Eaves explains, he turned to the classics for inspiration.

Concept illustrator John Eaves has worked on a total of seven *STAR TREK* movies, devising design concepts for everything from the *U.S.S. Enterprise* NCC-1701-E to Klingon weapons. *STAR TREK NEMESIS* generated a particularly heavy workload for Eaves, and among the many assignments he was given, he was asked to come up with a new version of the Romulan warbird.

The Romulans had been well

established on television, and they already had a very distinctive ship in the giant *D'deridex Warbird*. This vessel, however, had been in use ever since the end of *STAR TREK: THE NEXT GENERATION*'s first season, and the producers wanted to see something completely new in the movie.

Eaves said, "The producers never wanted to use *THE NEXT GENERATION* Romulan warbird. They wanted something completely new. I'd talked

▲ Illustrator David Negron Jr. came up with this sketch showing the underbelly of his design for the warbird.

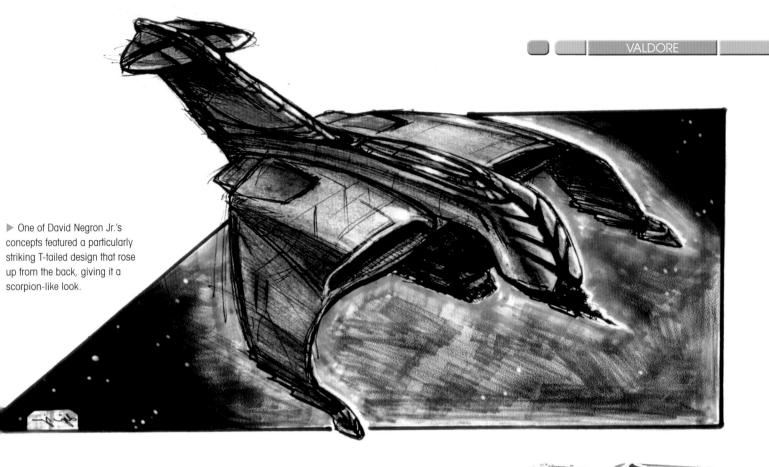

► One of David Negron Jr.'s concepts featured a particularly striking T-tailed design that rose up from the back, giving it a scorpion-like look.

► Another of David Negron Jr.'s concepts for the *Valdore* showed its scale next to the *U.S.S. Enterprise* NCC-1701-E. Despite being a compacted, muscular design, this illustration shows it was intended to be much larger than Starfleet's most well-known ship.

to a bunch of guys who worked on *STAR TREK* over the years, and one of the things I'd found out was that the bird-of-prey in *STAR TREK III* was originally supposed to be a Romulan ship.

"Due to budget concerns they kept the ship, but turned it into a Klingon vessel because Paramount had a surplus of Klingon costumes to use instead of buying new outfits and make-up. Thus the Klingons were piloting a bird-of-prey. It was a fantastic design and it had always been one of my favorites, so I thought, 'Well, I'll take that and rearrange it a little bit.' Then I took the cowling from the front of the *TNG*

Warbird that illustrator Andy Probert had designed and incorporated it with my new kind of stylized bird-of-prey. So, it was kind of a progression of the bird-of-prey and Andy's warbird."

ALTERNATIVE DESIGN
While Eaves was busy sketching out some concepts for the new Romulan warbird that would eventually become the *Valdore*, his boss, production designer Herman Zimmerman, also commissioned illustrator David Negron Jr. to come up with some designs for the same ship. Negron Jr. was working independently of Eaves at a different

location, and it was hoped that this arrangement would lead to a variety of different looks for a new warbird from which the final design would be chosen.

"David (Negron Jr.) came up with a very aggressive 'T-tailed' design that incorporated some of the lines from Andy Probert's TNG warbird," said Eaves. "He compacted the design, and I really liked the interpretation he came up with. For the sketches I was working on, I ran to Andy Probert's ship for an architectural lineage to use as the cornerstone for the renderings. A single page of three or four ideas went over to an art meeting, and Herman

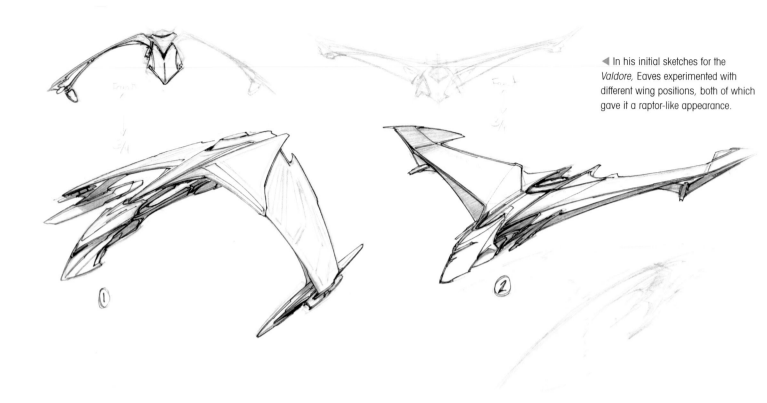

◀ In his initial sketches for the *Valdore*, Eaves experimented with different wing positions, both of which gave it a raptor-like appearance.

Zimmerman came back with a circle around one of the drawings that said they wanted to see more on that one."

Eaves then went back to his desk and worked up some more detailed sketches based on the design which Zimmerman and the producers had chosen, including some with exterior panels that featured a feather pattern.

"It was really fun," said Eaves. "When we were doing the drawing, we got a bunch of books on hawks and condors and stuff. They have a really unique feather pattern. I incorporated those very literally into the wings. When I looked at (visual effects art director) Nilo Rodis's design for the bird-of-prey from *STAR TREK III*, he had the exact same books because they matched perfectly. So, I took all mine off and redid them so they would be different."

After Eaves had come up with a unique feather pattern for the panels on the hull, he turned his attention to the belly details and the warp nacelles.

REPOSITIONED NACELLES

"There were going to be secondary warp nacelles attached to the lower hull of the ship," said Eaves. "The design aesthetics were to further the original backstory that they were a special type of nacelle to be used when the ship was cloaked so that its wake trail would not be traceable. As far as this detail went, I wasn't happy with how the nacelles in this position obscured the sweeping lines of the ship. In the end, I removed the nacelles from here and started working in a subtle arched bi-wing. The extra wing added a good break-up to the forward view and helped tie in with the design flow that Andy (Probert) had come up with for *TNG*."

Once Eaves's design for the *Valdore* had been approved, his drawings were sent off to the special effects house Digital Domain where Andy Wilkoff created the digital version of the ship. As with all the ships Eaves designed for

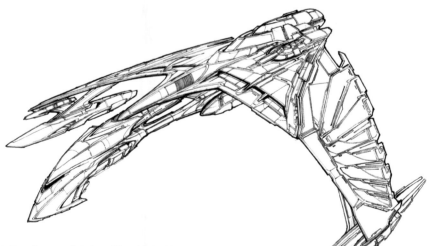

▲ Once the overall design of the ship had been approved by the producers, Eaves worked up a super-intricate pattern on the hull plating.

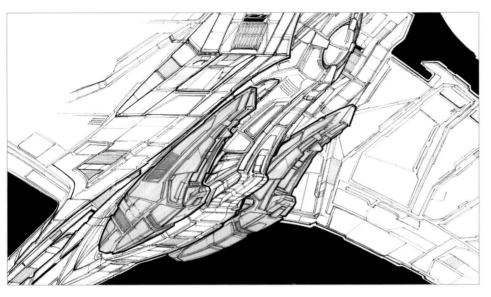

◄ Eaves put the secondary warp nacelles on the underside of the ship to begin with, but he felt that this spoiled the lines of the design, so he moved them to the ends of the outer wings on the final version of the ship.

STAR TREK, he greatly enjoyed the collaboration of working with the CG artist and encouraged him to add his own creativity to the design. "Andy Wilkoff was the modeler on the *Valdore*," said Eaves. "We'd meet quite often and he'd say, 'What do you think of this?' Even though the sketches had to be fairly finished for the approval process, I still liked it when we'd work with the model guy and say, 'This is the rough. Feel free to use your imagination.' That collaboration is really a lot of fun. Plus they'd add stuff that was really cool."

Despite having designed the *Valdore* himself, Eaves was totally blown away by the final CG version of the ship. He was particularly impressed by the fact that Wilkoff had managed to add a personality to the *Valdore* that he felt was not there in the drawings, elevating it into one of the best designs he had worked on. "This ship is one of my all time favorites," said Eaves, "and the modeling work was beyond incredible."

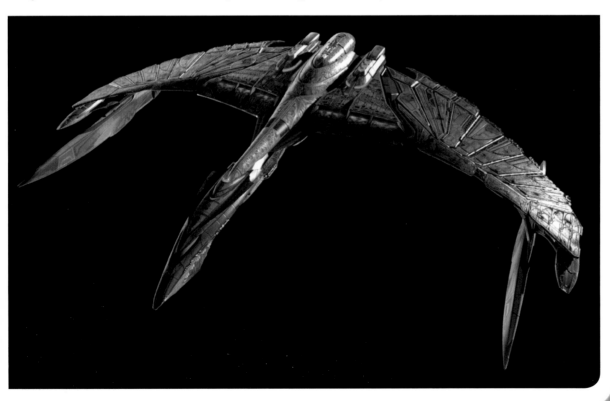

◄ The CG model of the *Valdore* was created by Andy Wilkoff at the computer graphics company Digital Domain.

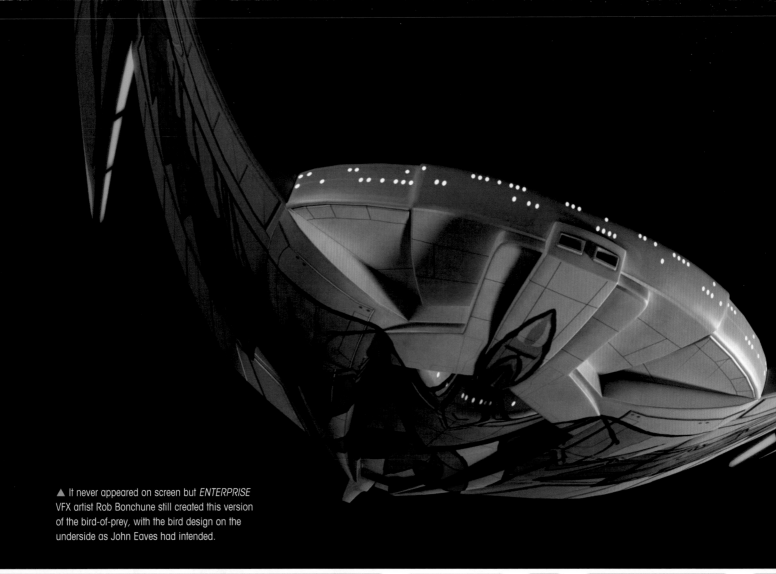

▲ It never appeared on screen but *ENTERPRISE* VFX artist Rob Bonchune still created this version of the bird-of-prey, with the bird design on the underside as John Eaves had intended.

ROMULAN BIRD-O

The Romulan bird-of-prey was the first new Romulan ship to feature in *STAR TREK: ENTERPRISE*. Production illustrator John Eaves was responsible for developing the design of this 22nd-century ship, and, as with the earlier Klingon vessels he had developed for *ENTERPRISE*, he was enormously excited to envisage a new starship for one of *STAR TREK*'s classic races.

"The art department was again filled with glee at the prospect of bringing in a legendary adversary to the latest version of *STAR TREK*," said John Eaves.

"Immediately the consensus was to retro-out Wah Chang's original design for our episode, as we had done with Matt Jefferies' Klingon battle cruiser that featured in the episode 'Unexpected.'

DESIGN LEGEND
One of the reasons that Eaves was such an ideal candidate to take on this task was that he was thoroughly acquainted with the history of *STAR TREK* design. He knew that Hawaiian designer and sculptor Wah Ming Chang was one of the great unsung heroes of

THE ORIGINAL SERIES. Largely unknown at the time, Chang had contributed numerous props and creature designs to the classic series, some of his most iconic creations being the phaser, the communicator, the tricorder, the Gorn and the tribble. Chang also designed and built the 23rd-century Romulan bird-of-prey that appeared in the episode 'Balance of Terror.'

Eaves knew that the bird-of-prey he was designing for *ENTERPRISE* had to pay homage to Chang's celebrated creation. "The Wah Chang ship was

► *THE ORIGINAL SERIES* Romulan bird-of-prey studio model was designed and built by Wah Chang in just two weeks. It was delivered unpainted and the bird graphic was added later.

► Chang's bird-of-prey model was constructed out of vacuum-formed plastic, plaster and metal parts. It featured internal wiring for the lighting and measured approximately 2.5 feet in width.

PREY

▼ John Eaves' initial sketches for the 22nd-century bird-of-prey featured fin attachments on the outside of the nacelles.

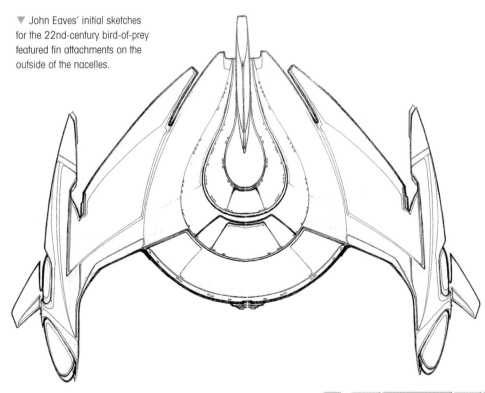

always a favorite," said Eaves, "so I didn't want to veer too far from it, but I wanted to do a phase prior to *THE ORIGINAL SERIES* version. I followed his lines a little bit, and then added more segregation on the parts of the hull."

Segmenting the different parts of the ship – where one section can be seen joining to another section – was a key aspect of a successful design for Eaves as it made the ship look slightly older, but also dynamic. Besides, the smooth hull appearance of Chang's 1960s design would not have worked with

modern visual effects. "With today's technology," said Eaves, "you can't go to the old 1960s style because the ships just wouldn't look right. You always have to design something that matches today's visual-effects style. The VFX guys always wanted deep shadows and detail lines to help make the ship look authentic on screen. Something that was completely smooth, like Chang's design was, would never make it through the approval process today."

One of the details that Eaves added in his initial designs was little wing fins

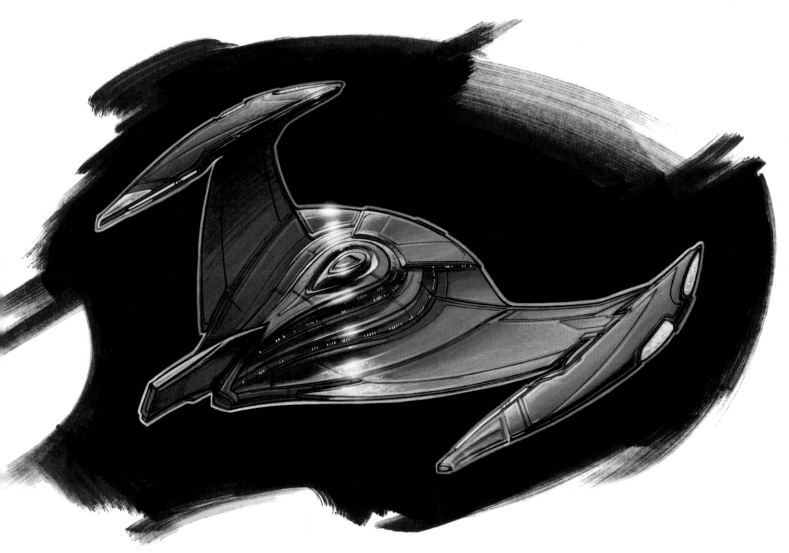

on the side of the nacelles. These can be seen in an early black-and-white sketch he drew as he experimented with different looks for the ship. "Those little wings tips were added detail," said Eaves, "but after I'd done a couple of versions of it, I abandoned them. I decided I'd taken it too far past where the design architecture had been established."

THREATENING LOOK
Eaves also made changes to the nacelles themselves as he sought to create a style more in keeping with the sinister Romulans. "The nacelles on the early black-and-white drawing seemed a little bit too rounded," said Eaves, "so that's why they evolved into jagged points. I thought the early design had too much of a soft, friendly look for an aggressive ship. That's why they go from the rounded tips to the more bull-horn-type points that I did in the colored drawings."

As a final nod to Chang's original design, Eaves drew a bird-of-prey graphic on the underside of the ship.

"I was trying to mimic that beautiful drawing Chang had on the bottom of his design," said Eaves. "I was trying to take his drawing back a little in time as well, but make it fit the new shape."

Unfortunately, this aspect of the design was vetoed. "It didn't make it through approval at all," said Eaves. "In fact, it got rejected brutally. I was hoping it would make it through because It was a neat way to pay homage to Chang's ship. But I understood that it had to go, as *ENTERPRISE* was set in a different era."

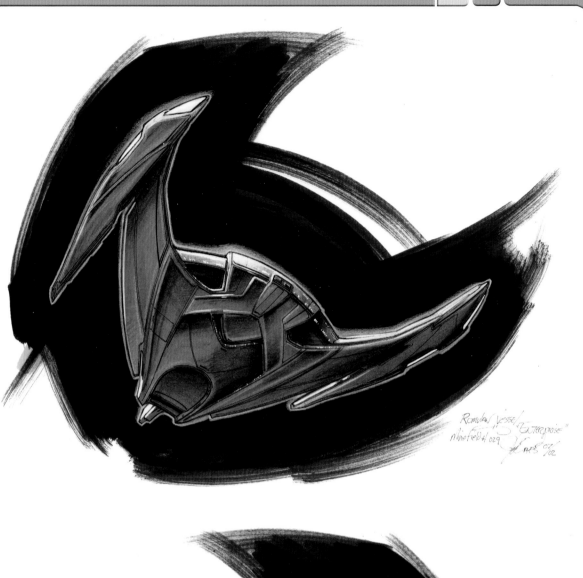

Romulan Vessel "ENTERPRISE"
Minefield #1 029 John Eaves '02

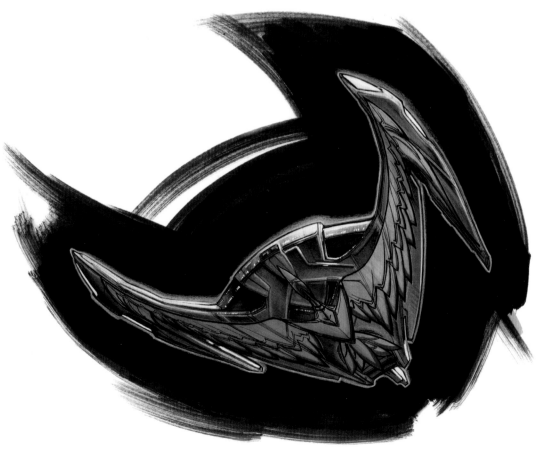

◄ The finished design of the Romulan bird-of-prey featured more pointed nacelles to help give it a more aggressive look. Eaves also added plenty of surface detail, as this helped to make the ship look more realistic when it was turned into a CG model.

◄ Eaves added a bird-of-prey graphic to the underside of the ship in one of his illustrations in homage to Wah Chang's original design. While Eaves hoped this graphic would make it onto the CG screen version, it was ultimately decided that it did not fit in with the overall design ethos that had been established on *ENTERPRISE*.

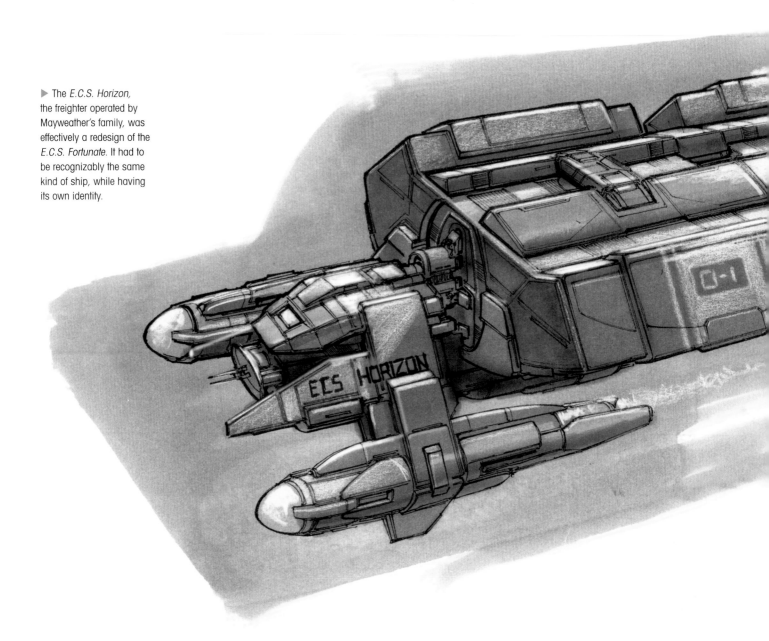

► The *E.C.S. Horizon*, the freighter operated by Mayweather's family, was effectively a redesign of the *E.C.S. Fortunate*. It had to be recognizably the same kind of ship, while having its own identity.

DESIGNING THE
III
E.C.S. HORIZON

When it came to designing *ENTERPRISE*'s second freighter the brief was to come up with something that was the same but different.

Enterprise "Horizon" ECS-Horizon Cargo Ship 1/03

For the *STAR TREK* art department the process normally began when they got a beat sheet – one or two sides of paper that broke down the story of the next episode into the most important moments. This would be the first time they'd learn about anything that needed to be designed. As John Eaves remembers, the beat sheet for *Horizon* made it clear they needed a freighter. "The beat sheet gave us the gist of what was going to be in the show. This one called for an Earth cargo ship."

On another show, or in another time, they would almost certainly have pulled out the existing model of the *E.C.S. Fortunate,* a cargo ship that had been designed in *ENTERPRISE*'s first season. Now, the ease of making CG models meant that the production could afford to come up with a new design. However, it was clear that although they could come up with a new ship, it had to be very similar to the *Fortunate.*

"We stuck to the same architecture," Eaves says, "where the bridge and the main vehicle were up front and they were towing the cargo modules. But we wanted to make sure you wouldn't confuse the two ships. We definitely wanted made it a different color. The *Fortunate* was very organic. It had a lot of curved surfaces and that little bridge module had kind of a retro 50s look to it. With this one I went very hard edged and gave it a lot of straight edges and straight lines to make it look different and we gave it some really heavy, tough nacelles.

"It was the same with the cargo holds. To give them a different look, I modeled them after the cargo units they put inside a 747. They have a kind of bowl on the bottom that's designed to fit into the bottom of the fuselage. Even

though these didn't fit inside anything, I liked that rounded bottom and angled sides, so I carried that through."

The beat sheet also described a sequence in which the *Horizon*'s 'cab' decoupled itself from the cargo units it was towing and mounted an assault on some alien ships that were attacking it. In this case Eaves didn't bother to fully design the cab as a separate ship since this was something he was confident the visual effects team could handle. "I didn't know whether they were going to separate the little unit as a little ship or if the whole tug was going to separate," he recalls, "so I just drew a whole bunch of separations lines so either one could separate. VFX worked all that out on their own."

Eaves remembers that his first sketch was approved almost immediately, and that although he did some work on the details the design never really changed.

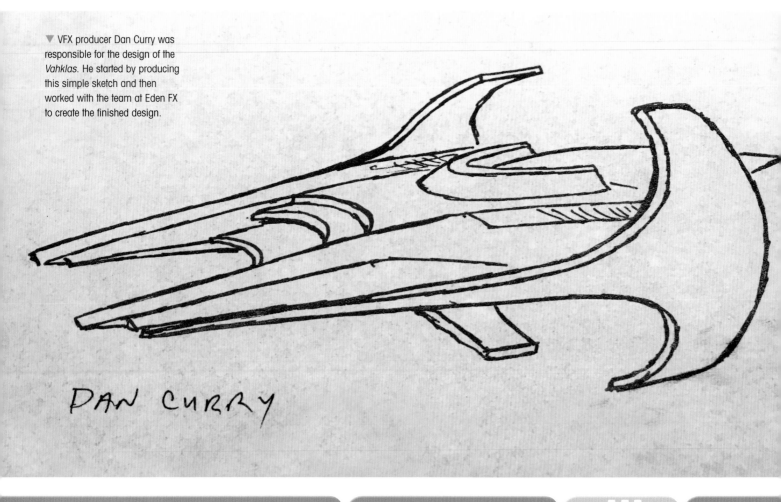

▼ VFX producer Dan Curry was responsible for the design of the *Vahklas*. He started by producing this simple sketch and then worked with the team at Eden FX to create the finished design.

DAN CURRY

DESIGNING THE
VAHKLAS

When the script called for a small, battered Vulcan ship, the VFX team stepped in to help out the art department.

Toward the middle of *STAR TREK: ENTERPRISE*'s first season the episode 'Fusion' called for a Vulcan ship that had never been seen before. The show's regular illustrator John Eaves was overworked, so the visual effects team volunteered to take on the design. *ENTERPRISE*'s VFX producer Dan Curry is a skilled artist in his own right and he quickly produced a

sketch that he handed over to the CG modelers at Eden FX.

Curry had some information about what was needed – the script described the ship as being an old civilian ship that was in need of some repair and it was clear that it was a relatively small vessel. He also had some ideas about what Vulcan ships might look like since several episodes earlier *ENTERPRISE* had

debuted the first 22nd-century Vulcan ship, the *Suurok* class, which had been designed by Doug Drexler and featured a ring-shaped engine.

VULCAN DESIGN

Curry says there was no particular inspiration for his sketch, and that he was simply trying to come up with a design that was in keeping with what

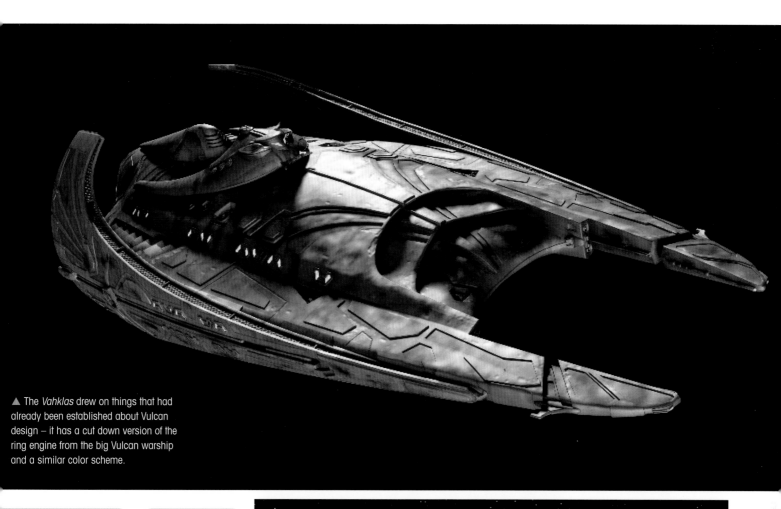

▲ The *Vahklas* drew on things that had already been established about Vulcan design – it has a cut down version of the ring engine from the big Vulcan warship and a similar color scheme.

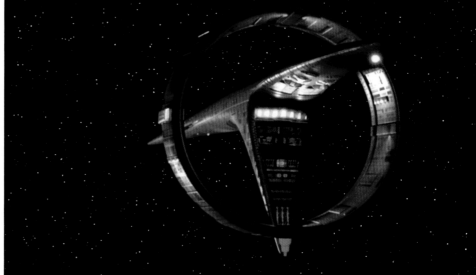

▶ The first Vulcan ship to appear in *STAR TREK: ENTERPRISE* was the *Suurok* class, which was designed by Doug Drexler.

had come before. "I wanted to keep a sense of the Vulcan ring to imply a consistent technology, but because the *Vahklas* was a smaller ship it did not require the full ring which was needed for deep space travel, so I decided to break that."

Curry deliberately kept his sketch simple – it had no suggestion of surface texture and it didn't show the underside or the rear. "I have found that with 'guest ships'" he explains, "giving a looser sketch to the digital modelers leaves them with the opportunity to

express their own creativity and that makes their job more satisfying and yields good results. I always enjoyed the collaboration and watching the ships evolve."

The CG model of the ship was built at Eden FX, where a lot of the details were fleshed out. As well as looking at

Drexler's Vulcan ship, the team looked to the *T'Planna Hath* from *STAR TREK: FIRST CONTACT* to provide them with a style for the surface details and a color for the ship. Finally, they added a rippled or melted effect to the surface texture to imply that the ship had been out in space for a long time.

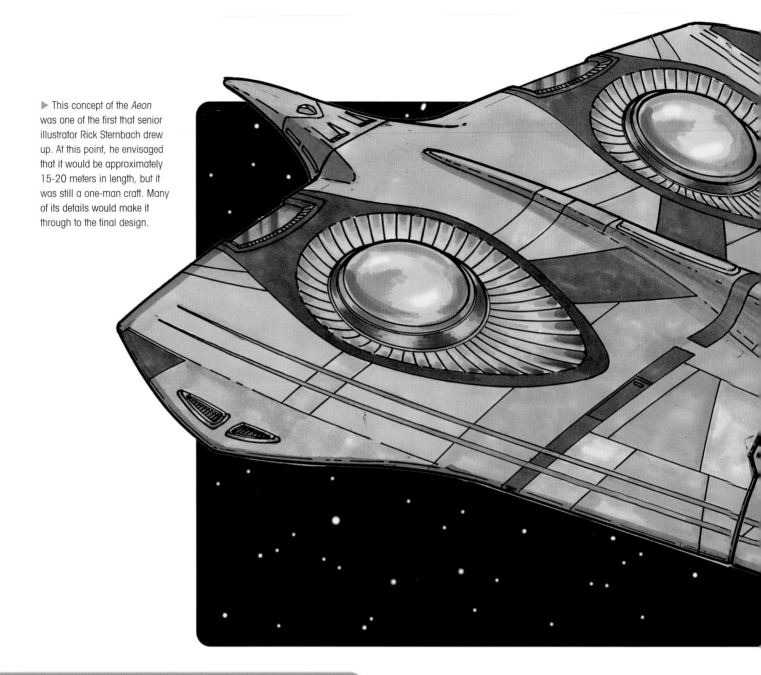

▶ This concept of the *Aeon* was one of the first that senior illustrator Rick Sternbach drew up. At this point, he envisaged that it would be approximately 15-20 meters in length, but it was still a one-man craft. Many of its details would make it through to the final design.

DESIGNING THE
AEON TIMESHIP

Rick Sternbach was faced with a tough task when asked to design a ship even more advanced than usual, but he was up to the challenge.

Coming up with designs for *STAR TREK* starships was a pretty cool job, but certainly not an easy one. On a weekly episodic show like *STAR TREK: VOYAGER*, the pressure was always there to deliver another ship that fulfilled the brief and met with the approval of the producers. Inspiration could never leave you, as the next ship was always just around the corner.

Fortunately, senior illustrator Rick Sternbach always appeared to be full of great ideas when

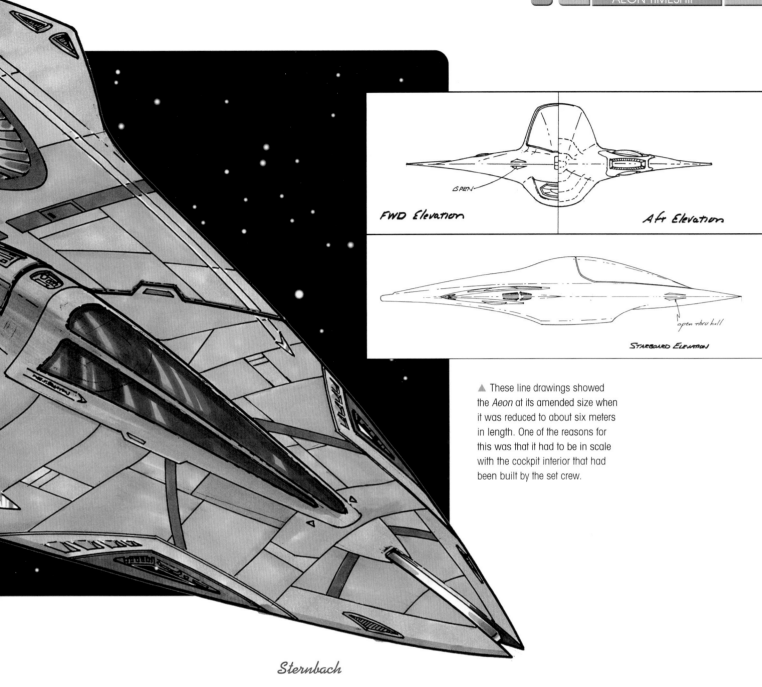

FWD Elevation

Aft Elevation

STARBOARD ELEVATION

▲ These line drawings showed the *Aeon* at its amended size when it was reduced to about six meters in length. One of the reasons for this was that it had to be in scale with the cockpit interior that had been built by the set crew.

Sternbach

it came to designing starships, and it was no different when he was asked to come up with a look for the *Aeon*, a 29th-century timeship.

FIRST THOUGHTS

"I don't recall exactly how the *Aeon* was described in the script, but I'm pretty certain it was always a single-seat craft," said Sternbach. "My initial doodles were influenced by sleek fighter aircraft, particularly stealth fighter concepts and the more dart-like exo-atmospheric research aircraft designs. My first finished sketch included an ejectable cockpit module, but that was eliminated

when the ship was reduced in size, and a few different takes on the smaller ship were inked up."

Normally, Sternbach would not have much time to design a 'ship of the week' on STAR TREK: VOYAGER as production rolled relentlessly on to the next episode, but he was given slightly more time for the *Aeon*. "The time between the first story synopsis and the various script drafts to the final sketches was likely a few weeks," said Sternbach. "In the case of the *Aeon*, we had to build the cockpit interior as a practical set, so I had some time to redraw the ship to better reflect what the set designers were doing, and get those sketches

▶ This illustration shows the final size of the *Aeon* in relation to an average-height human. The craft was small, and Sternbach did wonder how they could fit all the advanced technology it needed inside, but he guessed that by the 29th century anything was possible.

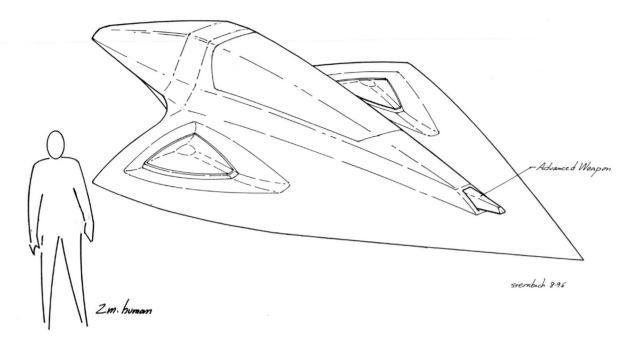

Advanced Weapon

2m. human

sternbach 8-96

▶ Sternbach made the canopy larger and moved it forward in this version of the *Aeon*. It many seem counter-intuitive, but this actually had the effect of making the overall size of the craft appear smaller. He also changed the weapon at the front and turned the Bussard collectors in the wings into semi-spherical orbs.

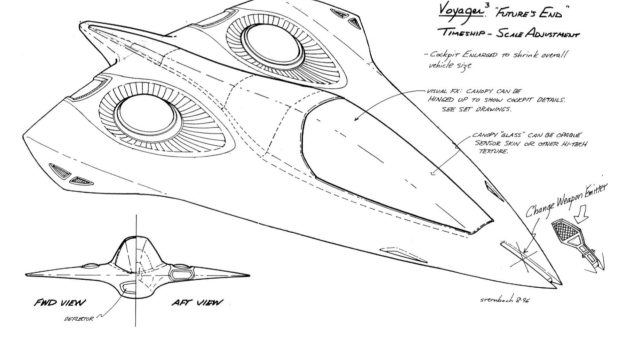

Voyager³ "FUTURE'S END"
TIMESHIP - SCALE ADJUSTMENT

- Cockpit ENLARGED to shrink overall vehicle size

- VISUAL FX: CANOPY CAN BE HINGED UP TO SHOW COCKPIT DETAILS. SEE SET DRAWINGS.

- CANOPY "GLASS" CAN BE OPAQUE SENSOR SKIN OR OTHER HI-TECH TEXTURE.

Change Weapon Emitter

FWD VIEW
DEFLECTOR

AFT VIEW

sternbach 8-96

off to be created in CG. For some designs, like alien craft seen in very short clips, quick doodles on a script page or rough grayscale CG shapes that I made in the art department were sufficient. Major ships and space stations took much longer, with more drawings and blueprints. The *Aeon* was somewhere in the middle."

Of course, one of the biggest challenges when designing the *Aeon*, a ship from the 29th century,

was making it look even more futuristic than the vessels that were normally created. Boundaries had already been pushed when creating the look of cutting-edge starships in the 24th century, but the *Aeon* had to look even more advanced. It also had to appear as if it came from Starfleet and was of alien origin, so it was important to update some of the more familiar elements that were common to the organization's design language.

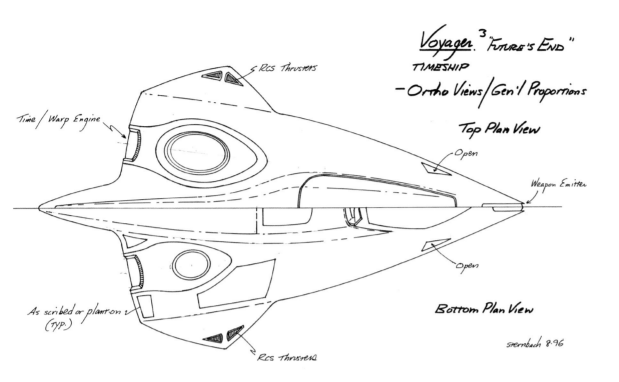

Voyager.³ "Future's End"
TIMESHIP
—Ortho Views/Gen'l Proportions
Top Plan View

§ RCS Thrusters
Time / Warp Engine
Open
Weapon Emitter
Open
Bottom Plan View
As scribed or plant-on ⌐ (TYP.)
RCS Thrusters
sternbach 8·96

◀ This was one of the final orthographic views of the *Aeon* that Sternbach sketched for the CG artists at Foundation Imaging. It showed its proportions and the location of some of its features.

"Pushing *STAR TREK* designs past an already futuristic style presented some challenges," said Sternbach. "But the fact that the *Aeon* was a Starfleet craft helped narrow the focus of the first sketches. I wanted to include some elements that might be seen as reminders of Starfleet tech, so I took the typical glowing red Bussard collectors, turned them 90 degrees and set them into the wings, as if the nacelles were routinely blended into starship hulls. It was the same with the reaction control thrusters, deflector and the impulse exhaust vents. These were just little bits that people had seen before, even if they didn't work exactly the same as back in the 24th century.

NEW DESIGN ELEMENTS
"The temporal emitter was obviously something that I had to include and that was new," continued Sternbach. "I put that in the nose of the ship. Also, some of my early sketches contained notes about nanotechnology built into the skin, which could have been done with animated glows or small morphing details. These were just suggestions in case the producers wanted to see something exotic happening.

"Of course, once the drawings leave my desk, many other people get involved in the decision-making process. In this instance, the final look of the *Aeon* was a simpler stealthy dark tone, which was fine by me. The bigger timeship, the *U.S.S. Relativity* from the later season five episode, actually received an intricately textured hull that could have indicated advanced shielding or other technology."

BUILDING THE CG MODEL
Once Sternbach had refined and finished his sketches of the *Aeon*, they were sent off to the visual effects house Foundation Imaging, so the artists there could build the CG model and the animation. They also supplied life-like renders of the *Aeon*, which were composited into the live action footage of a laboratory that had been filmed in Long Beach, California for the scene where it was viewed in the Chronowerx Building.

Sternbach was very pleased with how the *Aeon* turned out on screen and was also happy that they decided to rescale it. "I think the final smaller size of the *Aeon* was a better fit than the 16-20 meter craft I had originally envisioned," said Sternbach. "Although, the tech side of me really wonders how Starfleet managed to pack all of the necessary systems into such a little package. But it was 29th century tech, so why not!?"

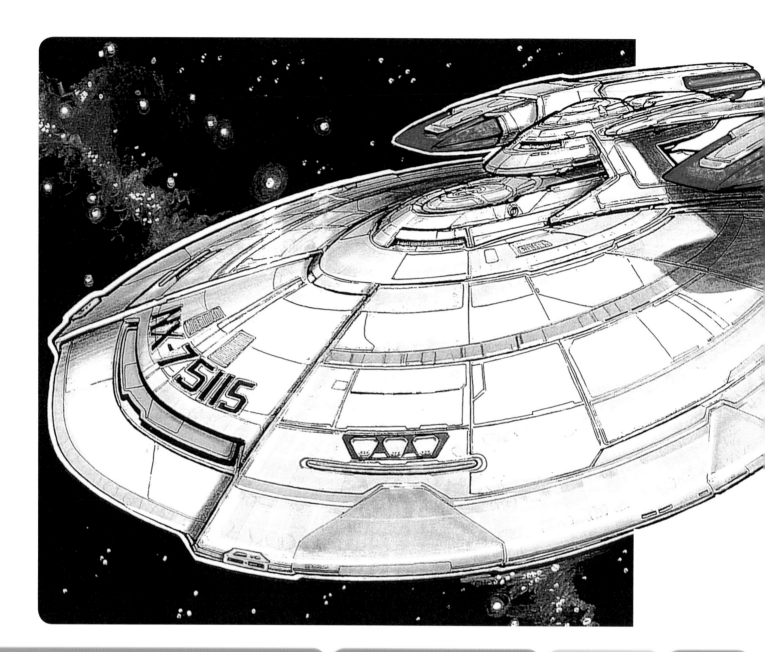

DESIGNING THE

FEDERATION HOLOSHIP

The holoship went through numerous changes as John Eaves searched for a design that would meet with the producers' approval.

As a concept artist on *STAR TREK: INSURRECTION*, John Eaves really had his work cut out. He was responsible for designing all of the *Son'a* vessels and all of the Federation ships, including the Captain's Yacht, a *U.S.S. Enterprise* NCC-1701-E shuttle and a scout ship. The design that really caused him the most problems, however, was the Federation holoship.

There had never been such a specialized Federation ship before in all the years of *STAR TREK*, and it caused Eaves some serious head scratching to know where to begin.

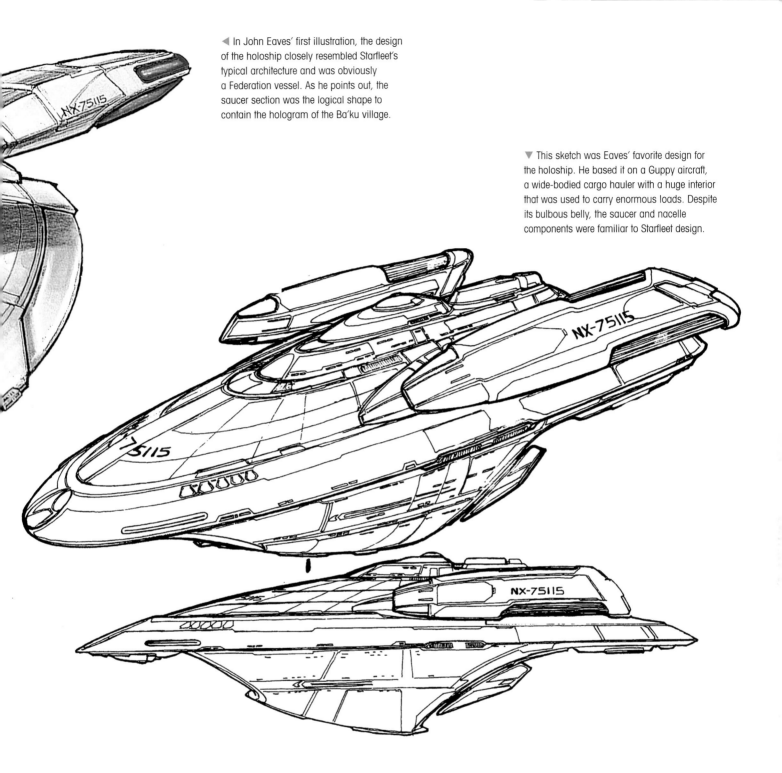

◀ In John Eaves' first illustration, the design of the holoship closely resembled Starfleet's typical architecture and was obviously a Federation vessel. As he points out, the saucer section was the logical shape to contain the hologram of the Ba'ku village.

▼ This sketch was Eaves' favorite design for the holoship. He based it on a Guppy aircraft, a wide-bodied cargo hauler with a huge interior that was used to carry enormous loads. Despite its bulbous belly, the saucer and nacelle components were familiar to Starfleet design.

"The holoship went through a lot of changes," said Eaves. "Originally it was a traditional Federation design, so I started out with a saucer section. The way the (Ba'ku) village was designed, it lent itself well to that shape – a saucer would be the best place to encase that holodeck image."

Eaves' first illustration of the holoship was the most conventional and featured a saucer section and nacelles, clearly indicating that it was Federation in design. The producers were not so keen on this direction, however, and they asked for something "more industrial."

"They wanted to go with something that was more freighter-looking," said Eaves. "So it went through another stage where it looked like a Guppy, one of those old 1950s cargo planes. That was my favorite one."

The producers still felt that this was too traditional and not quite right, so Eaves went back to the drawing board again. "They felt that the revised holoship still looked too 'starshippy,'" said Eaves.

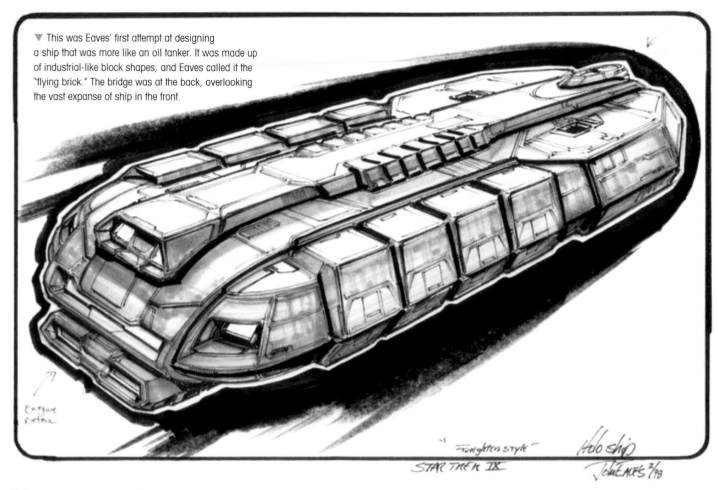

▼ This was Eaves' first attempt at designing a ship that was more like an oil tanker. It was made up of industrial-like block shapes, and Eaves called it the "flying brick." The bridge was at the back, overlooking the vast expanse of ship in the front.

"I then moved onto a 'flying brick' design. The producers wanted something like an oil tanker. I bevelled the sides, and put the cockpit at the very back of the ship, just like a tanker."

BUILDING THE CG MODEL

This design was approved and the illustrations were sent off to the visual effects house Blue Sky/VIFX so the CG model could be built. The upper half of the holoship was the only part that would be visible in the lake for the scenes shot on the Ba'ku planet, so a physical 30-inch scanning model of the top half was constructed. This helped save time as it meant the CG artists would be spared the task of building a wire-frame model freehand.

It was only when the CG model had been completed that they realized there had been an error. Eaves had drawn the holoship with the bridge module at the rear of the ship, much

like it is on modern-day oil tankers. Unfortunately, the design had been signed off in the belief that what they thought was the front of the vessel was in fact the rear – in other words the bridge module had moved from the rear of the ship to the front.

It would have been very expensive to rectify this oversight, not to mention the extra time it would have taken in what was already a tight schedule. It was therefore decided to keep the bridge at the front, although Eaves did make some changes to the command center

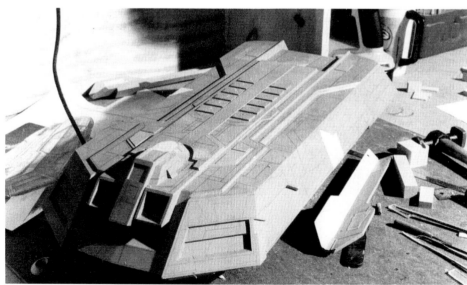

▲ A physical model of the top half of the holoship was built. This was just a rudimentary replica designed to help the CG modeller cut down on the time it took to construct the basic shape of the holoship for the scenes in the lake.

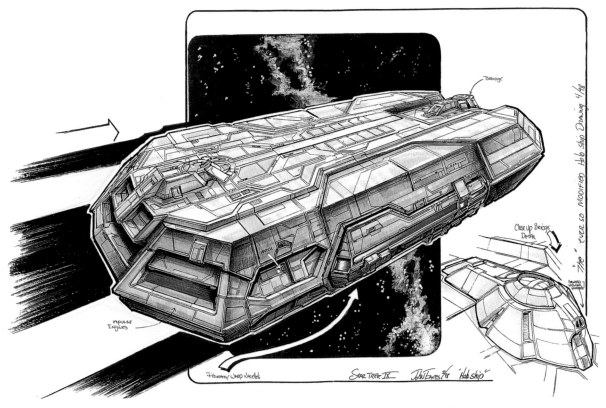

◀ This was the illustration that was approved. The bridge was still at the rear of the vessel, the blue section at the side indicated where the warp nacelles were positioned and the red inserts at the rear were the impulse engines.

to make it blend in more seamlessly to the overall structure. As it transpired, there simply was not enough time to take in Eaves' alterations, and as a consequence what was intended to be the impulse engines ended up on the front of the vessel.

The digital files were then handed over to another visual effects house, Santa Barbara Studios. They constructed the missing half of the ship for its scenes in space, meaning that the holoship was one of the very few models that was built by two companies.

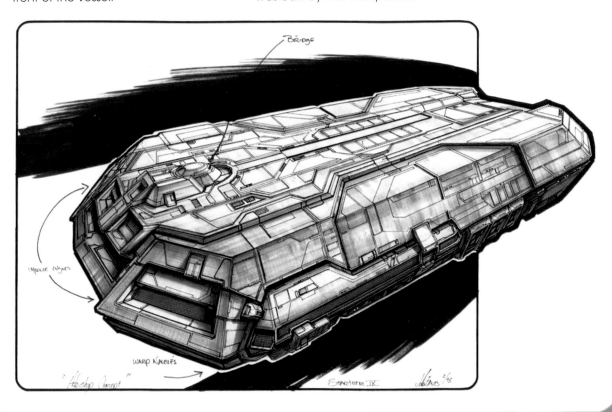

◀ Once it was realized that the holoship had been build with the bridge at the front, Eaves went back to make a few alterations. He blended in the bridge module at the front more organically, and altered the position of the nacelles. In the end, there was not enough time to make all these changes to the CG model.

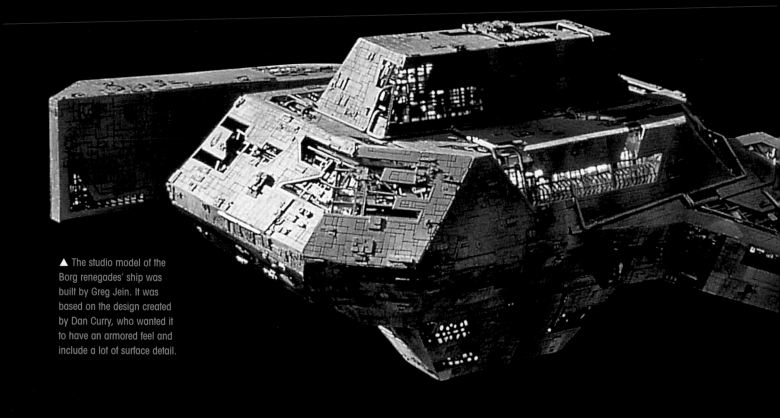

▲ The studio model of the Borg renegades' ship was built by Greg Jein. It was based on the design created by Dan Curry, who wanted it to have an armored feel and include a lot of surface detail.

DESIGNING THE BORG

RENEGADES' SHIP

Visual effects supervisor Dan Curry designed the Borg renegades' ship to look as if it was an arm and a fist, delivering a knockout left hook.

Most *STAR TREK* ships started out in the hands of the concept illustrators in the art department, but the Borg *Renegades' Ship* was unusual in that it was designed by Dan Curry, a senior member of the special effects team.

"*STAR TREK* was unique in that a lot of production companies have strict divisions between different departments," said Curry. "I was good friends with the people in the art department, so they were cool with it when I took it upon myself to design this ship. We had such a degree of mutual trust and respect for each other that

the normal medieval fiefdoms of each department were non-existent. The guys in the art department knew I was a good artist and they had no issues. It was one less burden they had to bear."

Rather than sketch out a concept with pencil and paper, Curry carved a study model out of Styrofoam, covered

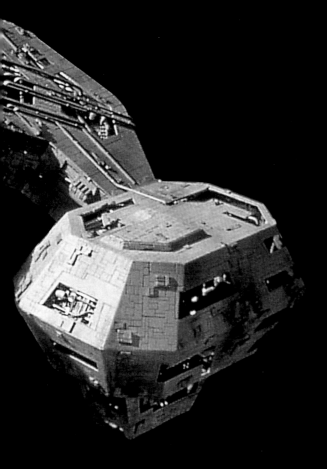

▲ Rather than draw a concept, Dan Curry designed the Borg renegades' ship by carving this study model out of Styrofoam and covering it with black tape.

it with black photographer's tape, and then painted in a suggestion of detail to give it scale. Curry said that he had a general idea of the design he wanted, but the process was organic, and it evolved as he worked on it.

"I wanted something asymmetrical to contrast with the Borg cube," said Curry. "Aesthetics in the normal human sense were irrelevant to the Borg, they just wanted what worked. Somehow they just stacked things on and attached them as needed. This was the result of that process, and I wanted to do something that was really different than what we'd seen before."

In fact, Curry was initially inspired by an old warplane. "I remember seeing a World War II plane that was asymmetrical," said Curry. "I think it was one of the planes from Germany that

never quite made it into production. I think it was asymmetrical because the bombardier would ride in one fuselage while another one was for the bombs, and it was kind of interesting. I wanted to do something weird."

BOXER'S PUNCH

As Curry carved away at the Styrofoam, his ideas for the ship came more into focus. "I started with a coffin-like shape and then added another block over to one side," said Curry. "I wanted it to look like it was about to punch you. When I put this on, it felt like it wasn't balanced enough, so I ended up putting an extra bit of mass over the other side."

Once Curry had finished the study model, which was about eight inches across, he sent it off to Greg Jein, the

model maker who was tasked with building a larger studio model that would be used for filming.

"Greg Jein is one of the legendary model makers, so his input cannot be underestimated," said Curry. "There were gaps in the hull where you could see some of the pipes. Also, that cool detail in the cut-outs on the front of the main part were done by Greg – I didn't paint anything on the front. It's important to me, when you're working with someone as talented and creative as Greg, that they need to have ownership of it too. They have to have their creative contribution."

Once the studio model was complete, it was filmed at the motion control stage at Image G, the visual effects company that filmed most of the models for *STAR TREK*.

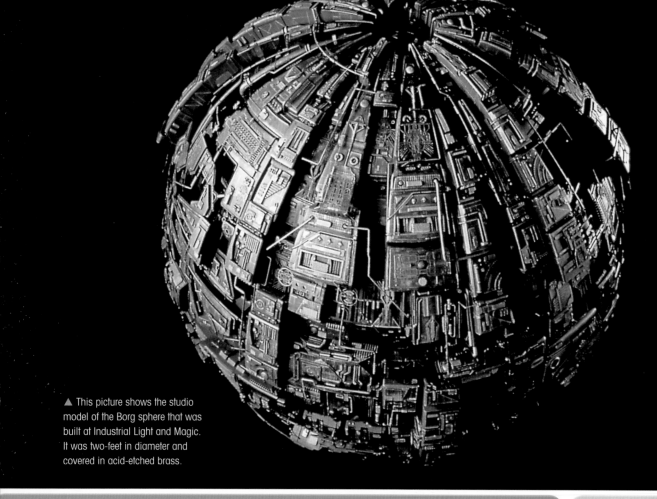

▲ This picture shows the studio model of the Borg sphere that was built at Industrial Light and Magic. It was two-feet in diameter and covered in acid-etched brass.

BORG SPHERE

For *STAR TREK: FIRST CONTACT*, the filmmakers really wanted the visual impact of a brand new type of Borg vessel. The Borg cube had been seen several times during the run of *THE NEXT GENERATION* so it made sense that if the Borg had other ships, they would also be geometrical shapes. It was decided that a spherical-shaped ship was the way to go, but that it would be hidden inside a Borg cube so that it would have that much more impact when it emerged.

Concept artist John Eaves, who also came up with the design of the *U.S.S. Enterprise* NCC-1701-E, was the man charged with working out exactly what this new Borg sphere might look like. At first there were worries that it might seem too much like the 'Death Star' from *Star Wars*, and as production designer Herman Zimmerman recalled, making the Borg sphere look unique was "our biggest challenge."

Zimmerman and producer Rick Berman felt that the surface detail should look really irregular with no mathematical patterns. Keeping this in mind, Eaves explored several designs by making the detailing on the hull really random and having deep gaps between the panelling.

Eaves worked through several ideas, including one that incorporated a large weapons platform represented by a series of rings, but it was felt that this was too reminiscent of the 'Death Star'.

After further refinement, Eaves came up with a colorized illustration that met with everyone's approval. It was felt that this design perfectly encapsulated the Borg's nightmarish mechanistic nature as it looked as if scavenged parts had been plumbed into the sphere as they assimilated new technologies. It was a design where aesthetics were irrelevant, and ultimately a design that could only have come from the Borg.

◀ Once it had been decided that the new Borg ship should be spherical in shape, illustrator John Eaves began experimenting with different looks. This early rough sketch introduced the idea of a patchwork of panels over the surface.

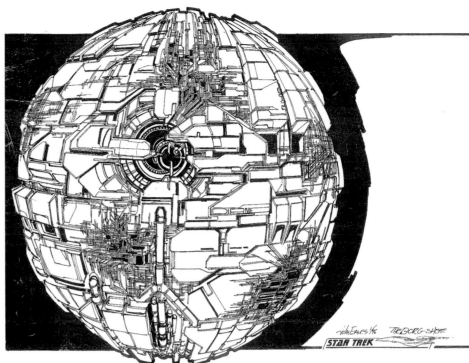

▶ This later design had more pronounced and irregular panelling, but it was felt that the weapon represented by the series of rings in the middle of the sphere was too similar to the 'Death Star' from Star Wars.

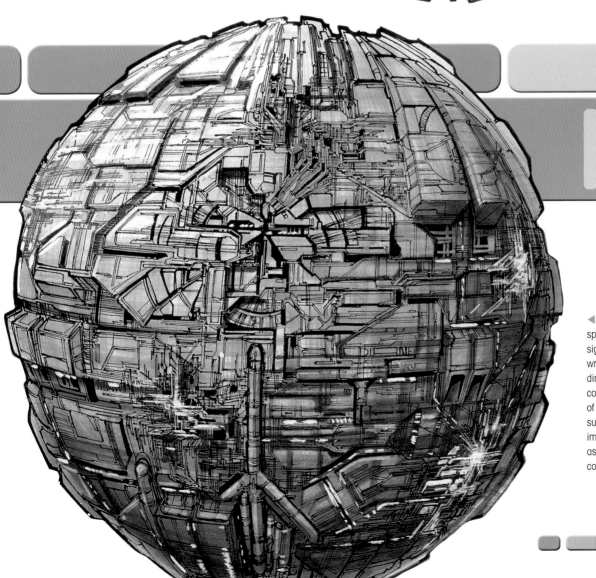

◀ This illustration of the Borg sphere was the one that was signed off by the producers and writers. It built on the design direction from the earlier concepts, incorporating a maze of exposed piping and irregular surfaces, which gave the impression that newly assimilated technology was continuously being added to it.

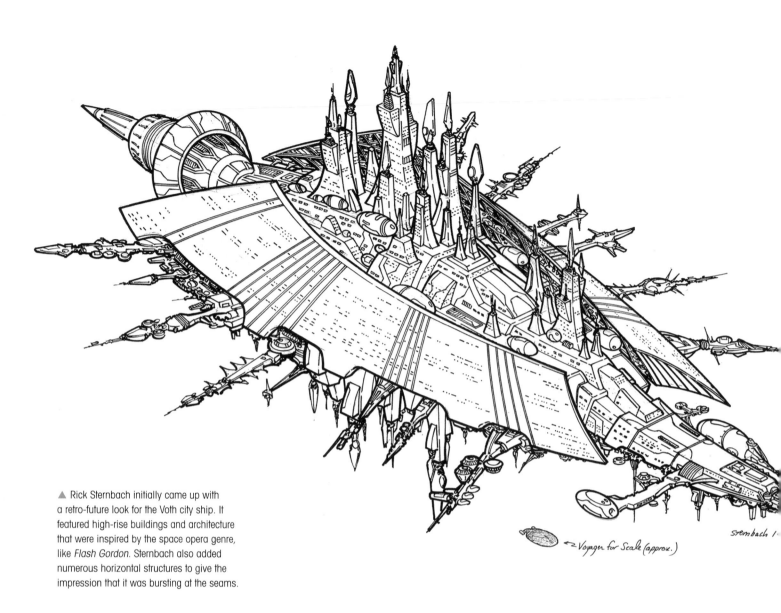

▲ Rick Sternbach initially came up with a retro-future look for the Voth city ship. It featured high-rise buildings and architecture that were inspired by the space opera genre, like *Flash Gordon*. Sternbach also added numerous horizontal structures to give the impression that it was bursting at the seams.

←z Voyager for Scale (approx.)

sternbach

DESIGNING THE | | | |
VOTH CITY SHIP

For the Voth city ship, senior illustrator Rick Sternbach devised an entire urban metropolis attached to a huge transwarp drive.

As the senior production illustrator on *STAR TREK* for many years, Rick Sternbach had designed countless futuristic props and starships, but the Voth city ship was the largest, as it was supposed to be the size of a... well... a city.

Sternbach also had a few more clues about how the ship should look, as the preliminary script outlined a few facts about the Voth. He knew that they were a race based on dinosaurs, they were highly advanced and that the ship should be equipped with transwarp.

After putting his thinking cap on,

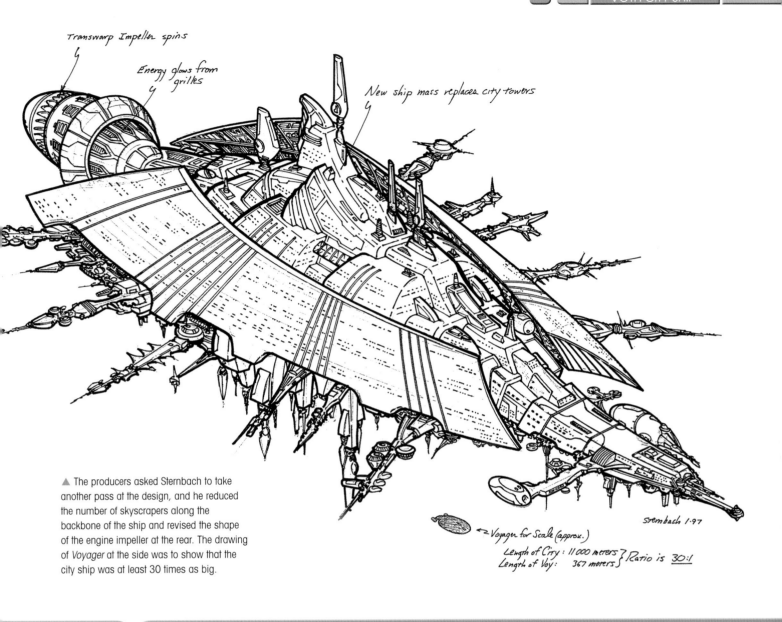

Transwarp Impeller spins

Energy glows from grilles

New ship mass replaces city towers

Sternbach 1·97

←2 Voyager for Scale (approx.)
Length of City: 11 000 meters } Ratio is 30:1
Length of Voy: 367 meters }

▲ The producers asked Sternbach to take another pass at the design, and he reduced the number of skyscrapers along the backbone of the ship and revised the shape of the engine impeller at the rear. The drawing of Voyager at the side was to show that the city ship was at least 30 times as big.

Sternbach soon came up with a design direction. "The original concept was a very large flying structure with many vertical towers and horizontal antennae, docking arms, and other support equipment," he said. "The central body of the ship had a few layers of smoother plating dotted with windows that could have been habitat areas.

The aft end contained an enormous matter-antimatter capacitance impeller for propulsion, which also provided onboard power. I drew the U.S.S. Voyager next to it in scale, so they could see the Starfleet vessel was very small in comparison."

It could also be seen from this initial concept that it was very much a city in the form of a starship. It featured numerous high-rise buildings along the backbone of the ship, topped off with diamond-shaped structures that gave it a retro-future look, similar to how the future was envisaged from the 1930s through to the 1950s. The zeppelin-shaped structures and jagged antennae that emerged from the side

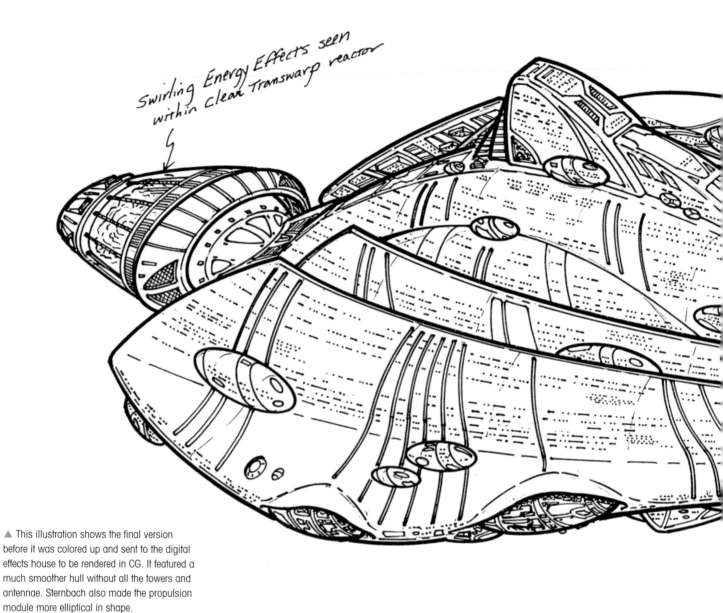

Swirling Energy Effects seen within clear Transwarp reactor

▲ This illustration shows the final version before it was colored up and sent to the digital effects house to be rendered in CG. It featured a much smoother hull without all the towers and antennae. Sternbach also made the propulsion module more elliptical in shape.

also added to this *Sky Captain and the World of Tomorrow* vibe.

REVISING THE CONCEPT
After seeing this concept, the producers asked Sternbach to scale back the number and shape of the tall city towers and give it a slightly different propulsion module. Sternbach's second illustration rounded off the turbine structure at the rear of the engine module, and drastically cut the number of tall towers, replacing them with much more streamlined structures.

It was felt that the design was still not

quite right, and Sternbach was asked to refine it further. "The majority of the hull extensions were eliminated and the hull was further smoothed out, bringing it closer in style to the smaller Voth research vessel," said Sternbach. "The sides were given a few more layers and the big aft engine was made more elliptical in cross section."

This was the final version that was then colored up and sent to the CG house to be built. Sternbach also drew up a concept envisaging the cavernous internal bay of the Voth city ship that was used to hold *Voyager*.

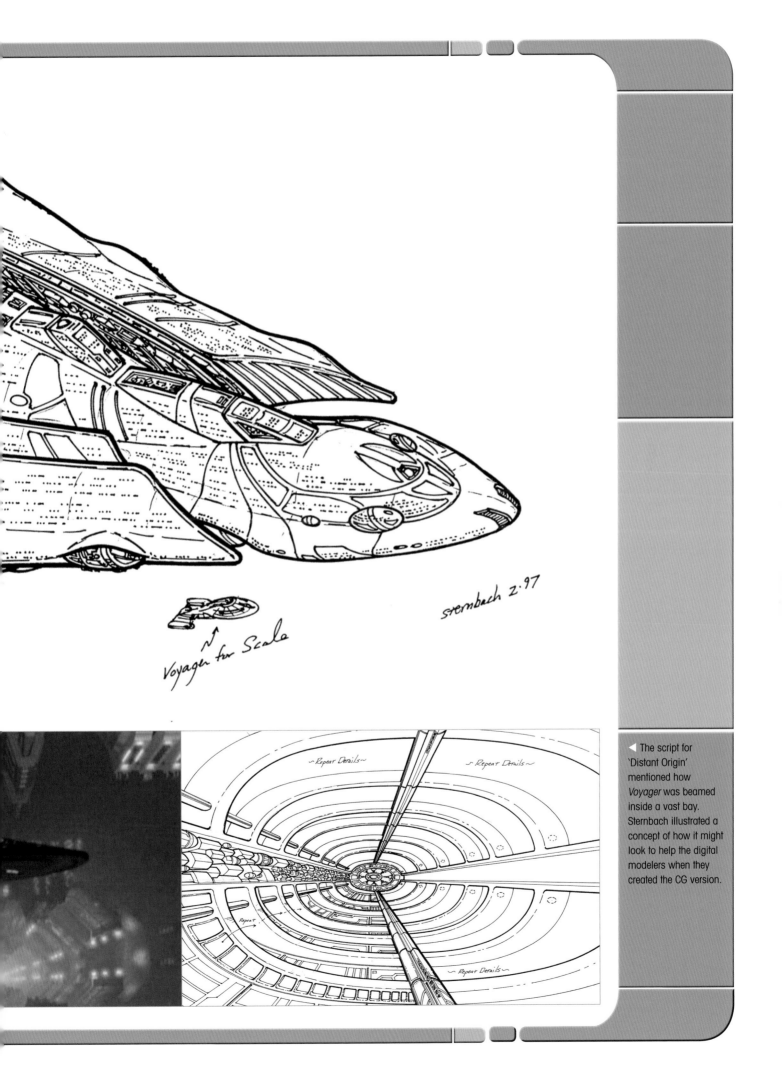

Voyager for Scale

sternbach 2.97

~Repeat Details~ ~Repeat Details~

Repeat

~Repeat Details~

◄ The script for 'Distant Origin' mentioned how *Voyager* was beamed inside a vast bay. Sternbach illustrated a concept of how it might look to help the digital modelers when they created the CG version.

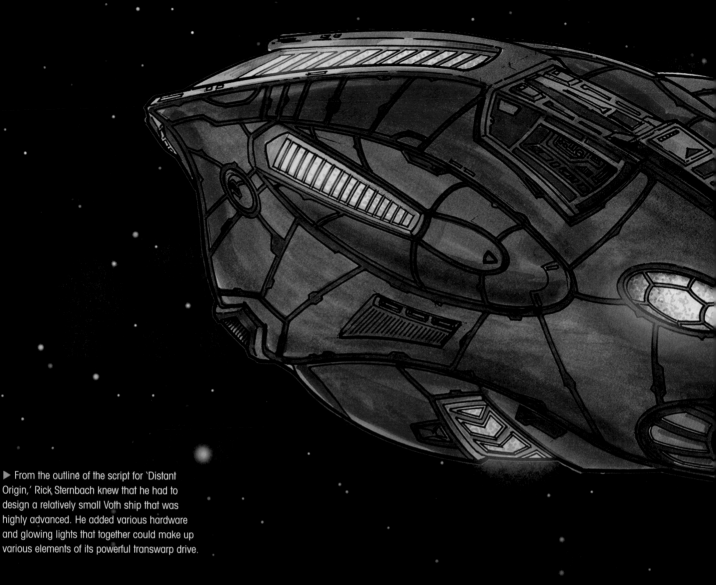

▶ From the outline of the script for 'Distant Origin,' Rick Sternbach knew that he had to design a relatively small Voth ship that was highly advanced. He added various hardware and glowing lights that together could make up various elements of its powerful transwarp drive.

DESIGNING THE

VOTH RESEARCH

For the Voth research ship, senior illustrator Rick Sternbach was asked to design a highly-advanced vessel with transwarp drive.

By the third season of *STAR TREK: VOYAGER*, senior illustrator Rick Sternbach had been working for the franchise for 11 years. In that time, he had designed countless alien starships, each one different from the last. In the case of recurring aliens,

Sternbach's job was somewhat easier as he had developed a particular style, so that the audience would know instantly if it was, for example, a Klingon or a Cardassian ship. For aliens that only appeared once, such as the Voth, it was a different matter.

"With some of the alien cultures of the week," said Sternbach, "we didn't have the time to really delineate what their architectural styles were. If I saw the set designers coming up with certain directions, that worked its way into my ship designs. Sometimes it

SHIP

would work the other way around. A ship exterior would say things about the interior. Every 10 days we were into a new episode, so it was bang, bang!"

QUICK SKETCHES

With the relentless pace of production on *STAR TREK*, Sternbach never had much time to design the alien ship-of-the-week. Normally, for a one-off alien ship, Sternbach would begin by producing a series of very rough thumbnail sketches. "I'd put together some sketches just to give the producers something to start with," explained Sternbach. "I didn't want to give them too many elaborate finished drawings because there might have been time lost if I was going in a direction they didn't like."

Once one of these sketches had been selected, Sternbach pulled out a 11"x17" sheet of paper and simply began a three-quarter perspective sketch. Once this was completed, it was handed over to the CG houses and they built their interpretation of it. In this case, the green colored hull that Sternbach had drawn was changed to a metallic silver. Also, the color of some of the power lights was changed, but otherwise the finished model was remarkably similar to his sketch.

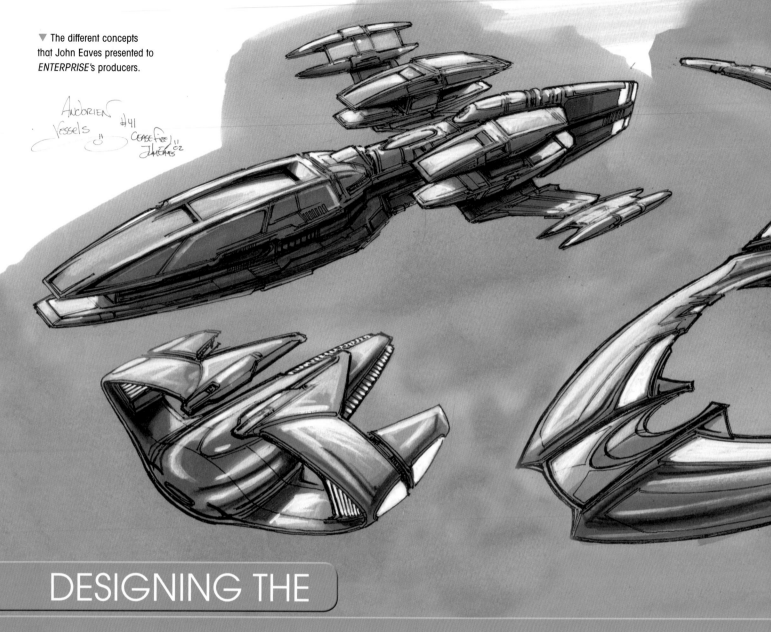

The different concepts that John Eaves presented to *ENTERPRISE*'s producers.

DESIGNING THE

ANDORIAN BATTLE

The Andorians had been around for decades before they finally got a ship of their own. The Andorian battle cruiser made its first appearance in 'Cease Fire.' As concept artist John Eaves remembers, although the Andorians had first appeared in 1967, he had very little to work with. "A lot of times I'd try to do a retro version of what we'd seen before, but we'd never seen an Andorian ship so this was open for me to figure out what we wanted to do."

As usual, he sketched out a series of alternatives on a single piece of paper for the producers to choose from. He was particularly pleased with a very organic "manta ray" approach, that even had a suggestion of antennae as a nod to the famous Andorian makeup and admits he was surprised when the producers chose a much thinner, rocket-like design.

This final design had two very distinct inspirations: a World War II seaplane and the *Battlestar Galactica*. "That was about the time that *Galactica* was starting up again," John explains. "I think subconsciously the main body is a little

bit of the *Galactica* flipped over on top and on the bottom, with some weird looking engines."

Those engines and the design of the wings that they were attached were inspired by the pontoons of an old aircraft. "A lot of my inspiration came from old World War II airplanes," Eaves explains. "There were so many great shapes. I'd been to the Phoenix air museum and they had this airplane called the Mariner that had this double-jointed wing like that. Actually it was the reverse – it went up and then dropped

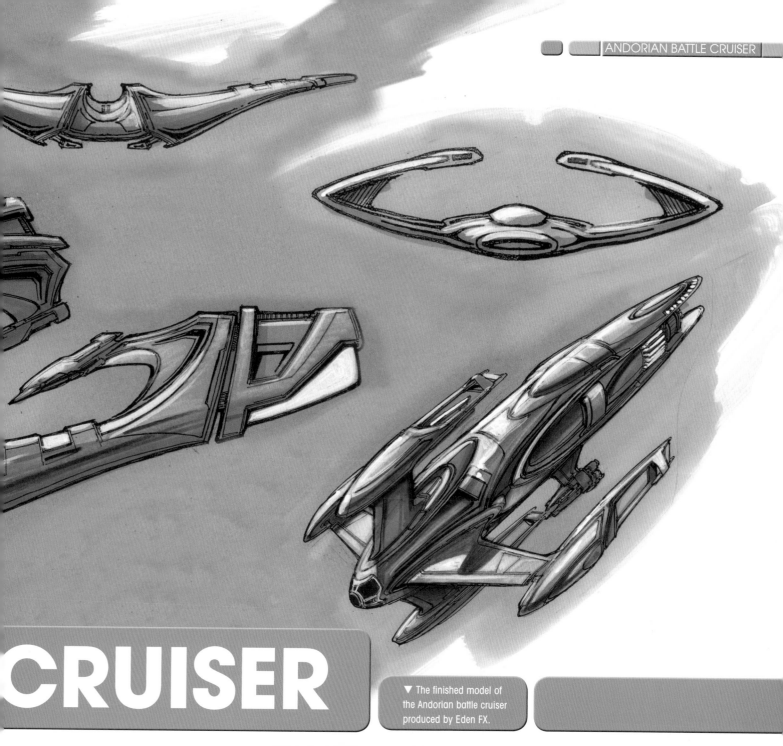

CRUISER

▼ The finished model of the Andorian battle cruiser produced by Eden FX.

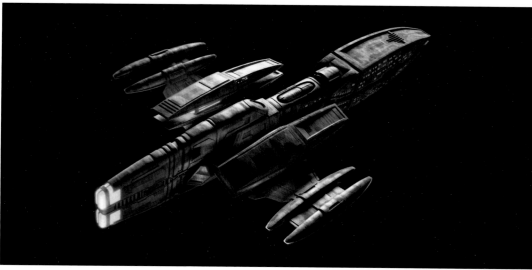

down. It was almost like the old World War II Corsair. And they had a water landing plane that had a landing skiff. I thought it was kind of cool to tie that together so the skiff became the double engines up on top of the wing."

As Eaves remembers, the episode was a busy one, so once this early sketch had been approved, it was sent straight over to Eden FX without any additional drawings. The design work was then completed by Pierre Drolet who refined the design as he went.

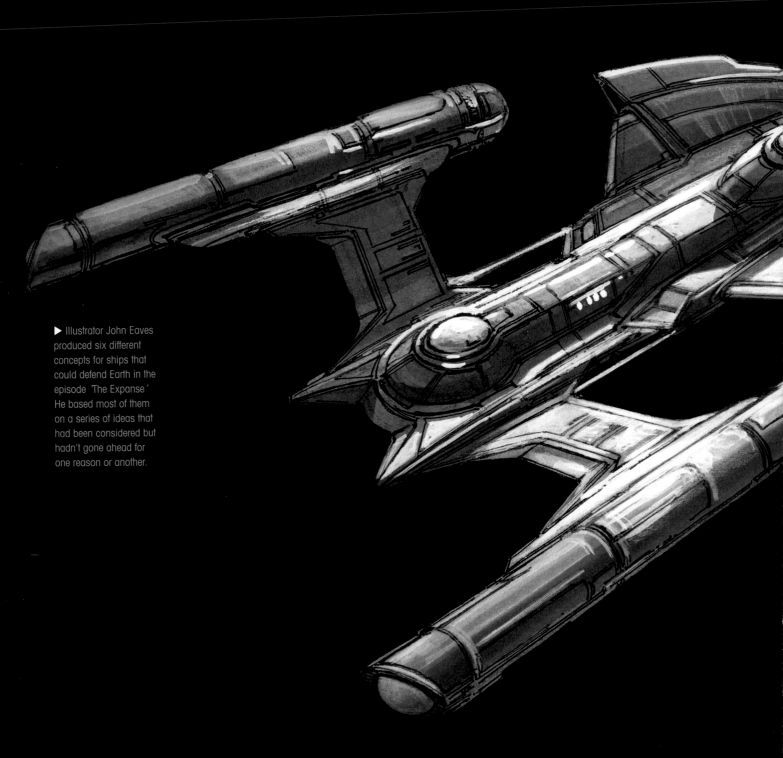

▶ Illustrator John Eaves produced six different concepts for ships that could defend Earth in the episode 'The Expanse´ He based most of them on a series of ideas that had been considered but hadn't gone ahead for one reason or another.

DESIGNING THE ||| |||

INTREPID

The *Intrepid* was one of *STAR TREK*'s missing links – an early warp ship that pre-dated the *Enterprise* NX-01.

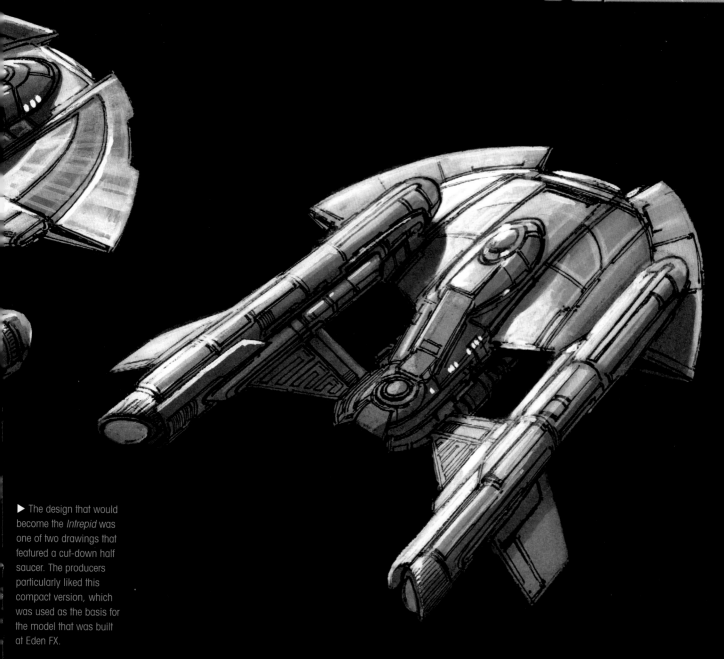

▶ The design that would become the *Intrepid* was one of two drawings that featured a cut-down half saucer. The producers particularly liked this compact version, which was used as the basis for the model that was built at Eden FX.

Not all starships are created equal. Sometimes a ship is only ever intended to be seen in the background. That was very much the case when it came to 'The Expanse.' In the story, Duras's Klingon bird-of-prey ambushes *Enterprise* as it approaches Earth, and Archer and his crew are only saved when a small fleet of Earth vessels come to their defense. If something similar had happened on *TNG* the VFX team would have used stock models like the *Excelsior* or *Nebula* class but the whole point of *STAR TREK ENTERPRISE* was that the NX-01 was Earth's first true starship, and as a result the art department simply hadn't designed any other 22nd-century vessels.

"They asked me to design three or four different ships that looked like they belonged in Starfleet but definitely didn't look like an *Enterprise*," John Eaves explains. "That's important - whenever they have a Starfleet armada they want starships that look good in a battle but that are not easily mistaken for the *Enterprise*. That means they've kind of got the same elements but when it comes to how the saucer looks and the composition of the nacelles and the body, they've got to have a very distinct shape. They were definitely just background ships but they had to stand out."

Eaves began by revisiting his old

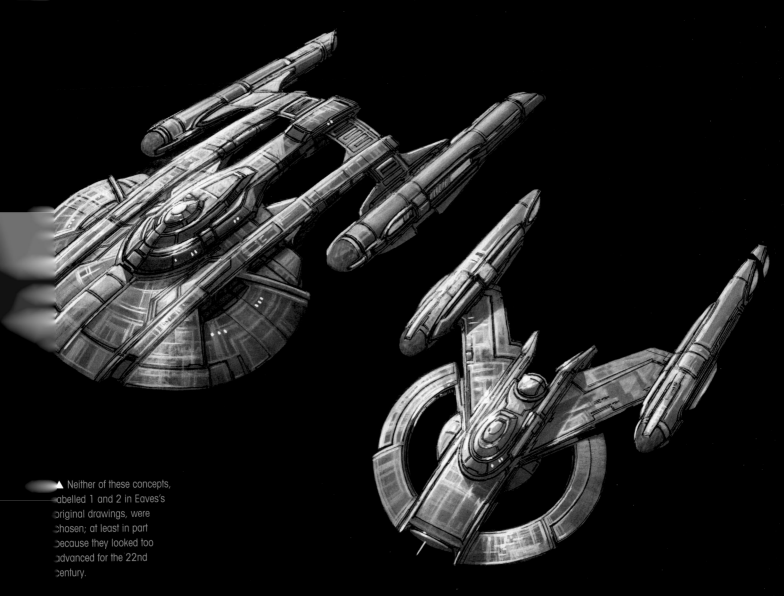

▲ Neither of these concepts, labelled 1 and 2 in Eaves's original drawings, were chosen; at least in part because they looked too advanced for the 22nd century.

sketches, looking for Starfleet designs that got a positive response, but hadn't gone forward, either because they had been written out of the script or because the budget had been too tight. "There was a bunch of elements the producers liked but we hadn't used, but there were some new ideas too. I remember thinking these were definitely ballistic ships that were defending the Earth. I took the design away from the starship, deep space exploration look and gave them more of a defensive posture. They all had these kind of sharp angles that look very aggressive. I tried to make them feel like fighters. I always look at the airforce and navy planes for inspiration and all three of those ships had a very

flat profile. I imagined they were about a third of the length of the NX-01.

"The half saucer was a neat new idea. I thought cutting the saucer in half would give it more of an aggressive profile. It looked like a modern plane so I compacted the shape dramatically to make it look like it was maneuverable. I remember they were doing a lot of shark shows at the time. The dorsal fins go down when a shark goes into attack mode, so that's why you have those little fins that give you that attack posture."

At the same time, Eaves made the nacelles a little bigger and more crude than the versions we were used to on the *Enterprise* to make it look as if the ship was more primitive. In total he

produced six drawings showing alternative designs. When he took them to the meeting with the producers, two of them were approved at once, with the half-saucer ship, as it was informally known at the time, getting a particularly positive response.

"I think cutting the saucer in half made it stand out. They liked the compactness of it, having the nacelles tucked into the body a bit and the little bits of wings."

The ships received such a positive response that Eaves had no time to do more work on his designs, which only showed the ships from one angle. "I was excited about doing those ships and I wanted to have more time to do

▲ The design on the right, the Warp Delta ship, was also built as a CG model. The fleet that saved *Enterprise* consisted of two of these ships and one of the *Intrepid* type.

more drawings of them but they liked them and that was it! There was a lot of stuff in that episode and they wanted me to spend more time on the Klingon bird-of-prey."

Eaves's drawings were sent over to Eden FX where Pierre Drolet built the CG model of the ship that would become the *Intrepid*. The episode was supervised by Rob Bonchune, who remembers that the similarities with the NX-01 meant that they could save time and money by cannibalizing the existing model. Eaves's drawing only showed a rear three-quarter view, and Drolet filled in the missing details using as much of the NX-01 as made sense.

When it came to putting the finishing touches on the model, Bonchune

remembers that the producers specifically requested that they leave any kind of registry number or name off. The half-saucer ship was always intended to be a background ship and, as such, it ran a high risk of being destroyed or being duplicated to make up a fleet. Putting a name on it only introduced an element that would have to be changed and by this point the goal was to get as much out of *ENTERPRISE's* VFX budget as possible. The half-saucer ship was however given a name in the episode, when Hoshi announces that Captain Ramirez was hailing *Enterprise* from the *Intrepid*. And, as the producers had predicted, it reappeared in two more episodes, filling out the fleet.

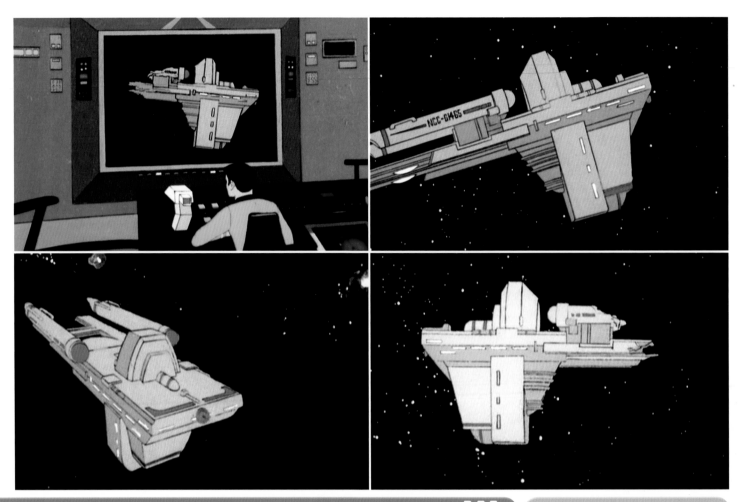

DESIGNING THE

ANTARES

▲ It was felt that the robot grain ship from *THE ANIMATED SERIES* episode 'More Tribbles, More Troubles' shared the same design philosophy as the *U.S.S. Enterprise*, and would be perfect for the *Antares*.

The design of the *Antares* in the remastered version of *THE ORIGINAL SERIES* owed much to *THE ANIMATED SERIES*, as Michael Okuda explains.

Back in 2006, CBS announced that they would be digitally remastering all 79 episodes of *THE ORIGINAL SERIES* in high definition. This provided the perfect opportunity to recreate many of the old visual effects with brand new, state-of-the-art digital imagery. The problem was, should they update a truly iconic series that fans had grown to love in all its original glory?

Fortunately, the producers behind the remastering of *THE ORIGINAL SERIES* could not have been more qualified for, or more sympathetic to, the task that lay ahead of them. These included

David Rossi, a supervisor on *STAR TREK* projects who had been working with the franchise since 1990, and Denise and Michael Okuda, scenic artists and technical consultants who know everything that is worth knowing about *STAR TREK*.

These producers were very wary of developing new visual effects just because they could. They wanted to stay true to the visual style and spirit of *THE ORIGINAL SERIES* from the 1960s, and respect the original artists' work as much as possible.

"We understand the enormous pressure under which the first series was made," said Mike Okuda.

▶ The robot grain ship was one of Mike Okuda's favorites from *THE ANIMATED SERIES* as he felt that it looked like it had come from Matt Jefferies' imagination, but was also clearly different than the *U.S.S. Enterprise*. Okuda set about creating these blueprints of the ship, so that the CG modelers had something to work from if there was time to build the ship.

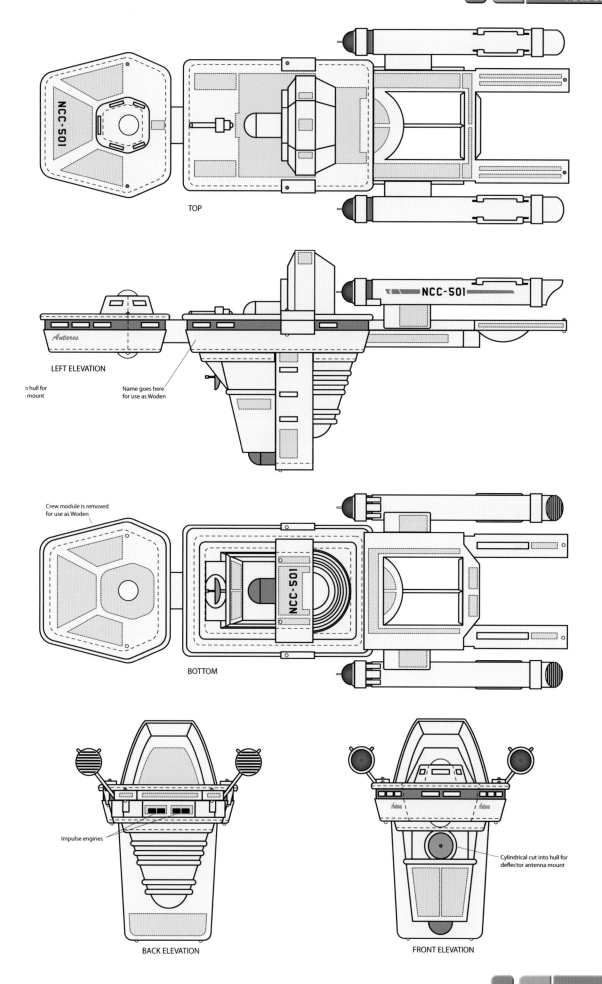

TOP

LEFT ELEVATION

NCC-501

Antares

○ hull for
 mount

Name goes here
for use as Woden

Crew module is removed
for use as Woden

NCC-501

BOTTOM

Impulse engines

Cylindrical cut into hull for
deflector antenna mount

Antares *Antares*

BACK ELEVATION

FRONT ELEVATION

▲ As well as appearing in the remastered episode 'Charlie X,' the *Antares* model also appeared in 'Court Martial.' Here, it was used very small [appearing just above the saucer of the *Enterprise*] and was renamed the *Yorkshire* NCC-330.

"To this day I take my hat off to the people who did the visual effects in *THE ORIGINAL SERIES*. They were brilliant under intense, intense budgetary, scheduling and technological pressure."

HONORING THE ORIGINAL

The lack of money and time, however, meant that it was very difficult for the makers of *THE ORIGINAL SERIES* to justify building and filming new studio models. In some cases vessels were represented by simple light effects, or not shown at all. It was here that the remastered version could make the most difference, but again they were careful not to destroy the classic appeal of the original.

"We wanted to leave as few fingerprints on these shows as possible," said Okuda. "We wanted it to be Matt Jefferies' show, we wanted it to be Bob Justman's show and Gene Roddenberry and D.C. Fontana – those people."

One of the vessels that they wanted to feature, if they could, was the *Antares* from 'Charlie X,' as it had never appeared in the original. "I can't recall

whose idea it was to use the grain ship from *THE ANIMATED SERIES*," said Okuda. "It might have been mine, or it might have been Dave Rossi's. One of the wonderful things from *THE ANIMATED SERIES* was that they could do a lot more spaceships than you could do in *THE ORIGINAL SERIES*. On the other hand a lot of their ships were impressionistic on screen, but if you were to try and build a model of it, the lines didn't quite match up.

"Fortunately, that wasn't the case with the grain ship. It was obviously well thought out and it had a wonderful quality that you could quite clearly see came from Matt Jefferies' universe. It seemed to follow the same design principles as the *Enterprise*, and yet it was dramatically different. It was my favorite ship on *THE ANIMATED SERIES*.

"I spent a couple of days looking at the grain ship from the episode 'More Tribbles, More Troubles,' and then I looked online to see if anybody had done blueprints. There were some very fine blueprints, but nothing that seemed to line up in the way I imagined it. So I did a 3D

drawing of what my interpretation of that ship looked like, and turned it over to Neil Wray (visual effects supervisor). The key to making it happen was that the blueprints had to be ready if Neil decided there was time to do it."

In terms of building the actual CG model of the *Antares*, it was a case of trial and error, but they knew there was not much time to perfect it.

BUILDING THE CG MODEL

"For the most part digital effects are an iterative process," said Okuda. "You try something and if it doesn't quite work out, you try again. The *Antares* ship was really a last minute add, even though it was planned ahead, so I simply said to Neil to use the same basic textures as the *Enterprise*. It has a little more relief to the surface texture, but unless somebody was very dissatisfied with it, we were pretty much going with Neil's first guess. I gave them the markings, but Neil used the same basic textures that were used to create subtle relief on the *Enterprise*'s hull, but exaggerated them a bit."

Despite the *Antares* being added late on in the process, everyone was pleased with the results. In fact, it turned out so well that they decided to use it in two more remastered episodes.

"We used the *Antares* again, very small, in 'Court Martial,'" said Okuda. "We wanted to create the impression that there was a little more traffic orbiting the planet, since it was a starbase. One of the ships we used was the *Antares* – I think it was renamed the *Yorkshire* NCC-330. Then, we asked CBS Digital to take the crew module off the front, and it became the *Woden*, the robotic cargo vessel in 'The Ultimate Computer.'"

While THE ORIGINAL SERIES was never about flashy visual effects, there's no doubt that the added CG elements of the remastered version add value, without taking anything away from the 1960s original. In many ways, the new effects are not even that noticeable unless you already know about them. It is testament to everyone at CBS Digital that ships like the *Antares* look perfectly at home in the remastered version.

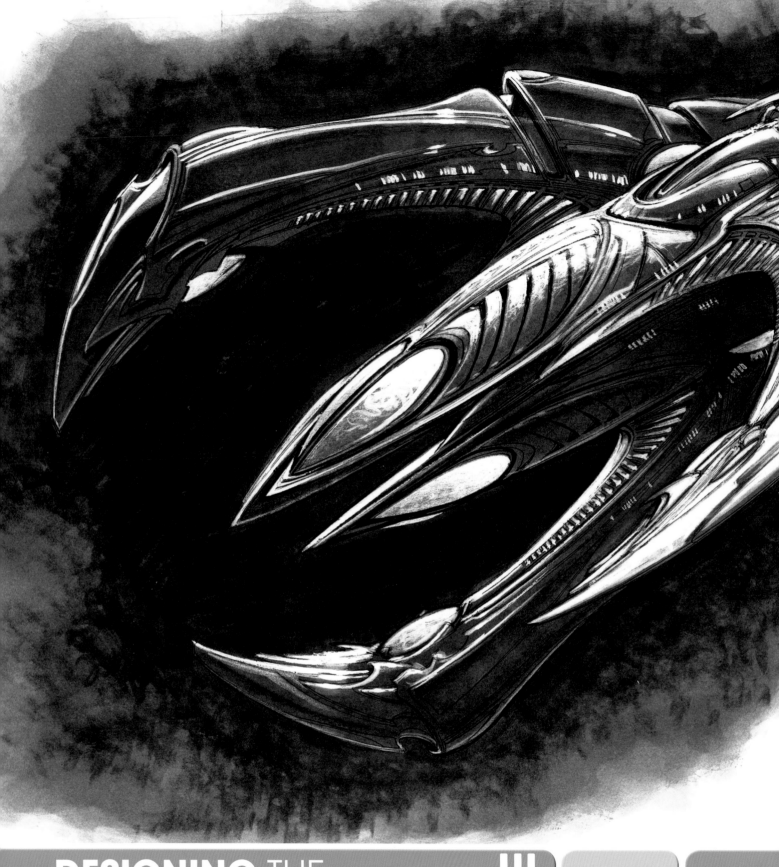

DESIGNING THE
XINDI INSECTOID

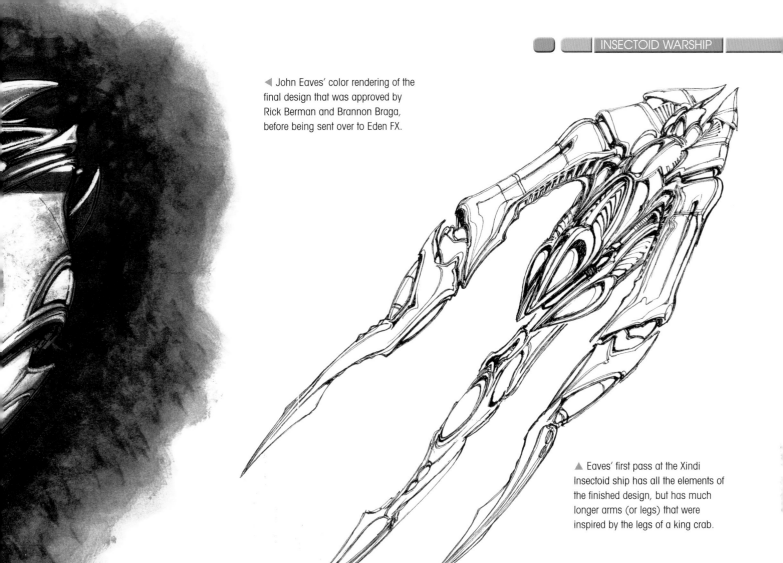

◄ John Eaves' color rendering of the final design that was approved by Rick Berman and Brannon Braga, before being sent over to Eden FX.

▲ Eaves' first pass at the Xindi Insectoid ship has all the elements of the finished design, but has much longer arms (or legs) that were inspired by the legs of a king crab.

As STAR TREK: ENTERPRISE entered its third season, the producers wanted to push things in a new direction. For the first time ever, STAR TREK would experiment with a series-long story arc. That meant a new enemy – the Xindi, an unusual race that was made up of five different species, each of which had its own unique look and its own unique ships.

"At first," ENTERPRISE's concept artist John Eaves remembers, "there was only going to be one particular race of Xindi but by the time that the script came out we were going to do a multiple version, kind of like people from different countries. Not necessarily different skin colors but completely different species of creatures, like insectoids, humanoids and so on. The Insectoid and humanoid species were the first ones we started working with."

As was often the way, the brief for the Xindi Insectoid warship was that it should be very alien and look like nothing we had ever seen before. "In the STAR TREK world the approval window was very small but the script would be very broad," says Eaves. "It would always ask for a ship we've never seen before,

WARSHIP

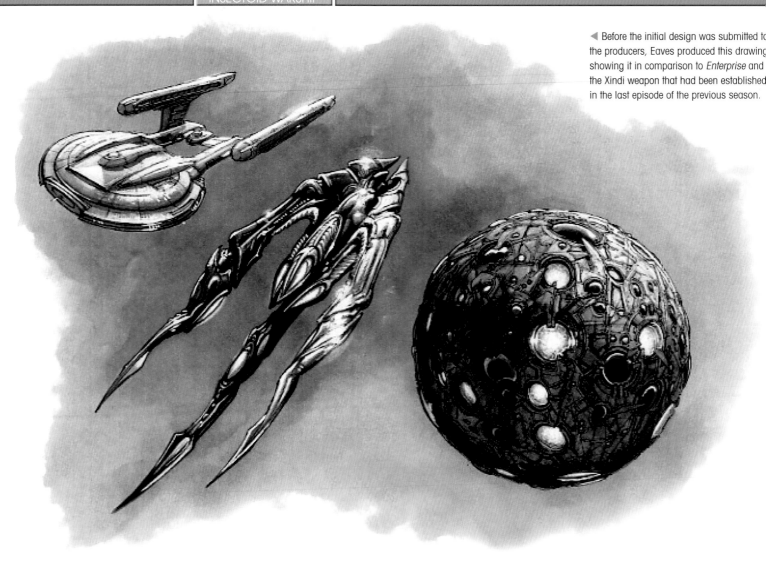

◀ Before the initial design was submitted to the producers, Eaves produced this drawing showing it in comparison to *Enterprise* and the Xindi weapon that had been established in the last episode of the previous season.

every single script would say that! You'd draw it that way but then it would fall back into the same three or four guidelines that would make it through the approval process."

For the Insectoids, Eaves took inspiration from two places: crickets and, more surprisingly, king crabs. As he explains, he was visiting the local market when inspiration struck. "I was looking into the ice chest and saw these king-crab legs and I thought, 'Wow, that would make a really creepy appendage to a spaceship', so that was where those jaggedy crab-like jointed tendrils came from. As well as the crab legs, I was influenced by cricket legs. I was looking for anything that would give it a bug look. On the backs of crickets they have that serrated shell, and that's where I got the

breakdown of the detail in the central body area. It's got that kind of faceted, louvered look, which came from the back of a cricket. Then I figured it should have some kind of eye port - that would be where the bridge or the command centre would be. So, for that I mimicked bug eyes, but not directly."

CUTTING BACK

Eaves produced an initial concept drawing that showed a long, thin ship with 'arms' that had three joints. He presented it alongside a drawing that showed the Insectoid ship along with the *Enterprise* and the spherical Xindi weapon that had attacked Earth. Rick Berman was enthusiastic about the basic concept, but requested one major change. "Specifically he wanted to shorten the really long arms," explains

Eaves. "So we pulled it back - it still has that knuckle, but it pulls back to a smaller point."

Eaves returned to the drawing board and cut the third limb of each of the arms off. To his delight, the revised drawing was approved. And, it's a design that he feels genuinely offered something different to the kind of ships we normally saw on *STAR TREK*. "Once in a while things would break through. This one kind of did."

The sketches were then sent over to Eden FX, where Pierre Drolet built the CG model. In the process, Eaves says Drolet refined - and improved - the arrangement of the central section. But the unusual design did cause a little confusion - until Eaves put them right the VFX thought the ship was meant to fly the other way round!

◄ The Xindi Insectoid warship was approved with unusually few drawings. For the second and final pass, Eaves simply shortened the arms, giving the ship a more compact and muscular design.

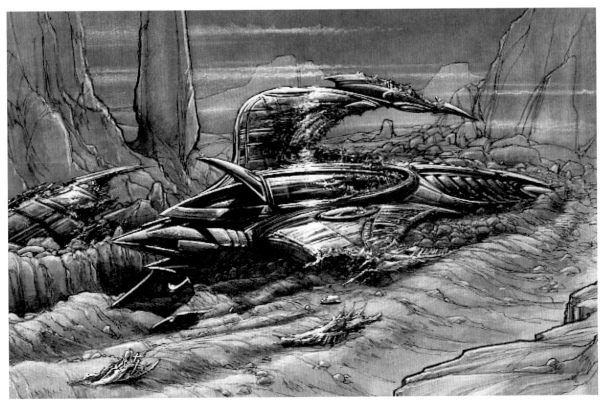

◄ Later in the third season, the crew discovered a Xindi Insectoid warship that had crashed on the surface of a planet. Eaves produced this drawing that showed the VFX team how the producers wanted the crashed ship to look.

DESIGNING THE
III
XINDI REPTILIAN

By creating CG sketches, Doug Drexler came up with some truly original concepts for the Xindi Reptilian warship in no time at all.

The pace of production on *STAR TREK: ENTERPRISE* was relentless, with many of the behind-the-scenes guys working above and beyond the call of duty to keep the series on schedule. The designing of the Xindi Reptilian warship was a case in point and illustrated just how efficiently *STAR TREK* was run. Concept artist Doug Drexler was called upon to create the look of this ship, but he was given just two days to do it.

Drexler had been involved with the franchise since the late 1970s and had worked on *ENTERPRISE* from the

▼ Once the producers had chosen the design of the Xindi Reptilian warship from the basic variations that had been submitted to them, a more refined version with a textured surface was created. The overall shape of this 'Fintail' version remained the same as Doug Drexler had originally envisaged it.

WARSHIP

beginning, so knew what was required without it having to be spelled out for him. But two days was still a quick turnaround time. He was obviously aware of the design of the other Xindi ships that had already been completed by illustrator John Eaves, and could take his cue from those. He also knew that the mark of any

good starship design was that it had its own distinct style and was recognizable at a distance.

Normally, a starship would begin with some pencil sketches, but with time being of the essence, Drexler started with what's known as "gesture sketches" in a computer.

"It's hard to beat it," said Drexler.

"When you do a gesture sketch with a pencil, you can't spin it around and look at it from a variety of angles, but you can in a computer. Being free to spin your sketch leads to stuff you couldn't imagine. The other thing that was very important was not to get hung up on one design. I set out to do four or five sketches. It frees up your

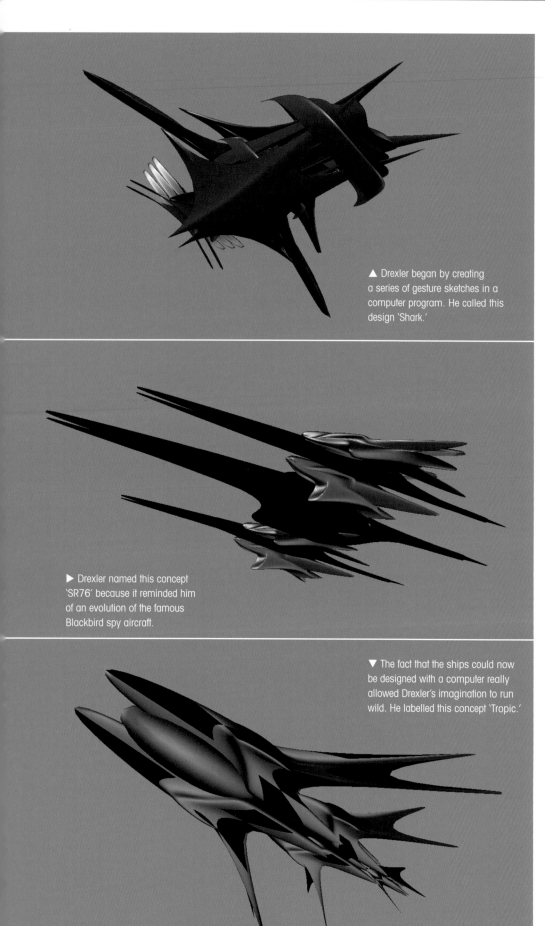

▲ Drexler began by creating a series of gesture sketches in a computer program. He called this design 'Shark.'

▶ Drexler named this concept 'SR76' because it reminded him of an evolution of the famous Blackbird spy aircraft.

▼ The fact that the ships could now be designed with a computer really allowed Drexler's imagination to run wild. He labelled this concept 'Tropic.'

mind. When something becomes too important, it can jam you up. Knowing I was going to do a bunch of them as fast as I could helped the ideas flow. Sometimes I'd combine two designs that were begging to be combined."

OFFERING CHOICES

Drexler was also sure to send the producers several alternatives for the Xindi Reptilian warship, as putting too much time and effort into one design could be a mistake. "The rule that we had in the art department was to send over enough stuff to 'give them something to hate,'" said Drexler. "If you drew just one design, it came across like you had everything invested in it. That's like waving a red flag at a bull. It looked like you were saying that they didn't have a choice, and that's asking for trouble. We always made sure we gave them choices."

By this point in *STAR TREK*'s production, all the starships seen in *ENTERPRISE* were built using CG, and this freed up the creative possibilities enormously, leading to more organic designs. Most of the starships that had been seen in *THE NEXT GENERATION* and the earlier seasons of *DEEP SPACE NINE* and *VOYAGER* had been physical models. They were very difficult and expensive to build, and the 'ships of the week' tended to be right-angle designs to make them easy to construct in a very truncated schedule. With the advent of CG in a weekly TV show, the designers were much freer to let their creativity flow.

"If the Xindi Reptilian warship design had gone to a physical model shop, they would have looked at me like I'd lost my mind," said Drexler. "I was aware that the ships over the years started to look like they had all come from the same shipyard, simply because of the limitations of physical construction. We had these wonderful

new tools, and I think we were one of the first television art departments that took advantage of CG. In the case of the Xindi Reptilian ship, I went for a more organic look to break the mold."

In the end, Drexler produced four different basic concepts that he labeled 'Tropic,' 'SR76,' 'Shark' and 'Forktail.'

"These were all rapid gesture sketches," said Drexler. "You go with a feeling. It's a form of expressive drawing that emphasizes an energetic and tactile approach to form. Once I'd completed the sketches, I saved the file and I needed a name for it. Those labels were just the names I came up with in the moment. It was a kind of Rorschach response... you know, when the psychologist holds up an ink blotch and asks you to say the first thing that comes into your mind."

For Drexler, these four concepts were separate and distinct designs, with no unifying theory behind them. "They were only related in respect to my creative state of mind when I sketched them," said Drexler. "They all came from the same 'feeling,' but there was no evolutionary process whatsoever."

Once they were complete, Drexler's boss Herman Zimmerman showed them to producers Rick Berman and Brannon Braga, along with the other department heads.

INSTANT DECISION

"The producers approved one on the spot, which was 'Forktail,'" said Drexler. "If you look at 'Forktail,' you will see that it is the final Xindi Reptilian warship design, although I took another day to clean it up and refine it. I didn't want to spend too much time refining it because once it went to the CG vendor for finishing, they had the luxury of a week or two, as opposed to my couple of days. I told the CG guys that a fun 'lizardy' surface might be the way to go when texturing the ship. To my eye, physically, the finished model is the one I sent over. I couldn't see any changes, except for the paint, which they lavished time on and did a really good job."

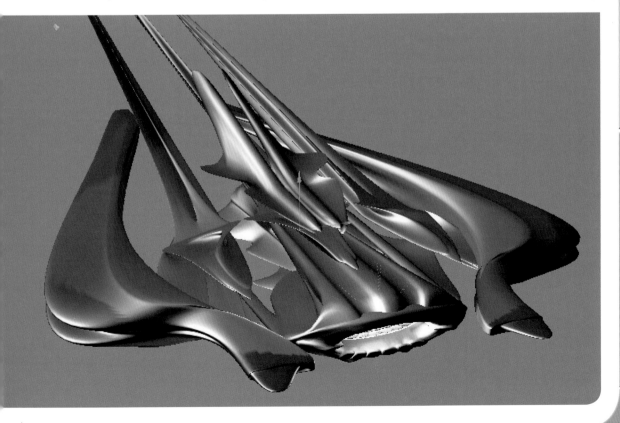

◄ This variant was called 'Forktail' for obvious reasons. It was the design that the producers chose straight away, and Brannon Braga particularly loved its sleek, organic look. Drexler then spent another day filling in some of the details before it was sent off to effects house Eden FX, where the finished CG model was built.

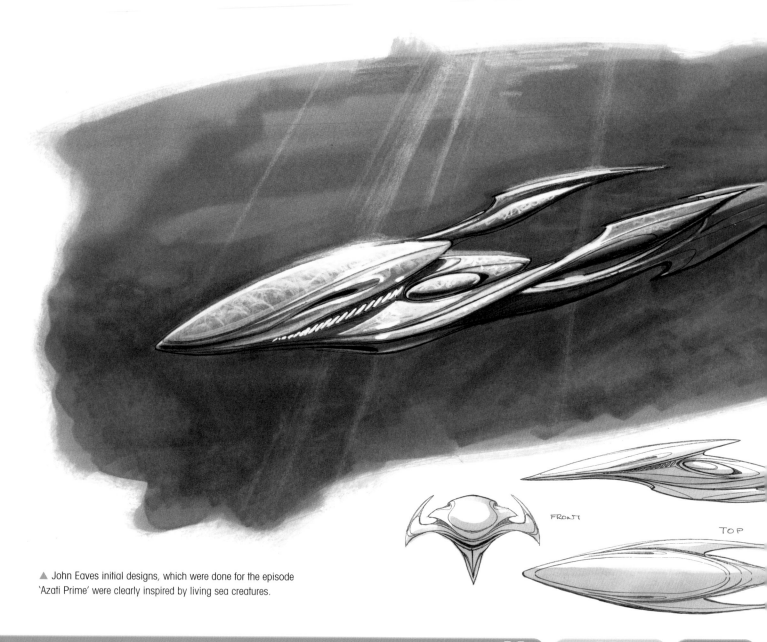

▲ John Eaves initial designs, which were done for the episode 'Azati Prime' were clearly inspired by living sea creatures.

FRONT

TOP

AQUATIC SHIPS

The finished Xindi Aquatic cruiser was a massive ship, but John Eaves' first designs could almost have been sea creatures.

STAR TREK ENTERPRISE's third season was dominated by the Xindi – a culture that consisted of five different species all of which came from the same planet. Despite their common origins, each Xindi species had their own distinct look and technologies so required their own design of ship. The Aquatics had been introduced at the beginning of the year but we only got to see their ships towards the end of the season, and as concept artist John Eaves remembers, the first Xindi Aquatic ship was something of a false start. "The first ship is an unusual little thing. You see it in 'Azati Prime', the episode where they find the bomb underwater."

That ship made the briefest, blink and

SIDE

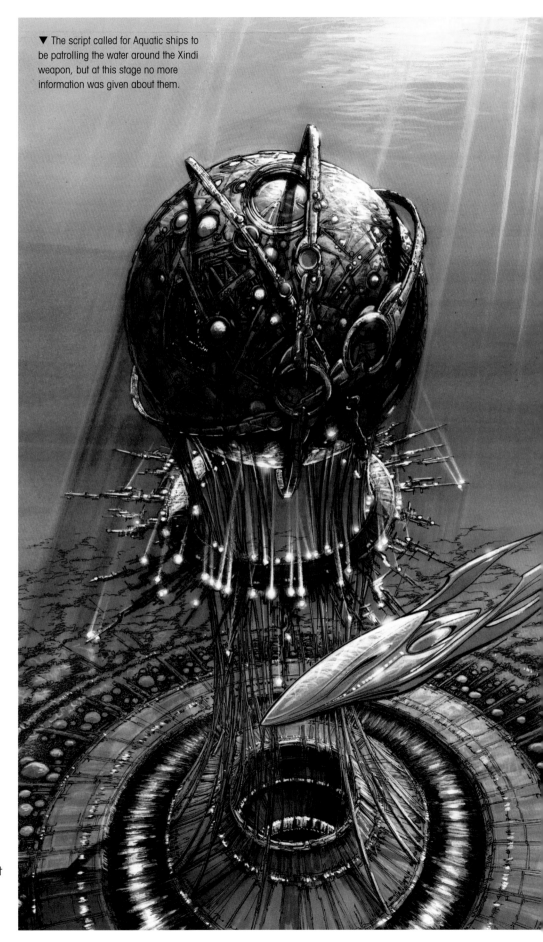

▼ The script called for Aquatic ships to be patrolling the water around the Xindi weapon, but at this stage no more information was given about them.

you'll miss it, appearance and can just be seen 'swimming' around the Xindi weapon.

As Eaves recalls, his first pass was rejected for being too like something that could be made on Earth. "I was trying to find a shape that was different. Ages ago I drew a spaceship for an Australian show. It had this big cannon that sat underneath the vessel. Kind of like a B-58 that has that gigantic fuel tank underneath. My first idea was 'What if the armament was concealed underneath the ship, in between the wings, kind of like a belly stinger gun that was hidden away and was its own little independent piece?'"

That first rejected design was

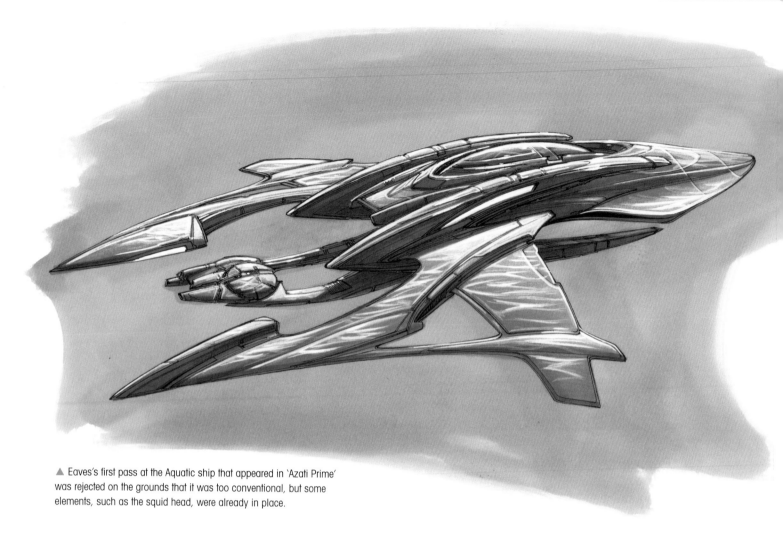

▲ Eaves's first pass at the Aquatic ship that appeared in 'Azati Prime' was rejected on the grounds that it was too conventional, but some elements, such as the squid head, were already in place.

relatively conventional and looked like something that had been manufactured. When Eaves returned to his drawing board he started to push in a more organic and "marine" direction.

WATERY INSPIRATION

"The Aquatics were an area that we'd never explored before. Using fish and stingrays as reference was a lot of fun and added a new direction that you couldn't use for the other stuff."

His next designs were clearly inspired by sea animals, in particular squid. To Eaves' mind the Aquatics' ships would have been produced by genuinely alien technologies and could even be mistaken for creatures. "I was trying to suggest a different kind of material, where there were not a lot of panel lines, or bolting, like you'd see on a

normal ship. I was imagining some kind of molded material so I tried to steer away from obvious panel lines that would make you think it was assembled.

That was kind of the identity of it. Instead of cloaking, it would just blend in with whatever kind of life forms were in their ocean."

▲ The Aquatic ships only play a tiny role in 'Azati Prime' and can only just be glimpsed in the corner of the frame. Similar ships can also be seen as part of the Xindi fleet, but they never played a major role.

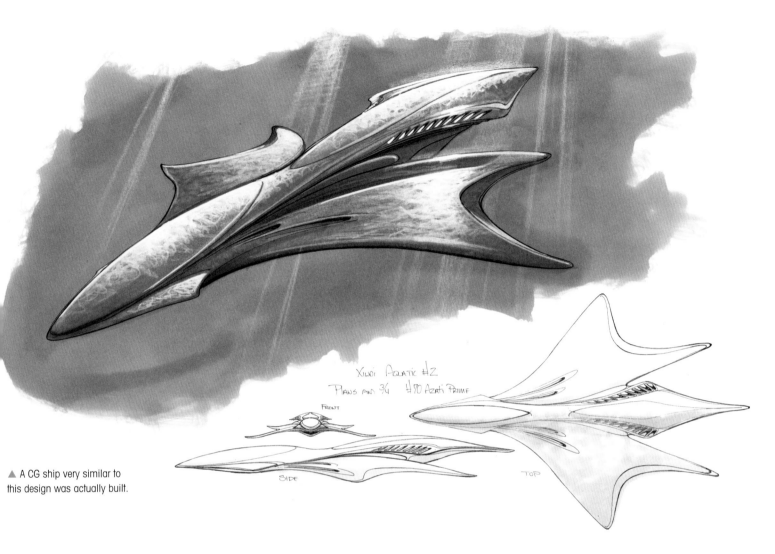

Xindi Aquatic #2
Plans and 3/4 #70 Azati Prime
FRONT

SIDE

TOP

▲ A CG ship very similar to this design was actually built.

HIDDEN VESSEL

One of these designs was actually made as a CG model, but it only appeared in the background and didn't have a major part in the story. A few months later the scripts called for the Aquatics and their ships to play a much greater role, and, as Eaves recalls, it was one that really wasn't compatible with the design that he had come up with.

"The story was very distinct – the Aquatic ship had compartments that hid the *Enterprise*. That dictated that it was going to be big. They felt the first version had too friendly a shape. It was more animal than ship, and the scale felt a little too small to house the *Enterprise*. The angles weren't sharp enough and it didn't have the aggressive nature they wanted.

"I think I did maybe three passes on this new one. There was a wild one. I still had *INSURRECTION* in my mind. I always liked that piano detail that we did for the Son'a ships, so I made a kind of Aquatic version of that. That was a fun one. But the producers said, 'It's kind of a nice idea, but keep going'.

"From there we went to a design with a bunch of windows down the side. That one looks more like the other Xindi ships. I tried to tie the architecture in to what we'd done before. It had a lot in common with Degra's shuttle but that wasn't what they were looking for so it didn't get much more of a response other than 'Give it another go'."

AQUATIC ENVIRONMENT

This design did, however, have elements that gave Eaves the clues that would

take him to the final version. "They liked the fact that it had a lot of glass on the outside. One of the story points was that it cracks open and the Aquatics float out through the damaged portions, so I kept that. That squid head was something they always liked. It travels through all the versions in one way or another so I kept that too. In the final design I just made everything more angular. I was a fan of the 'Stingray' TV show so I tried to do a combination of those kind of ships with my own Manta ray kind of thing." Eaves's new design had a squid head at the rear with extended wings and an open neck and this version was approved without any changes.

"They liked that shape," he recalls. "They liked the split hole in the center. I always tried to do that – give it that

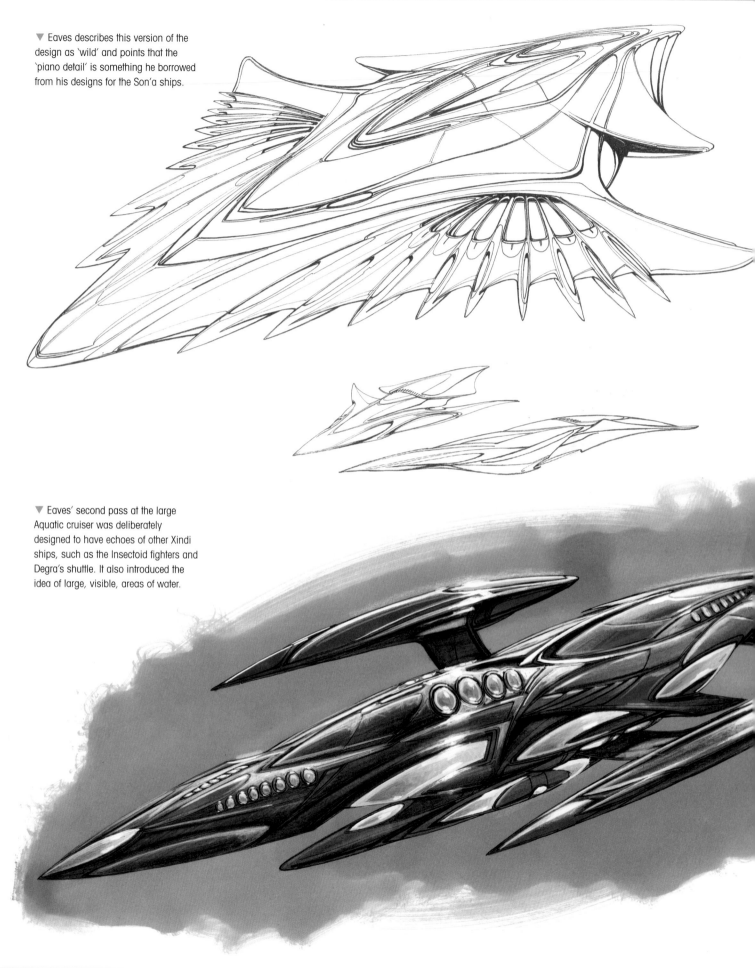

▼ Eaves describes this version of the design as 'wild' and points that the 'piano detail' is something he borrowed from his designs for the Son'a ships.

▼ Eaves' second pass at the large Aquatic cruiser was deliberately designed to have echoes of other Xindi ships, such as the Insectoid fighters and Degra's shuttle. It also introduced the idea of large, visible, areas of water.

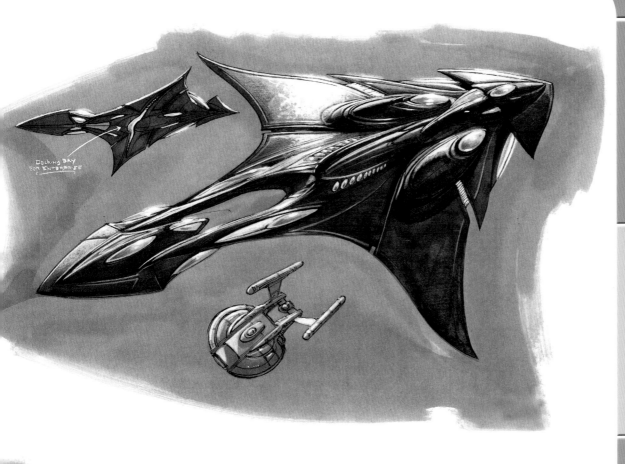

negative space in the openings so you could see through parts of it. I thought you could have something fly under the ship and you could see it through the holes. You couldn't do that easily with traditional models, but in the CG world that was much easier. I thought it would be fun to do the docking bay like a whale mouth. It's like a clamshell kind of thing on the bottom. It's not an obvious hatch until it opens up."

Eaves also points out a little nod to one of his own earlier designs. "The final one actually has a little bit of the Romulan *Valdore* on it. Those big round pods on the back of it – I liked the way it looked on the *Valdore* so I pulled that over here and gave it a Xindi twist."

The ship was then handed over to Eden FX where it was built as a CG model. The VFX team were excited by the idea that when the ship was attacked, the shell would rupture and the water would turn to ice as it froze in

space, and it was important to them to make it clear that the ship was filled with water. Although VFX producer Dan Curry did pause to wonder how the Xindi had transported such a large volume of water into space.

ALIEN TEXTURES

As Eden FX's Rob Bonchune remembers they came up with a texture for the hull that was "like semi-translucent glass with lots of refraction of light going through the 'water' and then the 'hull.' It also had a fresnel/oily/soap bubble surface effect that made areas change specular color as it moved or rotated from the camera."

The finished model was one of the most impressive Xindi ships, which dwarfed its Reptilian and Insectoid rivals. And the VFX team got the shot they always wanted as the climatic battle involved a shot of the Aquatic ship cracking in two.